THE
UNKNOWN
HIERONYMUS
BOSCH

THE UNKNOWN HIERONYMUS BOSCH

KURT FALK

 GOLDENSTONE PRESS *Benson, North Carolina*

 North Atlantic Books *Berkeley, California*

HEAVEN & EARTH PUBLISHING *East Montpelier, Vermont*

Cover and book design © Factotum, Inc.

Printed in Singapore

Published by

Goldenstone Press
P.O. Box 7
Benson, North Carolina 27504

Heaven and Earth Publishing
P.O. Box 249
Montpelier, Vermont 05651

North Atlantic Books
P.O. Box 12327
Berkeley, California 94712

GOLDENSTONE PRESS

GOLDENSTONE PRESS seeks to make original spiritual thought available as a force for individual, cultural, and world revitalization. The press is an integral dimension of the work of the School of Spiritual Psychology. The mission of the School includes restoring the book as a way of inner transformation and awakening to spirit. We recognize that secondary thought and the reduction of books to sources of information and entertainment as the dominant meaning of reading places in jeopardy the unique character of writing as a vessel of the human spirit. We feel that the continuing emphasis on such a narrowing of what books are intended to be needs to be balanced by writing, editing, and publishing that emphasizes the act of reading as entering into a magical, even miraculous spiritual realm that stimulates the imagination and makes possible discerning reality from illusion in the world. The editorial board of Goldenstone Press is committed to fostering authors with the capacity of creative spiritual imagination who write in forms that bring readers into deep engagement with an inner transformative process rather than being spectators to someone's speculations. A complete catalogue of all our books may be found at www.goldenstonepress.com.

The Unknown Hieronymus Bosch is sponsored by the Society for the Study of Native Arts and Sciences, a nonprofit educational corporation whose goals are to develop an educational and cross-cultural perspective linking various scientific, social, and artistic fields; to nurture a holistic view of arts, sciences, humanities, and healing; and to publish and distribute literature on the relationship of mind, body, and nature.

North Atlantic Books' publications are available through most bookstores. For further information, call 800-733-3000 or visit our website at www.northatlanticbooks.com.

Library of Congress Cataloging-in-Publication Data
Falk, Kurt.
 The unknown Hieronymus Bosch / Kurt Falk.
 p. cm.
 Includes bibliographical references and index.
 ISBN 978-1-55643-759-5
 1. Bosch, Hieronymus, d. 1516—Criticism and interpretation. 2. Soul in art. I. Title.
 ND653.B65F35 2008
 759.9492—DC22
 2008016094

1 2 3 4 5 6 7 8 9 TWP 14 13 12 11 10 09 08

This book is dedicated to Anne Stockton.

CONTENTS

AN OUTLINE OF HIERONYMUS BOSCH'S WORKS

INTRODUCTION

By Robert Sardello

In contrast to every form of art criticism and art history, this writing teaches us how to enter into the living activity of painting, painting not as something that we look at, displayed before us, but rather as living spiritual activity that is before and within us at one and the same time. Even more, this remarkable book you are holding provides a new and astounding way of spiritual practice—meditation with paintings. This new form of meditative practice is developed in the most careful way imaginable. You will find this book an invaluable guide in learning how to develop picture-attentiveness, a form of perceiving that focuses awareness with the whole while also noticing particular details. It is not an analytic form of consciousness; it is something more than mental; it is a high form of intuition.

The form of the book is somewhat unusual. It consists of a very detailed text, but somewhat of an outline format. When we received the text for publication and heard of the story and work of Kurt Falk from his wife Anne Stockton, we strongly felt that the text should not be severely edited. Kurt Falk had left this writing where it is at his death. No one would really be capable of taking up the writing; the mark of Kurt Falk's inner spirit pervades the work completely. In addition, the text reads so clearly as it is, and in this form it can be most easily utilized as a practice manual for meditating with the paintings of Hieronymus Bosch, as Kurt Falk intended.

Bosch's paintings become a whole new way of questioning—*of questing*—not in order to find an answer or solve a problem, but rather as a way of developing the inner capacity of letting things speak for themselves. That is, working with this book develops the spiritual quest of **listening.** Listening is fundamental to any spiritual practice, but it is even more so to the spiritual path depicted in so many different ways by Hieronymus Bosch.

We are given a very specific inventory of spiritual practices in this writing. The paintings of Hieronymus Bosch are not to be approached as if we were spectators at a gallery, or would-be intellectuals in an art history class, but rather as supplicants entering a holy place, crossing into the space of contemplation. That is, it is the paintings themselves that are the meditative "device," rather than any interpretation of the paintings. The commentaries provided by the author are meditations and are best worked with in that manner. The descriptions of each painting help us to stay with the images, and to let them enter into our soulbeing.

Working with painting as a spiritual practice requires something very different than other forms of spiritual practices. This work takes place in the realm of **feeling**. That is, it is necessary to enter into the feeling of the paintings, not what the paintings make us feel. Feeling is an objective realm, perceivable through the region of the heart. All art embodies feeling, but few authors, critics, or historians know how to speak of it, and fewer realize that feeling can be a path of spiritual initiatory practice. As you read this work, try to read it from the stance of feeling. Place your attention in the region of your heart when you look at the pictures of the paintings. Kurt Falk speaks the language of feeling and has found a way to convey this in a cognitively understandable manner. But it is beneficial to take what is spoken in this book into the realm of the heart rather than take the book only as a new and interesting approach to understanding the paintings of Hieronymus Bosch. It is that, of course, and you are completely free to stay at that level with the work, where a great deal can be learned. However, there is much, much more available in what Kurt Falk has given. This "much more" is nothing less than an initiatory path of the feeling life.

From the very first words of this book, it is apparent that Bosch's paintings are instruments of contemplation. Not any contemplation, but the

contemplation of Christ. Bosch's paintings are all religious, but they have nothing to do with religion; in fact, many of them are direct criticisms of the corruption of religion that was rampant during his time, and in spite of the fact that many of them were commissioned by churches, the priests never realized that the paintings they received were protests against the degraded state of the church. The Christ that Bosch was concerned with is the imagination of what every human being can become, as well as all that has to be gone through on the way toward becoming a spiritual human being. His concern is the future human being.

This is the sense of Christ that we take into contemplation through the paintings of Bosch. Contemplation here is not as we usually imagine it—an experience of solemnity—but rather contemplation that takes place in such a way that our very bodily constitution alters over time. It is possible, with the help of this book, to go through a body-soul-purifying process.

The word "pure" is certainly fraught with dangers, and I don't mean it in the sense of "untarnished" or some religious notion of that sort. I mean "purification" in the way that Dante understood purification. The word itself refers to the desire regions of the soul.

Dante's *Divine Comedy* exemplifies the path of purification of desire. And I think that Bosch's paintings are in this same genre. In Dante's imagination, **all** desire is good. Desire is like a big net thrown out by God to draw us back to the Divine. The trouble is, we take one desire as the whole of desire at any given time. Dante gives a wonderful picture of desire as a diamond through which a ray of light shines. Desire is the whole of the diamond and all of the rays. We go wrong when we take one facet and one ray as the whole of desire. Bosch's paintings are very much within this kind of

imagination of the purification of desire as being present, with intensity, to the fullness of every moment of experience, whatever that might be. He shows us the folly of singularly focused desire; and he shows the fullness of the desire for the Divine.

The outline in the first part of this book of Hieronymus Bosch's paintings is an extraordinarily important contemplative listing. Take it as a spiritual listing, a guide to contemplative practice. If you want to work on purification of the desires, go to one of the paintings concerned with that domain and work with it; if you want to work on the development of the sense of the spiritual "I," go to another painting. And, if you want to enter into spiritual development with care rather than trying out this and that, moving from one thing to another, then work with these paintings, which also show the folly of following those who do not know what they are doing. Or begin to develop the awareness of how much of what seems oriented toward helping our spiritual growth may be removing from us the very possibilities of growth. In fact, working with the paintings can help us awaken to the fact that deception is rampant in the spiritual growth industry. Unless we take our inner awakening into our own hands, we may find ourselves trying one thing after another without any developed critical capacity. The central image for inner spiritual development out of our own forces is the Treeman image visible in several of Bosch's paintings and the central image in the Cairo painting that inspired this writing.

It is completely unnecessary to have all the paintings in front of us as we read this spiritual inventory of spiritual practices, and of those things that can interfere with clear consciousness but which look as if they are providing spiritual service. We may want to look at the paintings, but it is actually good to hold the word descriptions of the paintings given

here for a long while. When you do look at the paintings, you will discover that you see them completely differently than if you had gone to the images first. The words are not dictating how we see but are rather a preparation for true seeing.

The paintings of Bosch also teach us how to see spiritual events on their own terms rather than terms that have been sanctioned by the church and often obscure the more esoteric dimensions of religious practices. There are, of course, many more forms of spirituality than are found within religion, but Bosch even goes beyond any of those. The true secret of Bosch's art is that he depicts the future development of the human capacity to produce spiritual experiences out of one's own inner soul forces. By "one's own inner forces" I am not referring to ordinary ego consciousness but rather to a completely conscious spiritual individuality.

The soul of the author is obviously deeply engaged with the artistic work, and thus our soul also resonates with this engagement and we begin to notice details while never losing a sense of the whole of each painting, and indeed of the complete oeuvre of Bosch. It is not even necessary to have the paintings alongside the descriptions of the paintings; we are still affected by feeling a sense of the unfolding of particularity within wholeness. The words of the text emerge out of the meditative silence of the author rather than appearing as already present words, that secondary kind of writing that speaks about something rather than from within it. And we see the paintings through feeling, not through intellect. That is, one gives oneself over to the images, enters into them, lets them wash over oneself completely, such that one becomes the image itself. It is apparent that Falk has followed this procedure himself, that this writing is a product of direct experience rather than intellectual curiosity.

We also have the hint in the spiritual inventory of

Bosch's paintings that one can work contemplatively with the paintings in a specific series in order to allow spiritual capacities to unfold in a kind of order. It seems important not to place too much emphasis here because, in spiritual work in these times, there may not be a prescribed order. Nonetheless, it can be helpful to consider the paintings in the sequence spoken of by Kurt Falk.

There is a kind, a type, a prototype of spiritual progression that is hinted at by virtue of the description of Bosch's paintings occurring in the order that they do. This progression should not be understood as processional, as linear, as if one had to proceed inwardly in development from what is felt from the first painting all the way through what is felt in the last. The sense of progression conveys that everything that one has to go through and develop interiorly does not all occur at once to the point of conclusion. On the other hand, when one is working inwardly with one felt sense expressed in a painting, then everything else, that is, the whole world of feeling, is also affected. We perhaps find it difficult to understand this mentally, but the heart does not have this same trouble. The heart, that great center of the feeling life, lives in contradictions, paradoxes, and multiple simultaneous happenings. This kind of sensibility is needed in working with paintings as an instrument of spiritual development.

It is extremely important not to take this spiritual inventory of the paintings of Bosch as sectarian. That is, the scope of the spiritual initiatory practices here do not belong exclusively within, say, the tradition of the Catholic religion. The initiatory practices depicted here are the **New Mysteries.** They have to do with the future of humanity, not a specific religion. They have to do with the process of entering into the spiritual "I," a call made to all human beings. Even more, the diversions and illusion of the individual process of spiritual development are shown over and

over; notice in particular the forces of ossified thinking, perverted feeling, and will that is taken over by other forces than the purified soul; these are chief among the misdirections we have to face and overcome.

There are two ways of reading this book. It is a work that, on the one hand seems intended for those who are engaged in some form of spiritual practice, and in particular to those who are in one way or another involved in what might best be termed "esoteric Christianity." That term alone covers an awful lot these days, so it might be better to specify it even further by saying that the book intends to be helpful for those on the path of a Rosicrucian-Anthroposophical work. For such individuals, this work offers a remarkably new and exciting way to have a sense of where they are in their inner life. Kurt Falk has done nothing less than discover that the paintings of Bosch are a mirror of the soul on this spiritual path. Thus, those who are engaged in this spiritual work will immediately have a sense of recognition in the descriptions of the paintings.

At the same time, however, there is another way of reading this book. It can be a true awakening to a desire to engage one's soul and spirit life in a disciplined way. That is, it also addresses the seeker who may not even know that he or she is indeed seeking something different from art than the usual art history and art commentary. The writing recognizes that people have always looked to art for spiritual guidance in the feeling realm, and only modern art criticism and art history have steered us away from this noble purpose. For such people, however, it might be more necessary to simply read through the whole book, perhaps at first wondering a bit what is going on with this approach to art. Once having gone through the book, however, the reader will feel it begin to do its work as gradually

one's whole inner life begins to be different, and one begins to be more aware that the feeling life is a mode of spiritual presence. It is that mode where all is interior, without a sense of there being any without at all. That is, Kurt Falk works with these paintings in such a manner that we are turned outside in, and the feeling realm is awakened.

A characteristic of esoteric Christianity as a path of spiritual initiation is that there is an emphasis on the development of individuality. For many people who are engaged in spiritual practices, individuality smacks of ego and the purpose of spiritual practice is to rid oneself of the illusion of individuality; certainly of that mark of individuality known as ego-consciousness. With the paintings of Bosch, it is as if each individual is called by his or her own peculiar path. Spiritual path thus means each individual has to find his or her own way by developing capacities of witnessing the interior landscape. As with Dante, so too with Bosch—the path upward is the path inward.

On this path, we are each the Prodigal Son, depicted on, for example, the outside of Bosch's tripych titled *The Haywain.* We stray and stumble, learning our imperfections, not with some goal of becoming perfect, but with the aim of facing them, getting to know them, stop projecting them onto others.

Bosch's paintings reveal that we are like the solitary figure of *The Haywain* traveling through the world of desire, learning, gradually, that desire is not to hold onto but is the indication that we are ***being desired*** by God.

Within such a view, which cannot be understood intellectually, but is given as a sensuous feeling, evil takes on very different possibilities than as something to be avoided or gotten rid of. The demons in Bosch's paintings exist right alongside the other spirit-beings. Trying to avoid evil inevitably results in projecting evil outward—as always belonging

to someone else or some group. The path of desire carries with it a felt sense that it is through the individual confrontation of evil within each of us that we develop true capacities for spiritual freedom.

Confronting the sense of evil as within does not, however, make it something only personal. Whatever occurs within is decidedly real, and not merely something made up, a fantasy realm. And it is something far deeper and stronger than what psychology terms the "shadow." The true mystery of evil, however, is that it can only be confronted within and that it has to be faced without being opposed. The result of doing so, we are told in the description of the painting titled *The Temptation of St. Anthony* is that it is only through the demons that we can find the spiritual worlds. Not by opposing them or avoiding them, and certainly not by reacting in fear to their presence.

Often, the spiritual work of Bosch's paintings has to do with the colors more than the content of what is painted. Falk mentions this when working with the *Temptation of St. Anthony* painting:

> As far as the content is concerned, this triptych is second only to the *Hortus Deliciarum* in Hieronymus Bosch's known works. The two grisaille paintings on the reverse side of the panels are sparsely dramatic and the gray-greens stand in strong contrast to the world of color breaking out from inside the altarpiece. These colors are not for show, not used for their own sake, but their hues and qualities are meant to move and grip us.
>
> There is an absolute unity of form and color that makes the observer more than a mere observer. The colors of the painting release forces in him that lead him out of and beyond his habitual mundane world. Looking becomes contemplation that inspires our imaginative capabilities. Thus a purely aesthetic activity turns into a moral-spiritual affair because the realm of the conscience is affected.

This is quite an amazing statement! Through the colors we enter into a unity with the paintings and there is no longer a separation between looker and painting. The reason painting can be a very powerful medium of transformation lies in the way that color works. We are affected not emotionally, but feelingly— and the realm of desire then becomes an ethical-moral affair. That is, we are able to palpably feel where we are in our soul life, to feel where we are off the mark, and also become able to feel when we are on the mark. This inner direction all happens through color.

Yet another characteristic of the path of individual soul and spirit development shown through the paintings and the astute commentary by our author is that the way of feeling, the way of color, is the way through the thickness of the world. There is never an attempt to develop a spirituality that is separate from the things of the world. There is no absolute division set up between the earthly and the spiritual. They are two sides, two aspects of the same reality. To work spiritually in the realm of feeling is to completely accept being an earth-being who is working to become, not a spiritual being, but a *spiritual human being,* which is something quite different than a human being who does spiritual things. The former is an advance in spiritual evolution, while the latter is where most of us are by nature and a modicum of goodwill. The object of this path of spiritual practice is not to have experiences of the spiritual worlds, to obtain enlightenment, and to leave the earth, but rather to serve the earth as fully bodied spirit-beings.

The way of feeling cannot work with absolute distinctions. The mind works that way. But feeling is all of the same fabric, so learning discernment in the realm of feeling is something very different than learning to make cognitive judgments in the realm of clear ideas. In our feeling life, we are more often confused than not. Here is where we most easily fool

ourselves. It is incredible the way that Kurt Falk reads the paintings, helping us develop discernment in the realm of feeling. Notice how a painting depicts real and truthful feeling standing right next to illusion in the realm of feeling. Notice also how Bosch has made available to our feeling-awareness the difference between true feeling and the double of feeling; we see this difference vividly depicted in the ways in which institutional, dead religion contrasts with the sense of the living Church, which is not an institution, but rather a prototypal coming into being that constantly unfolds, metamorphoses, as the life of the "I"; "I" as in "Not I but Christ in me."

These introductory remarks barely touch on the first few of the twenty-nine paintings commented on by Kurt Falk. Indeed, this first part of the book can be a new meditation manual, a manual for initiation into the spiritual worlds through the life of feeling.

The second part of this writing casts yet another lens over the whole of the work of Bosch, bringing initiatory practice to an even higher level.

The inspiration for this book is the mysterious painting titled *The Last Judgment,* which Kurt Falk found in a museum in Cairo. You will read of this discovery at the beginning of the second part of this book. I only want to address the question of the authenticity of this painting. Is it a real Hironymous Bosch painting? ***It does not matter***. If you were trying to buy the painting or put it on exhibition, it would certainly matter. But, for the purposes of this writing, it has been a revelation for Kurt Falk and the key to all of the works of Bosch. If it is not authentic, it was certainly painted by someone who thoroughly understood Bosch and may in fact have wanted to provide a key to Bosch. The key image in the painting is the figure of the Treeman, the witness, the act of individual spiritual

attention, the spiritual I-being, spirit-individuality, the inner presence of the individuated self.

The fact that Kurt Falk works with this one painting *in the context of the whole of the work of Bosch,* authenticates the painting *as* revelatory of the spiritual dimensions of the work of Hieronymus Bosch. This one painting fits within the whole context and makes clear what Bosch was doing. That is its primary importance, which may be something different and more significant than whether the painting is authentic. Falk, does, however, make a compelling case for the authenticity of the Cairo painting.

A different form of awareness is required to begin to perceive the significance of Bosch's paintings, and the nature of this awareness forms an important dimension of this second part of the book. It is, for example, necessary to be able to focus attention on the particularity of each painting while at the same time be within a diffuse form of awareness. This kind of awareness can be part of the spiritual practice of working with the paintings and consists of looking at a picture of a Bosch painting, focusing on some particular element for a few moments and then shifting awareness to a diffuse awareness of the whole painting all at once. Shift between these two modes of attention while looking at one of the paintings. Then, after a few minutes, stop the shifting and be present to the painting and notice your experience. Not only your sensing/perceptual experience, but also, at the same time, what is felt inwardly. The sense of the paintings will begin to open up in decidedly new ways. You will gradually have an inner sense of the paintings, though it may be an experience beyond words. With this form of perceptual practice the articulations provided by Kurt Falk take on much more importance, for you will find these descriptions speak what you might not be able to say. He has worked

to find just the right descriptive language, which is something akin to language that understands the qualities of dreams.

The dream qualities of the paintings of Bosch are, however, something quite different than night dreams. Bosch was not painting the imaginal landscapes of the so-called unconscious. Rather, he was painting the multiple spiritual worlds that are always here, all around and within us. Thus, Bosch's paintings, in some respects, mirror the surrounding landscape. It is as if the familiar world is layered with realm after realm of spiritual worlds. Bosch was not making up pictures of these worlds but rather pictures his seeing. He accurately pictures clairvoyant experience, but you have to be able to see through the content to the awareness out of which a content suitable to the awareness emerges.

It is crucial to understand that it is the *qualities* of the content of the paintings rather than the literal forms of the figures within the paintings that express the spiritual worlds. The genius of Bosch lies in his amazing capacity to create a content that vividly expresses the qualities and activities of spirit beings. Further, it is important to realize that the spiritual worlds are highly complex. All spiritual traditions and practices understand that the spiritual worlds are every bit as complex, indeed far more so, than the earthly world. The spiritual worlds are intermixed with beneficent and detrimental beings, with the dead who are helpful and those who are harmful, with levels that are helpful and levels that are not so helpful. Bosch beautifully pictures the wholeness and complexity of the spiritual realms, but it is how our attention is brought to their depiction by Kurt Falk that makes it possible to see much more of what is present in the paintings. The phenomenological description of the Cairo painting is nothing short of fantastic.

I also want to draw your attention to what may perhaps be the deepest aspect of the mysterious painting of Hieronymus Bosch and that no one besides Kurt Falk seems to be aware of except in the most superficial manner. Bosch's paintings are from the future! They come from the real, tangible stream of time from the future. Thus, the paintings are not really about the time of Bosch. They are not really about the decadence of the church, not at the deepest level of the paintings anyway. They are about what is coming to be. However, they are not predictive of the future. The future time stream is not predictive; it is not about what is going to happen the day after tomorrow. The esotericist and originator of anthroposophy, Rudolf Steiner introduced this notion of the time stream from the future. It is not a theory, but something quite possible to experience, though not with the mind. It is the sense of everything of the world, of the cosmos, and of the spiritual worlds, and most of all, of the human being, as in the process of coming to be, and this coming to be is an aura of everything that is. The coming to be of the time stream of the future does not refer to the domain of possibility. It is not that the paintings of Bosch, for example, depict some possibility that will some day be actuality. The time stream from the future is a dimension of everything that exists, and is thus present now; it is the coming-to-be aspect of the now. We might also think of this dimension as the realm of prototypal imagination as distinct, for example, from the realm of archetypal imagination as discovered and worked with by Jung. The prototypal dimension is the realm of the not yet, of the coming to be. It also includes those forces that would attempt to diminish the sense of awareness of the prototypal realms, blocking an ongoing, subtle experience that as we live our earthly lives, we are also, at the same time, citizens of the cosmos.

There is a particular stream of spiritual initiation tradition in which the sense of the time current

from the future is central. I came to understand this stream through the work we do at the School of Spiritual Psychology. The many practices of this spiritual work came first out of meditative work. Only later did it become apparent that these practices, completely of this time and not atavistic, were within this spiritual stream of the time current from the future. I will only mention the groups within that stream here, without going into the relation of the practices of spiritual psychology to them because the intention is only to locate Hironymous Bosch as belonging to this spiritual unfolding and to show that Kurt Falk was deeply perceptive in intuiting this fact.

This spiritual stream runs from the ancient initiatory practices of Mani, which began in the region that is now Iraq in the third century AD. The religion of Mani had this future time current at its heart. Many of the spiritual groups within this orientation probably were not aware that they were working from the time stream of the future. Thus, they took what they were doing as something that needed to be in the world as actual practices at those times—which got each and every one of these groups into the terribly difficult position of being labeled heretical.

I have also traced out an earlier branch of this spiritual stream that goes from Mani to Sufism. The Mani stream goes then to the Cathars, and from there to the Templars and then to the Troubadour poets. From there it goes to Dante and the *Divine Comedy*. It is quite explicit that this great literary work is an initiation document and directly connected with the Templars. Then the stream goes to the development of the Tarot in northern Italy, and it is at this point that there is a connection with Bosch.

What happens after Bosch? Where does the stream go? Falk locates Bosch within the Rosicrucian tradition and then to anthroposophy. That is

certainly not a straight-line evolution. What seems to me to be most important is the continuing sense within each of these spiritual groups of being pulled by the not yet of the future rather than being pushed from behind by the past. There is this same future sense, the coming to be, the unfolding of the spiritual human being within anthroposophy.

Robert Sardello, Ph.D.

The School of Spiritual Psychology

October 2, 2007

The present study of the painter Hieronymus Bosch represents a strange and intrepid adventure. It is a venture against reason, based purely on an act of contemplation, on an experience. This experience was triggered by the painting *The Last Judgment* in the Museum of Modern Art in Cairo. It was above all the so-called Treeman, the central figure in the painting, which exercised a strong fascination on the author and led him in increasing measure into the world of the painter. It was this unknown painting, then, which gave the incentive for this study. Nothing is known about its origin; its brushstroke does not indicate it to be an original work of the master or of his school.

Nevertheless, its content, subject matter, and composition made such an impression on the author that in spite of varying degrees of critical expert opinion he felt compelled to adhere to his aim of showing that this work of art—whether or not it stemmed from the hand of the master—speaks the language of Hieronymus Bosch in an impressive manner. Seen in the context of all his works, it represents a continuation and crowning in the true sense of his life's work. It cannot be seen, therefore, as a work by an epigone or a sixteenth-century imitator.

It is certainly a risky undertaking to embark on such a study without any documentary points of reference, purely on the basis of contemplation, and yet to hold fast to the original idea, which formed the basis of the initial experience, that this unknown painting in Cairo can make a fundamental contribution to an understanding of the works of Hieronymus Bosch.

But the search for and discovery of the meaning of his language gives validity to the Cairo painting. Its authenticity becomes irrelevant: it contains the key to breaking a code, the meaning of which stands clearly displayed in all of Hieronymus Bosch's works.

Kurt Falk

Forest Row, Sussex, 1985

It is possible to pass by the painting *The Last Judgment*, attributed to Hieronymus Bosch, for a great many years without really seeing it. One might notice individual grotesque features, but it is a painting, having undoubtedly darkened, that exercises no great appeal on the unprepared observer.

But, having ignored it for a long time, one can suddenly be attracted to this painting when the time is ripe. What is it that suddenly draws one's attention? It is the countenance of the Treeman, not quite in the center of the painting but central to its composition nonetheless, that makes one receptive to Hieronymus Bosch's language of the spirit. Its gaze is like a call to take the painting seriously and reflect more deeply on its content.

The appeal is less to our sense of beauty than to our consciousness, which is summoned up by the alertness of the countenance. We are challenged to investigate what this alert countenance consciously observes in its surroundings.

This original experience, which made a deep impression on the author, became the basis for the following study; it is the consequence of the author's awakening to the painting.

The Last Judgment in Cairo was the author's first meeting with the works of Hieronymus Bosch. It had a lasting effect and led to a deeper study of these works and the personality of the painter.

Kurt Falk

AN OUTLINE OF
HIERONYMUS BOSCH'S WORKS

In order to gain an impression of the extent and importance of Hieronymus Bosch's path of development, an outline of his extant works is given here. Few documents and little information about his life exist, and as a consequence the only approach to his personality lies through his paintings. The attempt to put his works in chronological order, as undertaken by Charles de Tolnay and Ludwig Baldass, can be seen as such an approach. Bosch's treatment of various subjects gives us a certain insight, even if there is little precise information about him. In the following pages, I will give an outline of Hieronymus Bosch's works to make some of this background available to the reader.

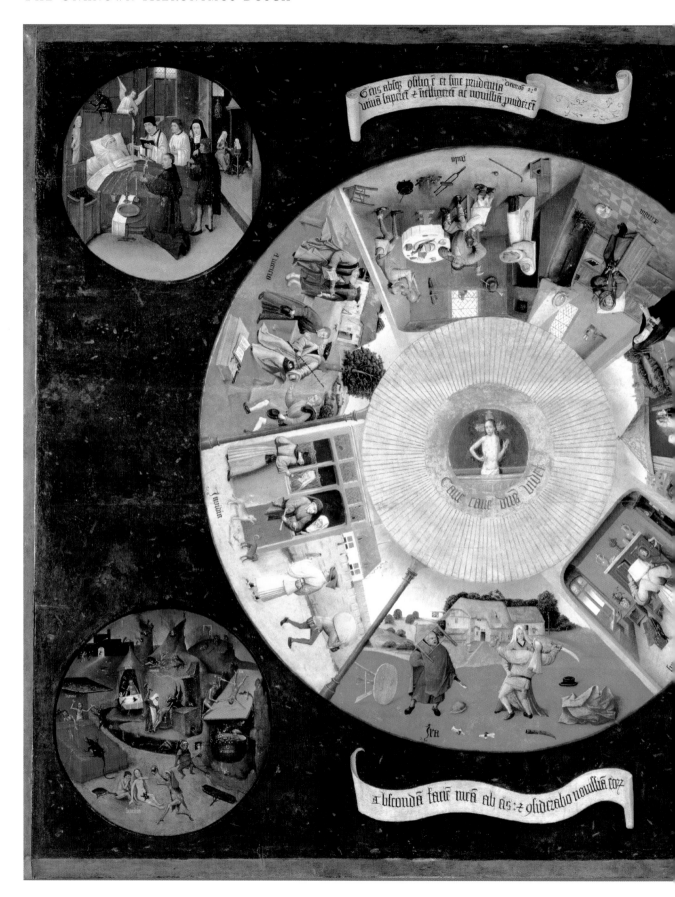

THE EARLY PERIOD

The Seven Deadly Sins and the Four Last Things
Madrid

This painting is one of Bosch's early works. The style is reminiscent of late-gothic miniature painting. It is painted on a square piece of wood with a black ground. A piece for contemplation, the observer was intended to become immersed in its content. The focus of the painting is Christ rising from the grave, surrounded by a luminous aura like a world iris: "Cave, cave, Deus videt!" ("Beware, for God sees all!") Christ is depicted surrounded by the seven ways in which human beings can sin, corresponding to the seven members of the body.* In contrast, the human being in the form of the redeemed Treeman becomes the focus of events in *The Last Judgment* in Cairo, consciously experiencing the consequences of the seven sins, which become his destiny.

At the four corners of the tabletop, tondi depict the four last things: death, the Last Judgment, hell, paradise.

The central tondo depicts the leitmotif of Bosch's life, the *Imitatio Christi (Imitation of Christ)*. It bears witness to his striving to make knowledge of Christ the focus of his philosophy. Only in imitation of Christ can the human being overcome the seven sins, which are predisposed in his sheaths, and thus achieve a proper relationship with the four last things. Christ has to suffer the tyranny of human deeds for as long as the human being is unable to gain control of his innermost self, for as long as he is unable to master his instincts and desires. Thus the table is like an admonition: grow strong in Christ, grow strong in your "I," so that your sheaths—evolved from past lives—are permeated and transformed by the power of your "I" and your soul achieves a proper relationship with the four last things: with death, with hell, with the Last Judgment, and with paradise.

*The seven-membered human being was already known in ancient Egypt and Greece.

The Cure of Folly
Madrid and Amsterdam

Two different versions of this painting exist, one in the Prado in Madrid and the other in the Rijksmuseum in Amsterdam. In the Madrid painting, which gives a portraitlike emphasis to the heads of the subjects, a monk and a nun are concerned with a patient who is to have the stone cut out. The doctor performing the operation is removing from the place where the human being is able to form his "I"—the pearl of the Buddha—two parts of a growth. Clearly a castration is about to take place—strangely, however, on the head. Lack of anatomical knowledge is not the problem, of course. The process is more comprehensible if we recall the close link between the forces of the head and imagination, and the sexual drives and instincts. After all, intervention in the sexual realm affects the consciousness and vice versa.

The idea that consciousness could be raised by suppressing the physical procreative forces appears to have haunted Bosch's time. Thus the type of practice depicted in this painting was carried out by numerous doubtful occult sects, causing mischief among the gullible population. Such actions are like a distortion of true initiation: inner development and transformation through prayer and meditation are replaced by surgical intervention. As a result, the operating doctor has an inverted funnel of wisdom on his head. The monk with the sacramental wine, which no longer has any potency, has little comfort to give to the patient tied to the chair. The nun standing beside him, doubtful, skeptical, and also watching the doctor, carries a closed Bible on her head: the wisdom of theology is no longer accessible. The monk and the nun are leaning on the table. On it lies a broken lotus blossom and three seeds, which have fallen out of the seedpod, and are threatening to fall off the table. The tabletop, supported on a plantlike leg, represents the surface of the general consciousness of the times, and the three seeds are being blown off of it.

The broken lotus blossom and the seedpod with the three ripe seeds: what is their significance? The potential for the development of the two-petaled lotus flower resides in the head and is the organ for higher consciousness. This organ is being removed in the presence and at the instigation of the representatives of the Church—the monk and the nun. As a result, no blossom can unfold, no fruit can ripen, and no seed can be formed. Bosch speaks a most vivid language: plant, broken blossoms, and scattered seed. The three elements—the potential of which the human being is being deprived—lie accusingly on the table. One cannot but recall the fact that a Church council decided to erase the concept of the trinity, the knowledge of the threefold nature of body, soul, and spirit that forms the basis to an understanding of the divine Trinity, from human consciousness. The sick human being is kept in a childlike state of consciousness through this operation and is unable to develop the faculties of his essential and complete humanity.

The Amsterdam painting depicts the process in a different way.* Unfortunately we do not possess the original. In this painting the doctor performing the operation is wearing a pointed hat. The wise doctor is sitting opposite the patient, and the operating doctor is on the other side of the table. The wise doctor is showing the spectators and the clerk, who is taking the protocol, a true pearl—a pearl whose luster and value have been created by the irritant grain of sand in the oyster. The transformation that creates the miracle of the pearl takes place through suffering.**

* *Copy of an unknown original*

** *Cutting out the stone, as the Church wishes, is contrasted with preparing the stone in the Rosicrucian sense.*
See Rudolf Steiner, Theosophy of the Rosicrucian.

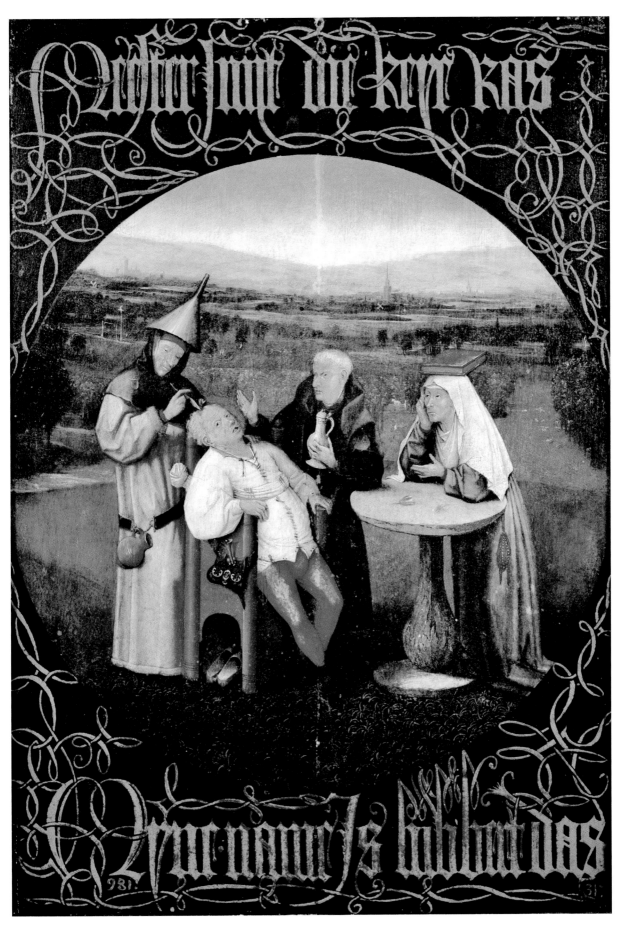

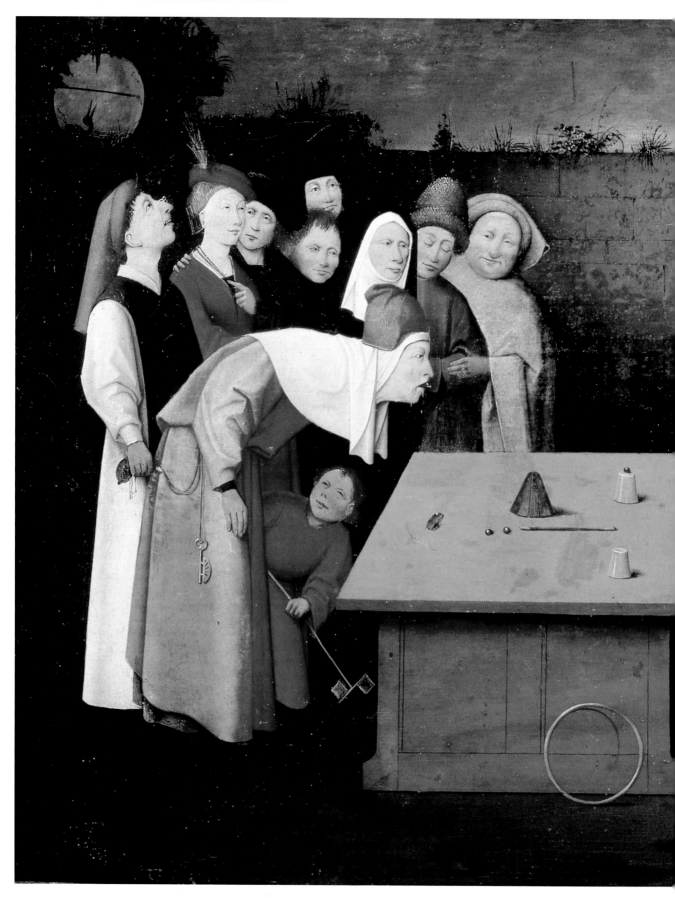

The Conjurer
St. Germain-en-Laye

The Conjurer is another painting in which Bosch depicts how people are deceived through lack of insight and alertness. People are willing to allow themselves to be deceived by trickery and illusion. The hankering after cheap miracles, after the magic of the fairground dressed up in a superficial occultism, was prevalent at that time, too. Even the nun, who would normally take a critical attitude to such things, is fascinated, as is her companion, a man who has no judgment and accepts unquestioningly everything the clerics say.

A pearl is also being shown here. It is probably a false one, which casts its spell over the credulous spectator, himself a person of rank. He is completely captivated and stares at the gleaming fixed point in the magician's hand. Meanwhile the magician's assistant uses this opportunity to relieve the staring admirer of the magician of his full purse. A strong magical tension is at play between the victim and the conjurer, who has the constitution of a eunuch. The nature of his intelligence is shown by the owl whose head can be seen poking out of the small basket. The basket is hanging below his belt where the sexual forces are usually active.

The noble lady—the soul in its pride—is equally unable to escape with her companion from the magician's display. The conjurer's assistant stands to one side of her and her lover on the other. But the latter is pointing to her heart: true miracles are an affair of the heart!

The horizontal arrangement of the two groups of spectators is divided by a vertical group of three. Among the latter is the child playing below, looking in astonishment at the seemingly egoless victim of the eunuch's tricks; toads are jumping out of the victim's mouth in his self-surrender.

At the center of the group of spectators stands a man who is concerned to understand what is happening. A second person stands behind him wearing a cowl, a black hood, and seems to see through the illusion with alert senses.

The figure of the conjurer reappears in Bosch's *The Temptation of Saint Anthony*. The painting of *The Conjurer* is of interest insofar as the spellbinding tension that keeps reappearing in Bosch's later works appears here for the first time. This tension, which the uninitiated can feel but not recognize, has been described as enigmatic.

Christ Among the Doctors
Paris and Florence

Free of all enigma, the miracle takes place openly in this painting. The twelve-year-old instructs the doctors in the temple while his parents leave sadly, for they cannot find the son whom they thought they knew so well. The holy transformation in the child is symbolized by the large colorful butterfly that, itself transformed, has just emerged from the pupa and flies toward the light.

The Adoration of the Magi
Rotterdam and New York

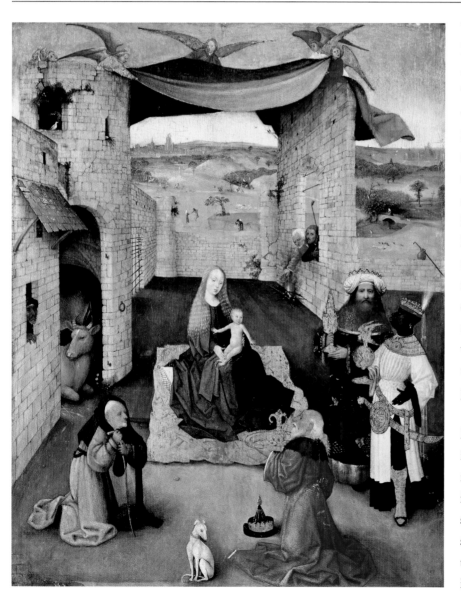

What a stroke of boldness, to paint the Madonna sitting on gold brocade, darkly clothed against a black background This demonstrates the originality with which Bosch pursues his path, refusing to bow to traditional ways of depicting the Virgin Mary. The supersensible nature of the event taking place in *The Adoration of the Magi* is shown by the tame dog in the foreground that modestly turns its head away at the greatness and glory of this birth. The dog is symbolic of earthly thinking, which—even when tamed—cannot grasp this event. The magnificent robes of the kings display an inner wealth. The depth of the colors increases the loveliness of the inwardness permeating the painting.

The golden cloth spread out beneath Mary recalls the gold background used in paintings of earlier periods. Here this is replaced by nature looking in. The ruins form a dark background and angels are spreading a canopy over ruined walls. The shining golden hair of the Virgin recalls the fairy tale of Goldmarie. (The painting is generally not accepted as an original.)

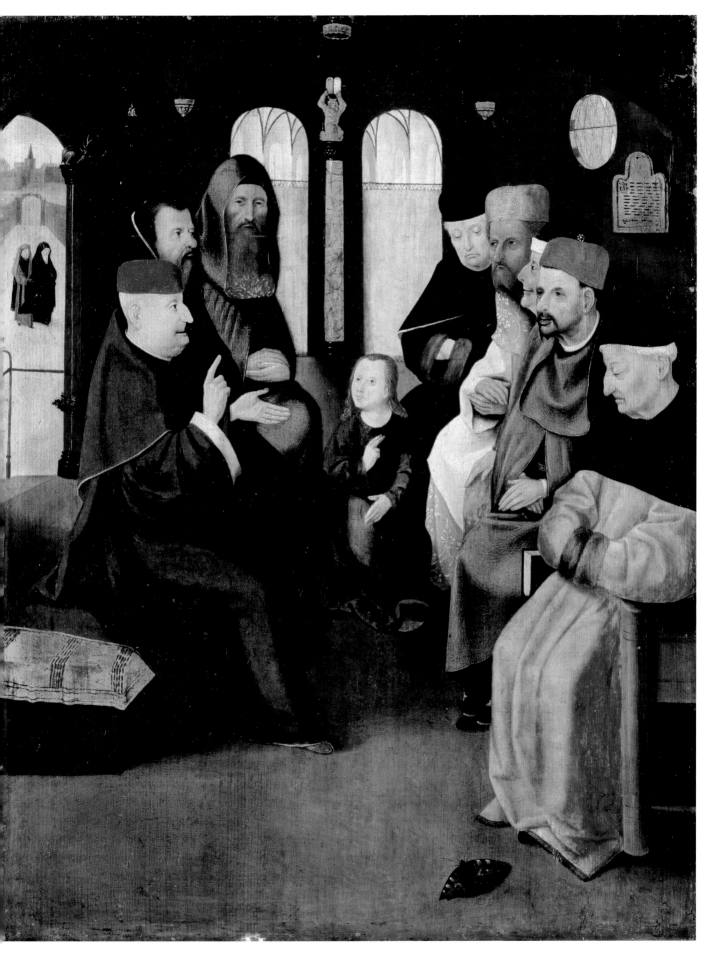

Epiphany
Philadelphia

"United by the magical power of the star, the five people give the impression of adepts in an esoteric-religious community" (de Tolnay). The Christ-child, surrounded by his aura, takes hold of the threefold golden chalice proffered by the first king as if it were his own— a chalice it had been born to fill and fulfill. The second king turns his gaze toward the observer of the painting but is nevertheless deeply connected with the event in noble humility and reflection. He is clothed in a rose-colored gown and girded with a sword. Next to him, his feet planted firmly on the ground, the Moorish king with turban and crown points to the embroidery on his arm depicting "gathering in the manna," the archetypal image of the Last Supper (Combe).

The loveliness of the Virgin contrasts with a withered tree stump in the foreground, but ox and ass stand in the ruined stable in the background in good grace.

An atmosphere of great serenity pervades the painting and the experience of Epiphany is mirrored profoundly and transparently in those involved.

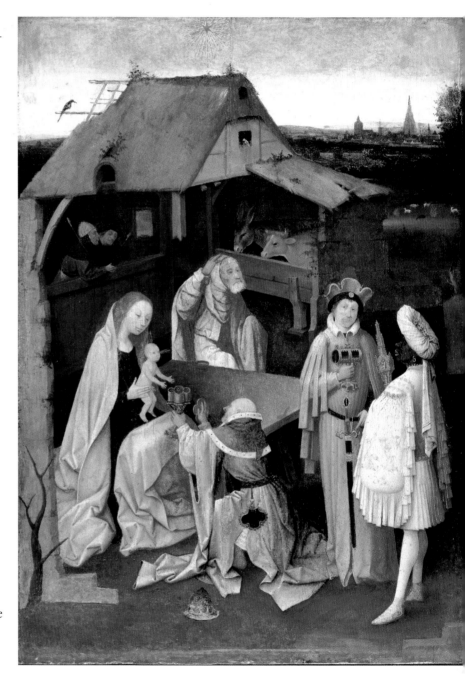

The Marriage at Cana
Rotterdam

The expansion of consciousness previously experienced in the painting depicting the miracle of the butterfly (*Christ Among the Doctors*) and in *Epiphany* (Philadelphia) leads to a split in consciousness in *The Marriage at Cana*. According to the Gospel of St. John, it is the first miracle Christ performed, the transformation of water into wine.

The painting exudes a strange atmosphere. The resplendent oriental garments are probably meant to indicate the biblical setting. Yet its style transcends the framework of traditional depictions. It is a Jewish marriage attended by Christ and his mother; some disciples are also present. The composition is clear and open, yet there are riddles here as well, with events that are difficult to grasp.

Unfamiliar mystery cults form the framework for the events taking place. A young acolyte in the center of the painting, representing the ancient Jewish cult, toasts the bride in accordance with the Law.

Spontaneously the question arises—where is the miracle, the transformation of water into wine, taking place? Nothing is happening where the servant is filling jugs, nor among the guests, nor at the heathen altar in the background. The bride, who is not wearing a veil, sits composedly between Mary, the mother of Christ, and the bridegroom. Is the miracle being revealed in the youthful acolyte with the golden chalice? Charles de Tolnay points out that the biblical miracle is displaced here by the eucharist.

No one seems to pay attention to the miracle and yet it is taking place. Is it happening in the silent Christ, the Master, who solemnly lifts his hands, as at the Last Supper, indicating the transformation of bread and wine, the sacrifice of the body? Only the Johannine figure of the bridegroom and Mary, in the wisdom of her heart, allow us to assume that both are aware of the hidden process. And at the end of the table, the strange Mary Magdalene figure shows that the new wine has worked.

The painter raises many questions in the observer of the painting, hints at many secrets. The mystery of the transformation of the blood is performed here as the first miracle of Christ, as a new mystery, a new cult.

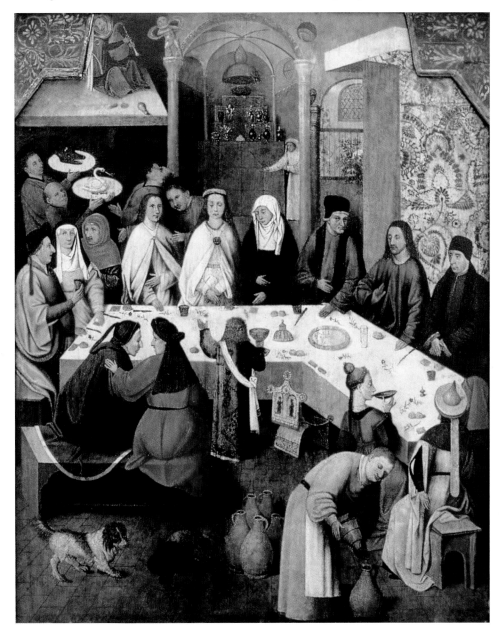

Ecce Homo
Frankfurt

This depiction of Christ being brought before the people is also described as the Council of the Antichrist. He is put on display on the world's stage and mankind rejects him. The members of the council, dressed in splendid robes and well protected, do not want him, naked and bare. The crowning with thorns appears to have passed by the ignorant populace in town and country without a trace. They do not want him, their redeemer and savior, who could have guided them to their true self, their humanity. The divine "I" that is neither recognized nor wanted suffers for the sake of those who mock and jeer.

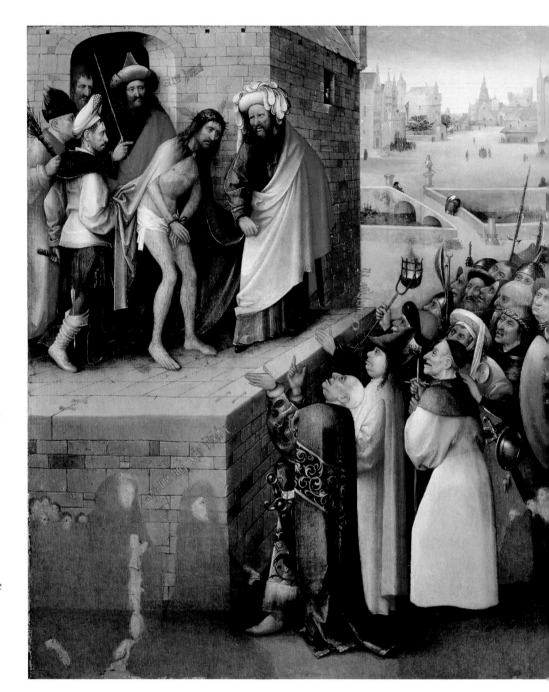

Death of the Miser
Washington

Death enters the room where the miser is dying and points his spear at the heart of the dying man. He feels death approaching and knows that his time has come: the spear is already throwing its shadow. Yet he still finds it difficult to choose between the words of his angel, pointing to the divine beam of light streaming through the crucifix hanging high on the window, and the solid money bag in front of him, which his demon is forcing on him and which his arms move to grasp without any will of their own. At stake here is not the choice between angel and devil; we are being shown the irresolute nature of the "I" that cannot separate itself from its material goods at the hour of death.

The dying man imagines that he has become rich because of his faith and his pious life. In fact it was demonic help that filled his coffers. The demons now turn out to be his laughing heirs and beneficiaries, abandoning the human being in poverty and nakedness at death. They steal his robes and coverings; armor, helmet, and spear have become scrap. Thus the "I" faces death in its nakedness, for "from him that hath not, even that he hath shall be taken away from him."

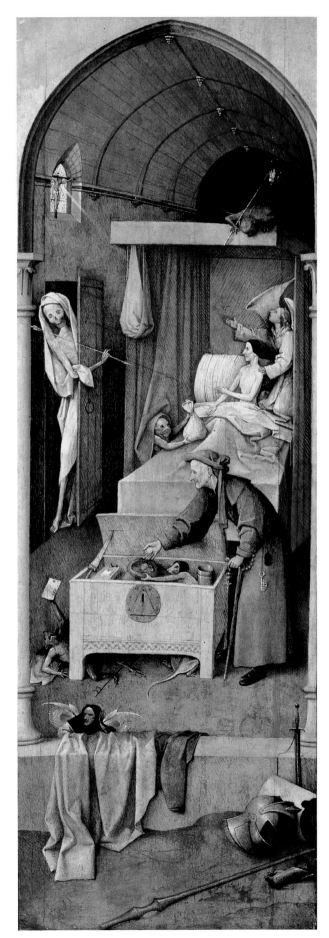

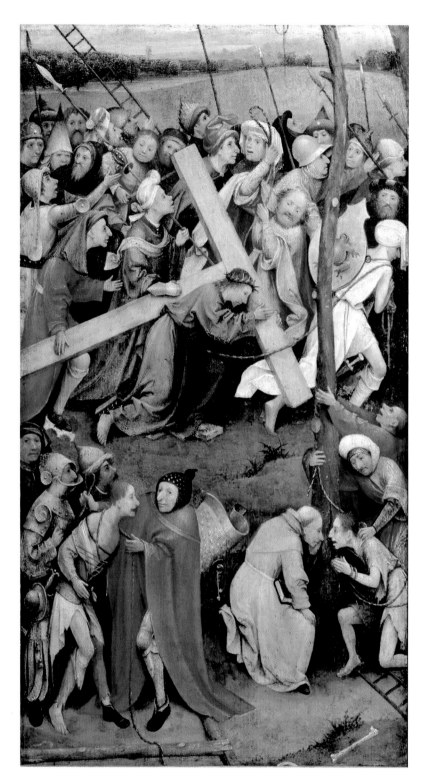

Christ Carrying the Cross
Vienna and Madrid

Vienna, Kunsthistorisches Museum
The reverse side of this painting of Christ carrying the cross depicts the infant Jesus holding a whirling and taking his first steps with a walker. These first upright steps of the child on earth correspond to the Christ on the front of the painting who is almost crushed by the weight of the cross. He is crushed because he bears the burden of the over-heavy cross of mankind and of the destiny of mankind. Alone and unrecognized, his is the one true ego, the unknown divine "I," in the midst of the raging mob. The sign of the demon army, the coat of arms with the toad, is carried before him.

Below, in the scene with the two sinners, the one is full of despair while the other is filled with hope, comforted by his confessor. Two men suffer the same fate on earth as Christ, but their future karma will diverge because they do not possess the same faith.

Madrid, Escorial (opposite)
A quite different mood pervades this painting in spite of the fact that the same subject of Christ carrying the cross is depicted in it. The individual figures are larger. Simon the Cyrenian helps to carry the cross. Christ's questioning gaze, a gaze penetrating our conscience, is turned at the observer of the painting.

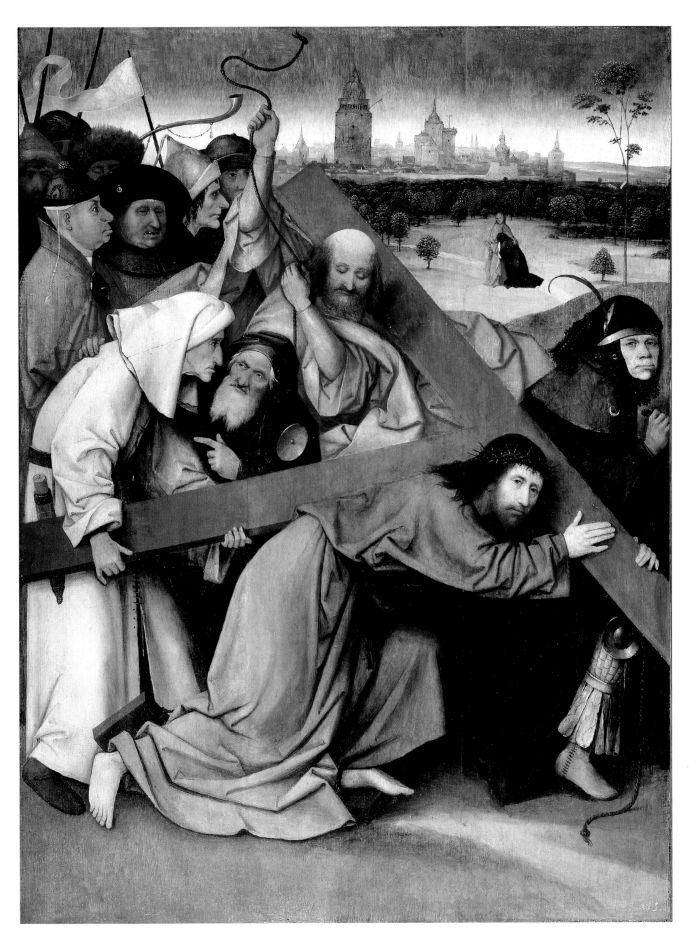

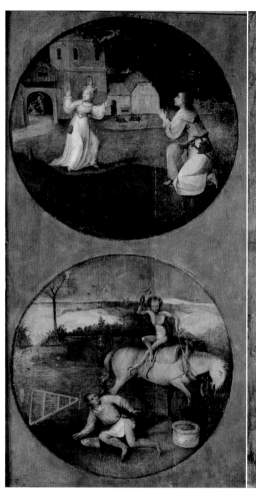
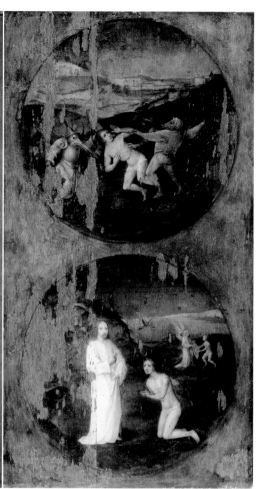
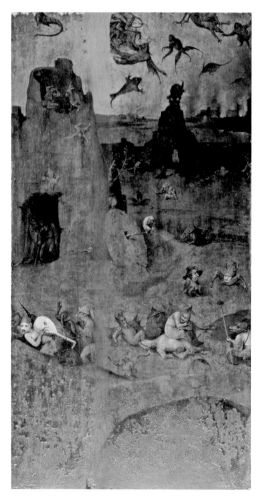
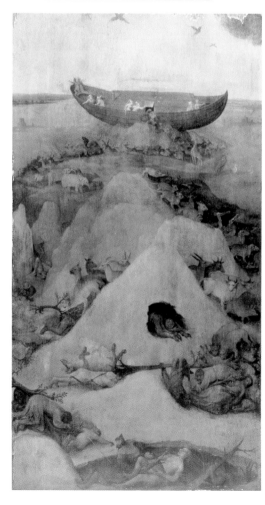

Hell and *The Flood*
Rotterdam

Only two side panels of this former triptych have been preserved. The central panel is missing and its content unknown. There is some difficulty, therefore, in relating the depictions on the two side panels to each other. We are faced with a riddle. And the four tondi on the outside of the panels have a very peculiar atmosphere about them as well. They are done in grisaille and lead one to the assumption that the altarpiece must have dealt with an important subject.

The four tondi appear to be illustrations of biblical events, yet they are of very individual character. The first tondo depicts the burning house of the father, which is occupied by demons. The daughter, the old faith, is being killed by a demon, and the mother, the richly dressed soul, is running in helplessness to the praying man outside. But outside the house she is defenseless and insecure. The child on her head is small; individual thinking has not yet grown strong. In contrast, the figure of John, representative of the new faith, is filled with calmness and peace. On the lower tondo, a demonic being is destroying the good seed. The still bare soul-tree of the sower shows that his faith is not strong enough yet. On the upper right-hand side, a human being is being attacked by three villains. They rob him of all of his possessions, and he is left naked to fend for himself. The three soul forces—ossified thinking, perverted feeling, and a will taken over by demonic beings—become threatening when the human being on the path to his "I" is not yet master of his own house. On the fourth tondo, the human being is without possessions and completely bare after overcoming the three astral demons. In his need he recognizes his Lord, who raises him up and gives him new clothes through an angel.

On the inner side of the two panels, the right-hand one depicts Noah's ark coming to rest on Mount Ararat and the animals streaming forth from the ark. Noah's animals encounter animals of a lemurian nature behind the middle mountain peak and turn away from them. A certain duality of events is particularly noticeable in the foreground of the painting. The male of the human couple in the cave in the middle mountain looks inward while the female looks outward. There is a second human couple a little farther down, also lying together. The female figure is dreaming while the male is half upright in a meditative pose. A blossoming branch is visible between them. Above, a pair of hyenas is feeding on a carcass. To the left, a pair consisting of a fox and a human being appear to have become entangled in the roots of a tree; they look as if they are fettered back to back. The figure of the drowned woman with a child in her lap floats in the pond at the bottom.

The other panel is even more mysterious with its gross demons and the devil's brood flitting about in the air. Compared with the scrawny, insectlike beings of the fallen Luciferic spirits *(Haywain, Last Judgment),* these elemental spirits give the impression of having been fattened on the banality of human beings, hardly able to take flight. The landscape is empty, inhabited by demons. A tower built of rock has become a ruin. A pitiful figure on crutches hobbles out of the dark opening. Below, in the pond, a female figure sits next to a demonic being; she is unable to utter a word. The whole scene is enveloped in spectral tragedy.

Visions of the Hereafter
Venice

The central panel is also missing here. The double side panels appear to have been arranged one above the other. The subject of the central panel, which united the *Ascent into the Empyrean* and the *Fall into Hell,* remains unknown. Perhaps it was a Last Judgment. The enhanced level of painting technique in these panels is quite astonishing. Light and darkness are highlighted here in their dramatic interplay. We experience the supportive forces of the light in the colors, while the darkness coveys the hopelessness of hell and the weight and burden of the deep. Rising towards the light and sinking into the blackness become elemental experiences. The four panels give a dramatically modern impression with their sparse figurative elements in the struggle between darkness and light. Details already familiar from other paintings are executed here with great force and sureness. The upward striving of those carried by the angels and the fall of those in the grip of the demons remind us of Dante.

But this painting differs from Dante's *Divine Comedy* in the way that the heavenly dome, the window of light, is depicted. It shows an individual path into the spiritual world from a completely individual point of view. With Dante it is still a firmly fixed pyramid construction that has a God-given structure through and through, lacking any indication of individual paths of development. In contrast, Bosch depicts the cone of light, which the spirit human being has to pass through and which is made up of all the heavenly hierarchies, in a grandiose manner: a new entrance to heaven that gives an intimation of endless, as yet undiscovered, expanses of light. The fullness of light that surrounds the spirit-soul and in which it makes its ascent gives meaning to Dante's words: "The angels in the vision of the Divine light become invisible for the wanderer in heaven!" The dramatic impact of the depictions on the panels makes them immediately accessible as a continuous process of illumination and tarnishing of the human soul and of the spaces of the spirit.

This outline of the first third of Hieronymus Bosch's works already provides a certain insight into the drama of his creativity. This is particularly relevant today as we struggle for our own spiritual existence.

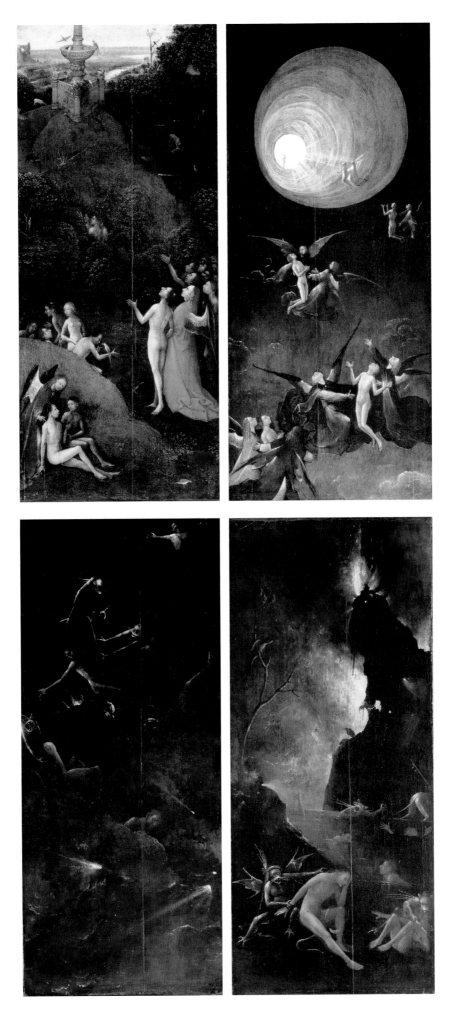

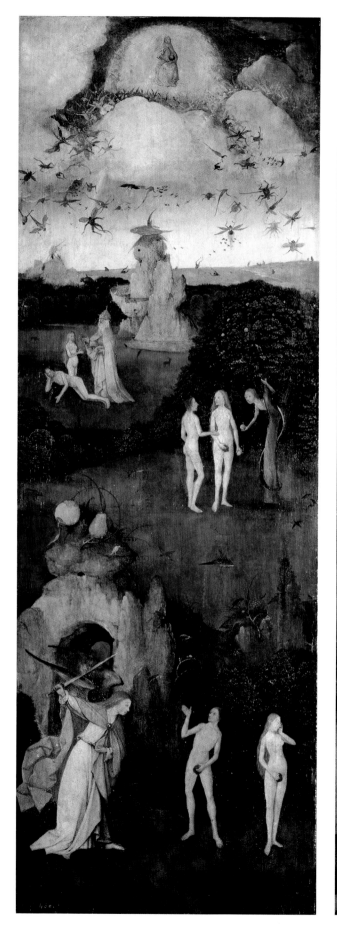
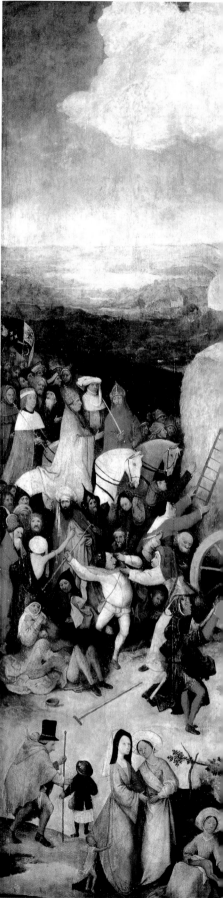

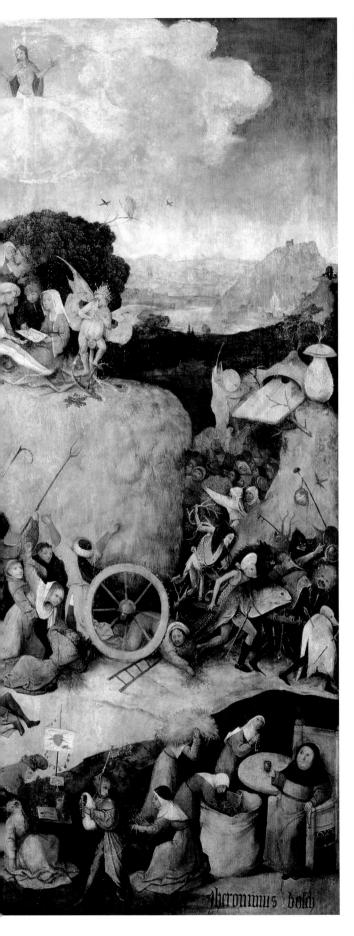

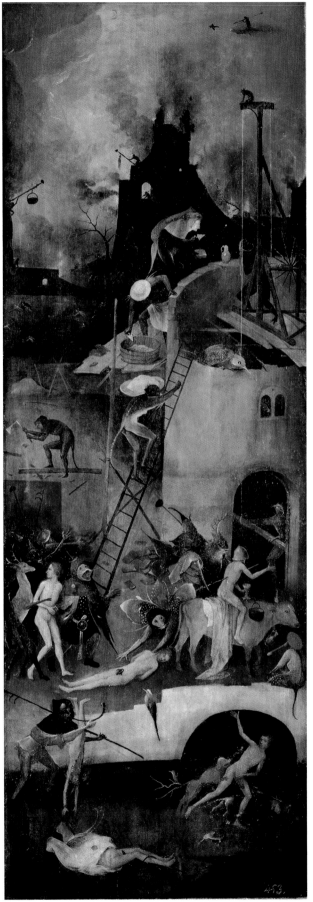

The Haywain (*previous spread*)
Madrid

There are two versions of this painting. One is in the Prado and the other in the Escorial. But it has not been possible to establish clearly which is the more valuable or original. The outside of both triptychs depicts the Prodigal Son, who strays and stumbles on his long journey on earth and home to the Father.

The strong colors of the interior of the *Haywain* altarpiece stand in powerful contrast to the solitary figure wandering through the world. The form and color of the work reveal the full maturity of the master.

Bosch describes the hustle and bustle of those people who strive for earthly possessions and sensual enjoyment. The left-hand panel shows the creation with the heavenly ruler on high and the fall of the spirits of darkness on an impressive scale. This fall is of such magnitude that one cannot but ask: did the all-powerful and omniscient God include evil in creation; is it part of the divine plan?

To Hieronymus Bosch the existence and necessity of evil in the world does not seem to have been incompatible with the wisdom and goodness of the almighty God. Rather, it is the condition for human development on earth. God permits the workings of evil for the sake of human freedom, and it is with the help and support of Christ that the human being liberates himself from the tower of his body and from the army of demons driving the world.

The image of the hay, of the wilted grass, has been a symbol of the transitory nature of the world in all periods of human development. Thus we find the following quote in Isaiah:

> All flesh is grass, and all the goodliness thereof
> > is as the flower of the field:
> The grass withereth, the flower fadeth:
> > because the spirit of the Lord bloweth upon it:
> > surely the people is grass.
> The grass withereth, the flower fadeth:
> > but the word of God shall stand forever.

Here, the striving to make hay is a metaphor for a humanity that has become absorbed in the mundanity of existence. The original freshness of the grass represents the still unspent etheric forces that now have become the vehicle of soulless habits and which are gathered in greedily by the people.

What is the fate that has befallen mankind after the fall from paradise? Whither is the wain being drawn, whither is mankind being driven? It is going in the direction of the tower being built by demons, fulfilling human destiny: the physical body must grow ever higher, ever heavier.

A young couple sits in complete innocence and harmony on the haywain below Christ, who appears in the clouds. The young bride is holding the music for the bridegroom, who is playing the lute. They are seated between a praying angel who is looking upward to Christ and a devil who is already playing a different tune, looking at the hustle and bustle of the world. Everything focuses on the wain drawn by demons; the powerful men of this world, the lords temporal and spiritual, are following behind as one, without realizing where they are going.

The haywain has started to roll and no one seems to care either where it is going or who is driving it.

Only the fool raises objections as to where the world is bound. A sibyl gives warning as well. But neither is heard, and the fool is to be killed at the instigation of the cleric for "disturbing the peace." The Christlike figure beneath the front wheel of the wain is impressive: "Life controlled by demons always seems to surge over Christian life," Wertham-Aymès writes. Does this helpless figure intend to stop the unhappy procession by sacrificing his life? Neither the wisdom of the fool, nor the prophecy of the sibyl, nor the sacrifices of Christ appear able to bring the headlong rush of the world to reason.

The right-hand panel leaves behind the still, peaceful background of God and nature in the central panel and is submerged in the subterranean red of hellfire, which destroys everything that is transitory. Below this zone of fire, demonic beings are building with great haste a ghostly tower intended for eternity.

An Eve-like figure is being seduced and marched along by two phantasmagoric beings while an Adam lies in the dirt. His genitalia, related to the toad, turn him into the victim of a Luciferic butterfly-mouse demon. Ahead of the naked couple, a human figure sits astride a cow; the figure is bare but only because the rose-colored cloak has fallen from its shoulders. A steel helmet is pushed deep down over its face, blocking its view and making it unaware of both the chalice in its hand and the pot of pitch, which are balancing one another. The lance of egoism has been run through its back, which does not, however, appear to impede its progress. Its mount is the divine cow with its patience, which receives human beings into the realm of the Father at the end of their arduous wanderings on earth, as in the painting of the Prodigal Son. Here the cow is turning away from the entrance to the tower, but the figure on its back is demanding that it enter.

But who is this impressive figure riding the cow, this almost bare human being whose face is hidden and who is turned completely toward the tower? Who is it whose head is squeezed into the iron helmet, who carries pot and chalice in his hand, who is still supported by the forces of the cow? Who must enter the depths of the tower? It is the "I," which has to make its home in the tower in spite of the demonic goings-on. That, at least, is Wertham-Aymès's interpretation of the figure of the naked rider.

Returning to the central panel once more, we see on the right an opening in the rocks that is like the gates of paradise, through which more and more souls stream into the world without being aware of the demonic procession leading to the underworld. In this triptych Bosch shows the path from pre-earthly existence to earth-ego and the latter's burial in the world tower. Demons are at work to make this tower the eternal destiny of mankind.

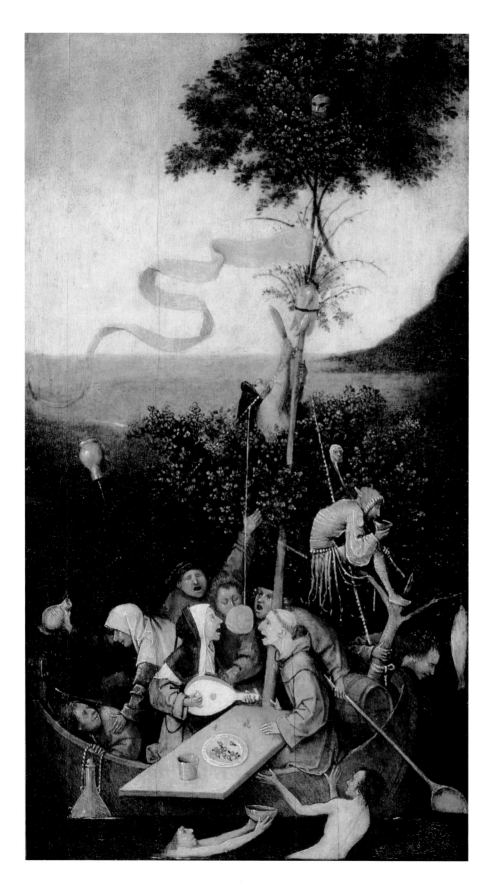

Ship of Fools
Paris

Painted in strong and rich colors, this painting depicts a merry and boisterous company in a boat with a moon pennant* and a leafy tree as mast. All are enjoying themselves—the nun, the monk, and the people—because nothing is lacking, neither meat nor wine. They pass the time trying to snatch the occasional mouthful from the roast dangling from the mast without using their hands. Everyone is participating in the feast except the fool, who is sitting to one side on a dead tree. All of them enjoy the abundance, and the helmsman of the ship of the Church is not particularly concerned about the destination of his craft. Absentmindedly he uses a cooking spoon** as a rudder and indicates thereby the direction the boat is sailing.

* *The flag of the infidel*
** *Symbol of a purely material interest*

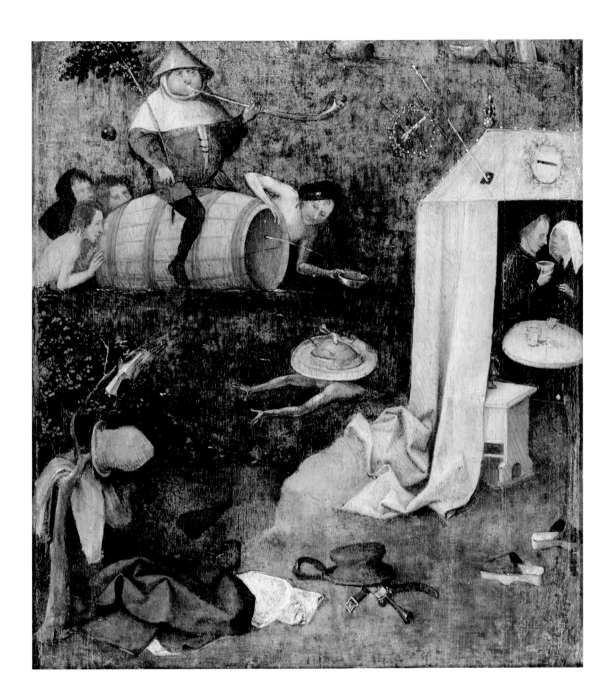

Allegory of Gluttony and Lust
Yale University

The two paintings *Allegory of Gluttony and Lust* and *Ship of Fools* have much in common not only as regards the subject matter but also as regards color. Here, too, there is enjoyment—swimming and leisurely drifting along—shattered only by the drowning man in the midst of the general unconcern, whose hands can only just be seen rigidly stretching out of the water. In the carefree bustle

scarcely anyone notices the man in need. The seriousness of the situation is shown by the person swimming to help and rescue him; his clerical hat makes it impossible for him to see.

Both paintings contain much criticism of contemporary life, reminiscent of Peter Bruegel the Elder. Silent tragedy can be felt in the gesture of the drowning man's hands, unable to find a hold, and in the hands of the blindly groping man, waiting to help yet unable to see the true need. What an accusation against the ruling institutions!

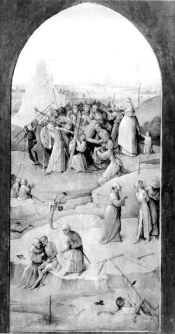
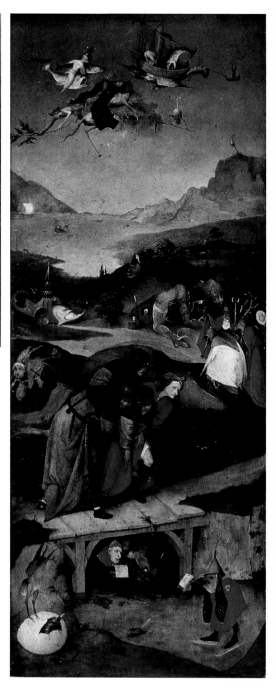

The Temptation of St. Anthony
Lisbon

As far as the content is concerned, this triptych is second only to the *Hortus Deliciarum* in Hieronymus Bosch's known works. The two grisaille paintings on the reverse side of the panels are sparsely dramatic and the gray-greens stand in strong contrast to the world of color breaking out from inside the altarpiece. These colors are not for show, not used for their own sake, but their hues and qualities are meant to move and grip us.

There is an absolute unity of form and color that makes the observer more than a mere observer. The colors of the painting release forces in him that lead him out of and beyond his habitual mundane world. Looking becomes contemplation that inspires our imaginative capabilities. Thus a purely aesthetic activity turns into a moral spiritual affair because the realm of the conscience is affected.

The subject of the two previous paintings was the foolish life led by mankind. Here the left-hand panel reverse side depicts the seizing of Christ and the right-hand panel reverse side, Christ carrying the cross—which introduce the event inside. We are led to ask the question: how can I respond properly to the forces of the adversary? Christ accepts his destiny and carries the cross of mankind. In contrast we have Peter's destiny, resistance, and Judas's destiny,

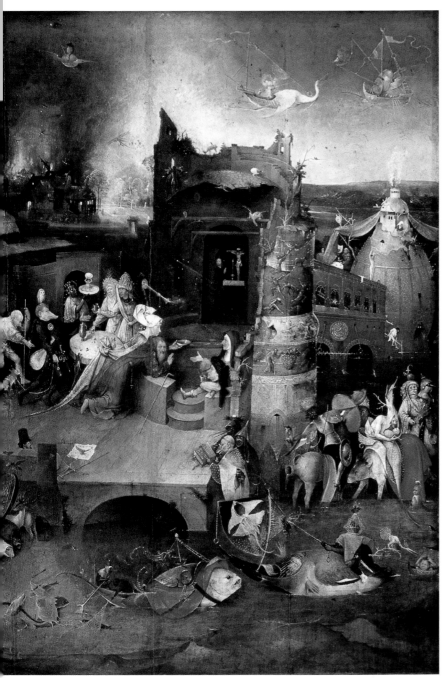
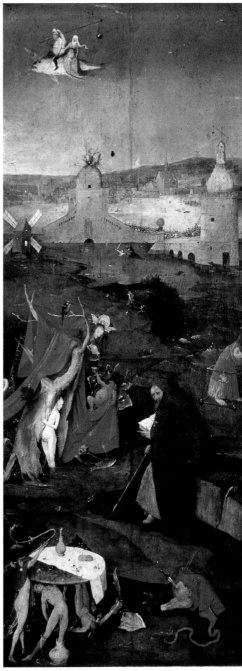

betrayal. The third figure of destiny, briefly shown, is the escaping naked youth who leaves his clothes behind in the hands of the soldiers, symbol of the new impulse of Christianity. The panel with the crucifixion is bathed in bright daylight in contrast to the cosmic night of the seizing of Christ. Another figure of destiny can be seen in the crowd of people:

Simon the Cyrenian, who helps to carry the cross. And St. Veronica, archetypal image of the soul, bears the being of Christ within her in the image of the shroud. Alongside are the two thieves with their similar but radically different destinies. Then there are the figures standing in close proximity to the dramatic events surrounding Christ who, however,

have not seen, experienced, or understood anything.*

The nature of the world that Bosch intends us to enter on the inside of the altarpiece is already apparent on the inside of the two side panels. A dead St. Anthony is carried from the coffin in accordance with the legend. This is without doubt an initiation. The scene above indicates this and shows the experiences of the saint in the supersensible realms during the death of his initiation. He who is beset to the utmost by demons on earth and in his passage through the astral realm is now carried by them to spiritual heights. They have to serve him because he has recognized, apprehended, and overcome them. It becomes clear that it is the complementary process in the spiritual realm that makes the meaning of the physical events comprehensible. Simultaneously the saint observes the spirit of his youth, allowing him to experience how the burden of former worldly possessions weighs down and suffocates his will to stand upright. He sees his soul locked helplessly into his physical existence and his own thinking killed by the scorpion's sting of the Church and her dogmas. The Church is gobbling up the true fish. The prince of the Church advises Anthony to follow the three false dignitaries standing in close proximity in order to achieve salvation and replace his egoless spiritual forces. Thus the saint experiences his past.

The temptation to tie oneself too strongly to the earth, depicted on the left-hand panel, becomes the temptation of despondency on the right-hand side: "Escape from the world, you cannot change it in any case. You cannot improve it, cannot eliminate evil, and enforce the good. Take the cup and put an end to your misery!" Thus the legend. St. Anthony sees this in his meditation; he experiences the powerlessness of the soul in the female figure who

* The old woman with the child and the three watching boys

leans in nakedness against the hollow and rotten tree trunk of his former body. As to his future destiny, he sees himself carried on the back of the fish of the Church in bourgeois complacency on a false flight of the spirit. At the same time he sees himself in senile old age, able to walk upright only with the aid of the child's walking frame of lifelong habits.

The altar with bread and wine shows the false representatives of the bourgeois-religious life: the buffoon, certainly no figure of John, plays false notes on his instrument; a second person supports the table with his shoulder with the help of his own crutches, a secret eunuch without any positive standpoint; a third lifts the table with his legs and wants to defend it with his ornamental sword but is himself stabbed by demons. The champion of the "I," fighting against the fiery dragon, is visible in the waters of the spirit in the background. His counterimage is the battle among the soldiers as an expression of the religious wars. Still farther in the background one can see the large town that the saint keeps in his sight as the aim of his continued striving.

The so-called tempation scene on the right-hand panel jointly depicts inner and outer events, while the happenings in the higher and lower worlds are depicted on the left-hand panel. A third example of such a joint view is given in the scene at the altar in the central panel. Here the question of right and wrong is posed—of the real living cult and of the falsely perverted cult. We must learn to recognize the true cult through which the "I" is transformed.

On the central panel, the altar with the burning candle between the crucifix and the risen Christ in the recess depicts the mass that does not require a priest; with his immediate presence, Christ himself in full reality imbues the mass, which lights the flame within each individual. St. Anthony's gaze is not fixed on the altar. He experiences the scene, the transformation within himself, and is filled with it.

A black mass is being celebrated to the left, contrasting with the mass of the risen Christ. False priests give false nourishment to the hungry congregation; they receive neither the body nor the blood of the Lord. The cripple with the hurdy-gurdy, the crumbling physical body (see the instruments in the *Hortus Deliciarum)* has to hold on to the fellow in green to keep his balance. The green fellow, carrying the lute (already familiar to us as the symbol of the human etheric or life-body), has an owl on his head and a small dog on a leash as his faithful companions. The dominant feature of his face is the pig snout. He, too, becomes a dubious character who demands without restraint the wine from the hypnotizing priest to give himself strength. The host, carried in on a silver platter by a fat woman, gives proof of the demonic nature of the sacrament being celebrated here.

Below, the fettered fish draws the ship of the Church that is being guided by demons and sinister figures. They are casting their nets to pull in for themselves a rich catch of souls in the name of Christ.

There is no end to the imaginations Bosch paints in connection with the Christian mass and the demonic mass. The group on the right represents a false epiphany, the spectral appearance and false worship of things that no longer contain any divine elements, that have become ghostly and cause chaos in the human realm. Everything that loses its divine connection with the power of the risen Christ becomes an epiphany of demons. This is also shown in the ship of the Church, the ruling might of the Church become temporal, as well as in the inhuman education system that does not do justice to human potential. This makes the child to be educated tear its hair in desperation. Social deprivation grows and fraternity dies.

On the left is the red kaki fruit of divine creation with mankind emerging from it. Since human beings still lack the strength to regenerate themselves,

they become victims of the witch, of magical superstition, of the conjurer, and of the raging worldly and spiritual inquisition.

An abandoned human child, an infant, can be seen in the midst of the effluent of social deprivation, its helpless look pleading for assistance. Although it carries a spoon on its head with the nourishment it needs, it has no arms and cannot feed itself without help. It is dependent on philanthropy and waits to be received and supported by it. It is waiting for its St. Christopher.*

* *The above description follows from Wertheim-Aymès's research, which presents an account of the inner relationships of the* Temptation of St. Anthony *altarpiece in his book on that subject.*

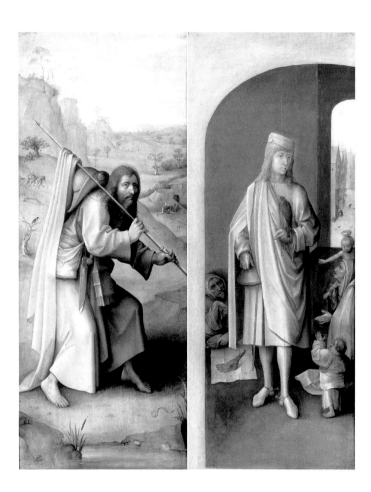

The Last Judgment
Vienna

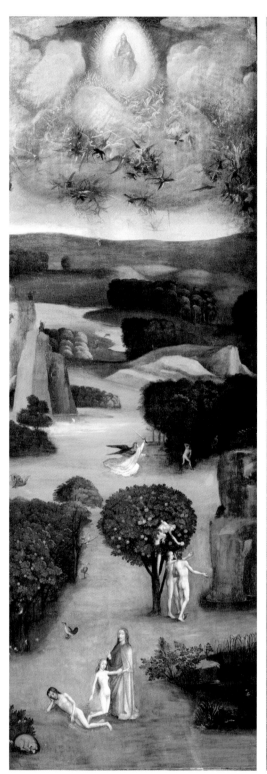

As with the majority of Bosch's triptychs, the grisaille paintings on the reverse side of the side panels reinforce the intensity of the colors on the inside of the altarpiece here as well. In this respect Bosch has reached a peak here. What a contrast: the vivid colors of the interior against the gray tones on the landscape with the hanged man in the background on the reverse of the left-hand panel. The hazy, nebulous Atlantean atmosphere that pervades the painting might just as well have been painted by a Chinese master.

If the gruesome, hellish depictions on the inside of the altarpiece hardly served to edify a pious congregation, the two saints on the outside do indicate that the altarpiece might have been intended for a church.

St. James of Compostella is depicted on the left with the scene of the beggars under the blossoming tree in the background, painted in a quite modern style. In addition, the two cripples on a pilgrimage are depicted with complete realism.

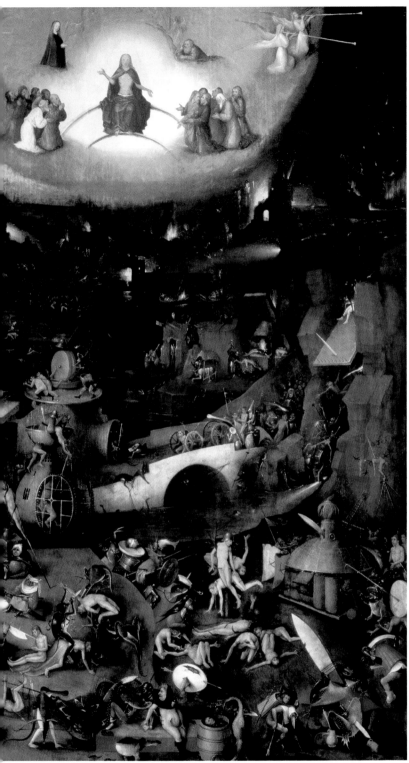

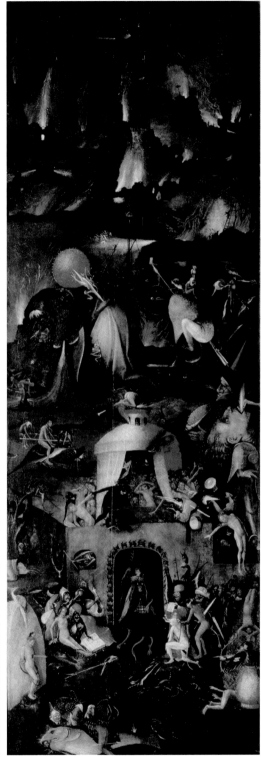

On the opposite side, St. Baavo stands self-confi-
dently in his house. He stands securely on the ground,
unlike St. James who seems hardly to touch the earth.
The background here is not open, untouched nature
but the confined gothic town and its beggars. The saint,
with his inner riches, stands between an emaciated pair
of beggars.

Contrasted with St. Baavo's noble posture, the couple
seeking sympathy and alms do not appear to be genuine,
and there is some doubt whether they are deserving of

sympathy or whether hypocrisy is at play here. It is hard to believe fully the sorry fate of the beggar with the severed foot, and it remains unclear whether it is his own foot. The old beggar woman does not instill much confidence either. Are the very dissimilar children her own? The three drops of blood on the cloth with the severed foot touch us in a peculiar manner, drawing our attention with the same vividness as the three seeds from the lotus blossom in the painting *The Cure for Folly.* If we look through the window to the background above the child, who is like the pure child of mankind in the St. Anthony triptych, the hen surrounded by her chickens is probably a symbol of the nature-given virtue of motherliness.

The Vienna altarpiece is the second time that Bosch treats the subject of the Last Judgment. It appears first in *The Seven Deadly Sins and the Four Last Things.*

Here, as in the painting of the haywain, the cosmic drama begins with the battle in heaven and the fall of the angels as a cosmic event preceding the creation of man in paradise. But here the battle between the heavenly hosts is incomparably more dramatic and powerful. These fallen Luciferic beings appear to lodge themselves in the human astral bodies like insects. The falling spirits stand in strongest contrast to the well-fattened demonic elemental spirits on the left wing of *The Flood,* which appears to represent a kind of contrast to the fall of the heavenly spirits. The battle in heaven is depicted very powerfully with the three archangels; Michael, with armor and cross, is most strongly involved in driving Lucifer from the heights. Below, the events in paradise occur in an unusual way. Looking from the top, the expulsion from paradise is seen in the middle of the painting. Below that, Lucifer hands the apples from the tree of knowledge to Adam and Eve, and only at the bottom of the painting does the creation of the two sexes of the human being take place at the celestial

lake in the presence of Christ. Here the order of events is reversed. Paradise appears almost empty in contrast to the verminous tumult and the falling dark angels in the sky. Hardly an animal is to be seen. But here, too, as in the *Hortus Deliciarum* in Madrid and in paradise and hell in the painting *Visions of the Hereafter* in Venice, a lion is attacking an innocent deer in the midst of the tranquility of paradise. This event takes place at the same level as the expulsion from paradise. An owl sits on the dead branch of an otherwise green tree opposite the tree of knowledge. Below that a peacock is fanning out its tail, and a cuckoo also belongs to this grouping. A sleeping dog lies near Adam and Eve, whom Christ is in the process of creating.

In the upper part of the central panel, the Lord over the heavens and the earth is enthroned on a double rainbow in heavenly glory. Above, Joseph and Mary are visible between the four trumpeting angels. The two groups of saints to the right and left of Christ are arranged most dramatically. Partly praying and partly suppliant, they bow to the divine judgment.

Below this scene stretches the kamaloca sphere, evolving into hell. The earth, nearing its end, is almost as depopulated here as in paradise on the left-hand panel, and all the human souls seem to be in the region of the demons. The sky is empty, and only a few souls succeed in rising to the empyrean fields. The majority are in purgatory, which, here, is no longer a transitional stage but has acquired a Dantean permanence, turning into the actual regions of hell on the right-hand panel.

On the right-hand panel we enter the blackest part of hell with its prince: an all-consuming being of awesome power, wearing a crown of fire and an anti-cross on his turban. He is stepping from the toad gate, the entrance to his residence. With the aid of the genital toad forces he achieves the greatest power

over human beings. His lance has four blades that rule the realms of hell. And four incisors give him the look of a wild beast. He keeps mankind in its creature state through the fourfoldness of the world of creation and prevents it from reaching the fivefold state of ego-existence. Thus the earth becomes the material and the substance for his own aims. The prince of hell, as anticreator, stands diametrically opposed to the creative source of all existence. He symbolizes the reverse principle of the three and the four: he has the four above and the three below.* Here the prince of hell is not merely a devourer and the demon of the threshold who excretes the human ego-substance that he cannot digest (see *Hortus Deliciarun* and *The Last Judgment* in Cairo): cosmic time has tolled the end of the world and everything unable to raise itself as "I," all human substance that has lost its ego, is melted down. Everything is about to be destroyed. No path out of these horrors is apparent. This *Last Judgment* is unlikely to have given much comfort to the congregation. Only a single angel is visible saving a poor soul. Christ is distant and the regions of hell are omnipresent.

On the left, hardly noticeable in the background and drawn in the faintest lines, a few individual human souls are about to embark on their ascent. They are not easily seen on the painting as they rise with their angels, and it must be asked why Bosch painted them, since they would have been invisible to the congregation in the service.

In the kamaloca part of the painting, human beings are prepared in all kinds of ways to make them palatable for consumption by the demons: milled, chopped, roasted on the spit, fried in a frying pan, or salted in a barrel. Even freshly sliced human meat is not scorned. Where they do not serve as food, the human souls are trained to serve the demons and

2 x 4 fingers and 2 x 3 toes

are spurred on to work. A dilatory person is shod and saddled as a packhorse.

Conspicuous are the so-called synthetic demons, half organic and half mechanical in nature. They are no longer ordinary elemental beings but appear to be beings that humans themselves have created by their spiritless actions and that now pursue them. In the kamaloca world they become part of his future destiny.

On the right-hand panel, a glowing red spiked ball above the palace of hell reminds us of the strawberry of mankind *(Hortus Deliciarum),* which was covered with innumerable seeds, the seeds of human egohood. Demonic beings roll the strawberry fireball—like the ancient Egyptian scarab that daily guided the sun's sphere out of the lap of the night to renewed life— into deep hell fires on the back of a mighty demonic being. The large figure on the right-hand edge of the painting is looking upwards. It is the only human countenance in the painting. The arms have withered away, and the stumps of wings from which they grow do not provide the strength to soar upwards of the flight of the spirit. The living power of the word has turned into breath of fire: it is the last breath.

The cervical chasm that indicates a rebirth in higher regions in the *Hortus Deliciarum* is present here as well. But here it is not an opening and entry to new worlds for human egos. It has become a snake pit from which where is no escape. Thus the fish, having been gutted by demons and in which a human being is still hiding, lies at the place where the exit no longer exists.

On the central panel Bosch for the first time gives an indication of the source of his inspiration: a human being, a boy being carried in a basket by a demon, is given a view of these realms with the help of demons. The fright that this vision causes him is visible on his face. This small scene, almost lost in the chaos of the kamaloca world, indicates that Bosch drew on his own insight and sources.

St. Jerome/James in Prayer
Ghent

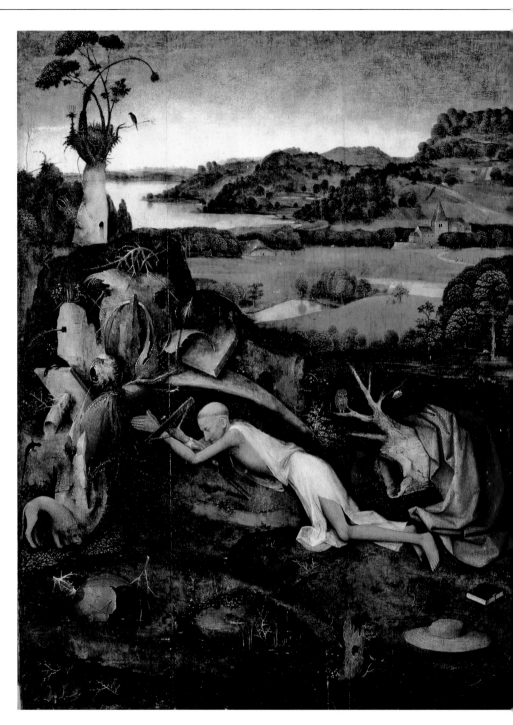

The painter places this saint, who is deep in meditation, in rich and colorful surroundings. The poorly dressed figure in a white shift stands out against the three blocks of deep red color around him: the broken church roof, the discarded church gown, and the cardinal's hat. The saint has discarded everything that might indicate a traditional link with the Church. Moses's tablet of the law lies carelessly around. Liberated from the world of Old Testament law, he has also lain his prayer book aside. The disintegrating world of his immediate environment does not disturb the calm of his meditation. The world does not trouble him; he has overcome it. His peace of soul is reflected in a landscape free of demons. An owl and a great tit perch on the hollow tree trunk behind him and have become disinterested spectators of his world. The prostrate position of the saint is interesting and probably unique. There are probably few paintings that depict a meditation stance of such intensity of will so convincingly.

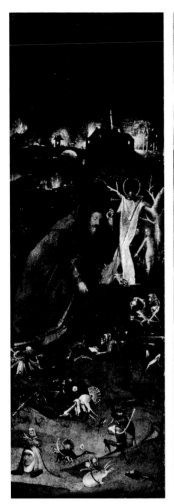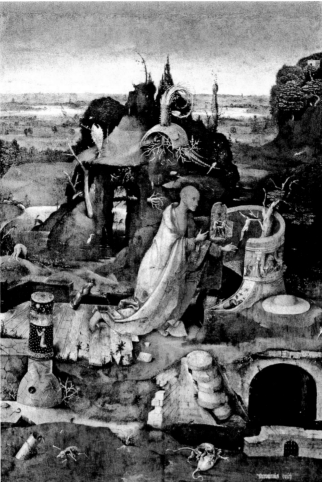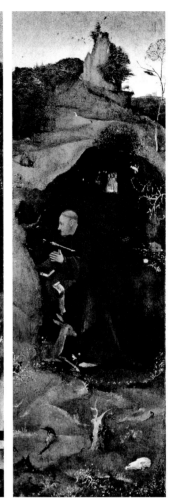

Altarpiece of the Hermit Saints
Venice

This triptych depicts the steps of initiation and mystical elevation of the three hermits. Each one of the three is depicted in different surroundings in accordance with his character. The left wing shows St. Anthony in a kamalocalike world. The world conflagration forms the background. Supported on his pilgrim's staff, the saint is filling his jug with fresh water. The importance of this act for his inner life is shown by the lovely figure of the soul that looks expectantly, but by no means seductively, at the fresh content of the jug. All the demonic beings that were once so feared have become small and insignificant in St. Anthony's world.

A quite different environment is depicted on the central panel with St. Jerome. The saint is seen conversing eloquently with himself before a crucifix with the Savior among the ruins, surrounded by a tranquil landscape. No demons are present here, but droll, plantlike forms give the impression of former life in the ruin. The tower of the Old Covenant, within which the crucifix leans on a half-withered tree, has broken up. Sun and moon worship and a fallen idol are indications of what the saint has left behind him.

On the right-hand panel, St. James is deep in prayer at an altar in an earth hollow. He does not need a prayer book because, as legend says, the names of all those for whom he is praying appear before him during the mass. His attitude in prayer is imbued with well-being in God. He has long overcome the pain caused by the arrow of egotism that pierces him. The hind at his feet will nourish him with her milk in his solitude.

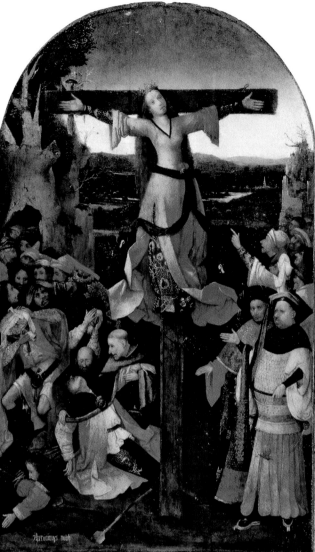

The Altarpiece of St. Julia
Venice

The central panel of this triptych of St. Julia is completely dominated by the radiating faith of the martyr on the cross who has overcome all physical pain through her inner strength. What is intimate soul experience by St. Anthony on the left wing becomes, on the right, a dubious assessment of the crucifixion by St. Julia's slave masters, whose ships of life are by no means sailing securely on the seas: an assessment in terms of profit and loss. But the drama escalates to a climax on the central panel to a tempest of the soul. Those who called for the crucifixion of St. Julia are full of consternation and the worthies are losing their self-assurance. Filled with fear, the crowd awaits the direct intervention of God. The governor, Felix, stands to the right of the cross in a Pilate-like attitude. Eusebius, Julia's protector, stands to the left with an owl embroidered on his garment and a pelican brooch on his breast—a contradictory character who faints with shock. The gold of St. Julia's martyr's crown sheds its strength giving light around her, strength-giving to her followers in Christ. "Faith is not postulate for her but has become her inviolable possession," de Tolnay writes. In the background flows the stream of mankind, which she will serve in her new life with the forces won through her martyrdom.

Christic on the Cross
Brussels



Christ on the Cross
Brussels

This crucifixion can be seen as a transition from the previous group of hermits and martyrs to the following group of bearers of the human "I." The painting is almost unique in Hieronymus Bosch's works with regard both to the composition and the coloring.

A large city stands in the background. A windmill is situated between the city and Christ on the cross, one of the mills of God that will not spare the human being his destiny or his cross.

Two worlds face one another on either side of the cross. Peter, key in hand, looks at John and is surprised that the latter pays so little attention to him and his protégé, the donor of the painting, in spite of the power invested in him.

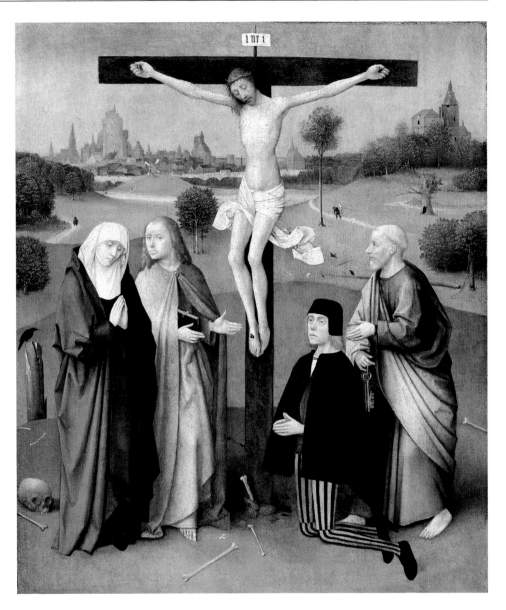

Meanwhile John, unaffected, is in deep conversation with the mother of God. He speaks with the spirit of Christ in him, and Mary grasps his words with her heart.

The world of Peter and his protégé, who kneels so demurely before the cross in his striped trousers, appears almost plain in contrast. His inner absentmindedness, a certain lack of ego, stands in very strong contrast to John carrying the book of the

Apocalypse and Mary's suffering through knowledge. The contrast between the two groups is also expressed powerfully in the coloring. The figure of John, wearing a rose-colored cloak and with reddish-golden hair, is filled with the being of Christ; he will have eternal life and never succumb to death: "If I will that he tarry till I come, what is that to thee?" (John 21:22)

The Group of Bearers of Mankind *(John the Baptist, St. Christopher, John the Evangelist)*

John the Baptist in the Wilderness
Madrid

The landscape which surrounds John the Baptist is by no means a desert but appears rather to be a pre-earthly paradisiacal landscape. The saint is at peace with himself. It is not clear whether he is pointing to the coming of the Lamb or whether he is pensively inscribing his vision of future events into the earth. The lamb resting in front of him belongs to the atmosphere of pensive contemplation. Everything breathes an atmosphere of serenity; nevertheless, there is a thorny branch in the foreground, its fruits enclosed in hard capsules at which a bird is picking. They recall the shiny polished fruit capsules and pumpkinlike creations in the *Hortus Deliciarum,* which Wertheim-Aymès refers to as discarded bodily shells. The rock formations in the background also recall the planetary mountains in that painting.

John the Baptist's life branch divides into two growths, half bush, half thorns. The remains of two singing birds are hanging on the left growth, victims of death, of the shrike. On the right, almost above the hand of John the Baptist, blood is dripping from a fruit capsule spiked on a thorn with the black bird of death sitting on it. Below, a pomegranate with a hard shell hangs on the same bush. A shrike is picking individual seeds from it. A shoot with black currants—delicate, in a row singly like pearls— contrasts with the seeds enclosed in the hard shell of the pomegranate.

If one is aware of the language spoken by every detail in Bosch's works, one is reminded here once again of the secret of John the Baptist: the blood flows, the fruit has ripened and died, and the new berry sprouts *(see also* Hortus Deliciarum). The justification for speaking openly about such esoteric secrets becomes an inner necessity when we see such secrets revealed in Bosch not only once but repeatedly.

The whole mood of the painting of *John the Baptist in the Wilderness* speaks of the ancient individuality of John and his connection with the wisdom of the earth, of the coming of the Lamb of God and the transformation of individual destiny through death— but also of a new life in Christ.

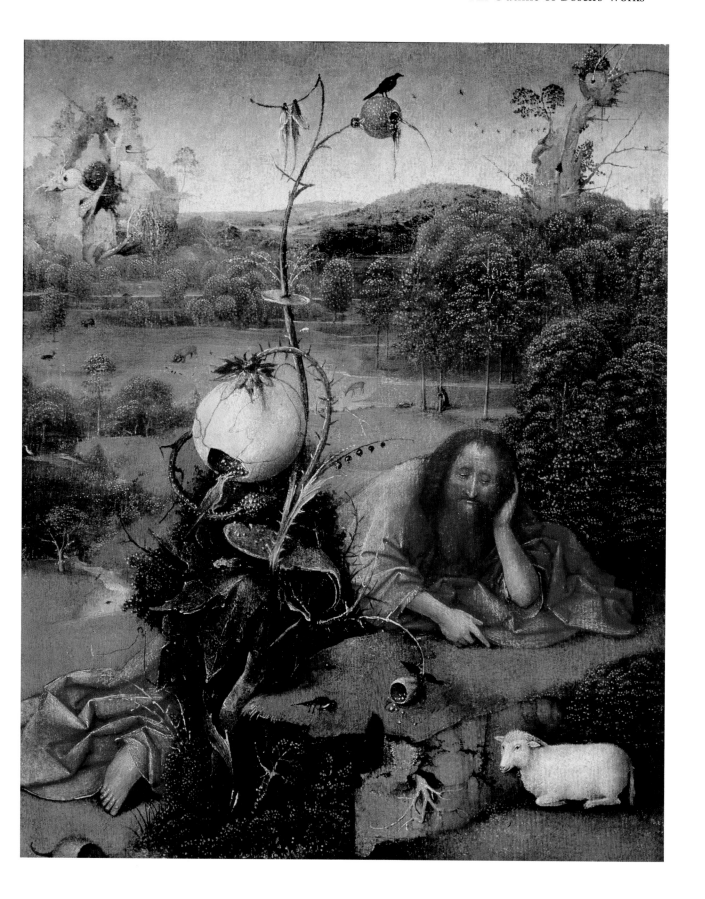

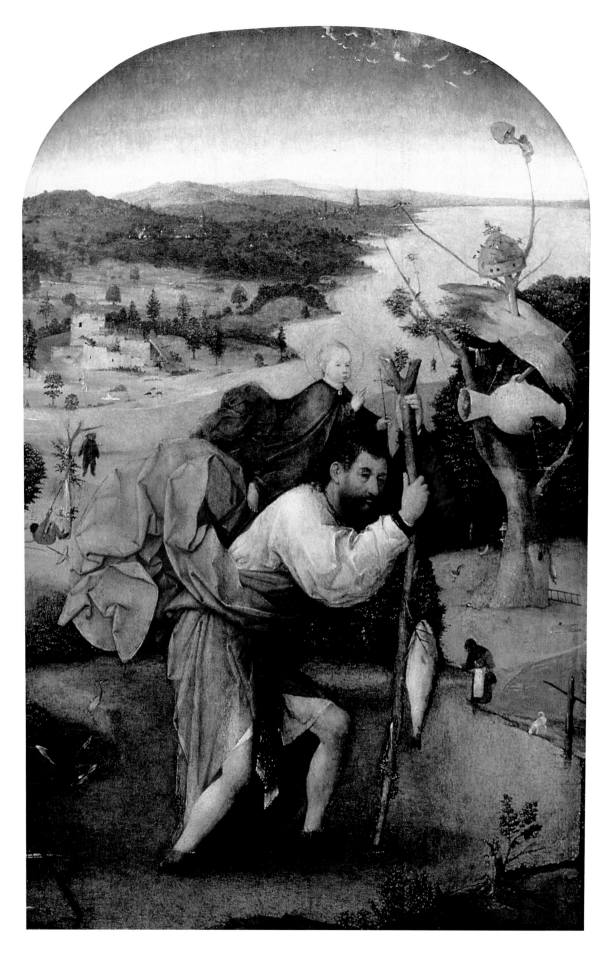

St. Christopher
Rotterdam

The painting of *John the Baptist* is bathed in evening light, but here full daylight reigns. The legend says that St. Christopher wanted to serve only the most powerful of earth and that in his search he also served the devil. But when he noticed that the latter quaked before an even more powerful being, he set out to find him. In the middle of the night a child called him to carry it across the river. St. Christopher is shown as a strong figure in the painting, but the burden of the child seems to him to become ever heavier. The staff with the fish bends under the great weight. St. Christopher is crossing the waters of his own soul, which bring him close to the stream of mankind. The child seeks support in the folds of his white undergarment and in the dramatically gathered bloodred overgarment—symbol of the transformed etheric and astral bodies. The heads of the man and child stand out strikingly against the folds of the garments, as if they are nearing and penetrating one another: the child's head, with the halo, and St. Christopher's head, formed from ancient experience on earth. It is the archetypal image of the baptism in the Jordan in which the "I" of Christ combines with Jesus of Nazareth, an earth ego that sacrifices itself for the Almighty Being.

St. Christopher leaves behind him the bear, the animal of earthly heaviness and violent temper, which ends up on the gallows. The dead hollow tree on the right bank once served the saint as a dwelling. The Treeman has become St. Christopher, but now the head is not weighed down by a millstone on which bagpipes and ghosts frolic. Now he is carrying a new load! The jug, the abandoned body in which there is till a weak glimmer of fire, is visible, covered by a shabby straw roof, image of the old Adam. The church dome that once used to be his spiritual home has become a dovecote, mostly used by dark birds for nesting.

A beehive, which a naked boy is trying to reach, floats high on a swaying branch. The beehive appears to be freed of physical weight; its extension is the heavenly beings flying in the etheric realm. The beehive is the contrasting image to the bear: the child reaches its abundance by overcoming the burden of earth.

The old tree is abandoned, as is the hermit fetching water with his dog. They are St. Christopher's former being, which he has left behind to become the bearer of a new master, whose symbol is the fish. In the far background a naked human figure is fleeing from a dragon on the farther bank of the stream of mankind. He has abandoned his clothes. Is it an episode from the former life of the saint, a time when he was still in the service of the dragon?

There is another painting of St. Christopher in Madrid that depicts him bearing the Christ child on his shoulders. It is hidden in a shining crystal sphere of the earth: St. Christopher as bearer of the child. As Atlas once carried the heavens, he carries the divine child, who now shares in the burden of the earth. St. Christopher has become the new Hercules.

The saint reminds us of another figure as well: the Prodigal Son, who also wanders the earth bearing the burden of his covered basket. But the saint's burden has ceased to be that of his own destiny; the mighty folds of the bloodred garment are bunched up behind the saint to provide support for the child. Is St. Christopher already fully conscious that he is carrying the Christ? His awareness seems to be growing: his staff is beginning to blossom!

> The "I" seems merely like a child
> And yet so difficult to bear;
> Crossing the stream in fullest light
> Together with the "I" is hard to dare.

John the Evangelist on Patmos
Berlin

The reverse side of this panel contains Christ's passion painted in grisaille in the form of an iris. The composition is similar to *The Seven Deadly Sins and the Four Last Things.* But here the subject is not Christ rising from the grave with the call: "Beware, for God sees all!" The focus is a pelican feeding its young with its own blood as an expression of the highest love.

The painting depicts the seven stages of initiation—the octave is formed by Christ being lain in the grave—and the resurrection is symbolized in the image of the pelican, sacrificing itself as symbol of the Eternal Christ who renews mankind with His blood, His divine substance. Divine blood becomes nourishment of mankind. The iris, the eye of the world, points to the cosmic, apocalyptic vision of John, who has become capable of receiving and writing down the revelation because he has experienced the seven stages of the passion. This is the introduction that prepares the observer of the painting for the mystery of the revelation of John the Evangelist itself.

If nature as a reflection of spiritual events is permeated by a sunset mood in the painting of John the Baptist, the revelation received by the Evangelist is bathed in the light of dawn. John , in his rose-colored robe, possesses the beauty of a Greek youth. His tree of life strives upwards close behind him, straight, slender, and purposeful. The healed incision on the lower part of his tree of life indicates the great transformation that has taken place in John's life through his initiation in Christ. They are incisions of death in what is clearly a family tree. The great city, the New Jerusalem, is visible in the distance on the far bank of the cosmic stream.

The herald angel, whose importance in the hierarchies is indicated by the splendor of his wings, descends from the mountain to John, who is sitting on a hill, awake and spiritually receptive. The blue-green-gray angel draws his attention to the heavenly Virgin with child appearing in the etheric heights, sitting on the sickle of the moon and in the eye of the sun of the open heavens. The Madonna is reunited with John, and he receives the revelation from her. The earthly mother, crowned heavenly queen, is the new wisdom of Isis.

The small, forbidding scorpion-being at his feet stands in stark contrast to John, who is completely immersed in the cosmic expanses of the painting. Its wings are pinned because its head and shoulders are pressed into dark armor. The hands growing from the shoulders lack arms. A pair of glasses reinforces the sharpness of its eyes still further, enabling them to see with precision everything concerning the sense world. The eagle of John looks accusingly and with great suspicion at the malformed scorpion-being.* The script devil always appears when spiritual content is to be fixed in writing. The eagle stands guard so that the apocalyptic visions are not falsified too greatly by Ahriman.

In conclusion, the historical progression that Bosch depicts in these three paintings must be mentioned. In *John the Baptist* we have mankind's past and the change in human thinking that has become necessary; *St. Christopher* deals with the present and how we can bear our own destiny under the sign of the divine "I"; the vision of *John the Evangelist* points to the future of mankind, anticipating vast periods of time in the spirit.

In this context we must draw attention to the coloring of the garments of the three leaders of mankind. It indicates the purification of their blood forces that make them bearers of the Christ impulse.

* As the painting shows, Hieronymus Bosch is aware that the eagle and the scorpion are symbols of the highest and lowest aspects of the same sign of the zodiac: spiritual ascendancy and material descent.

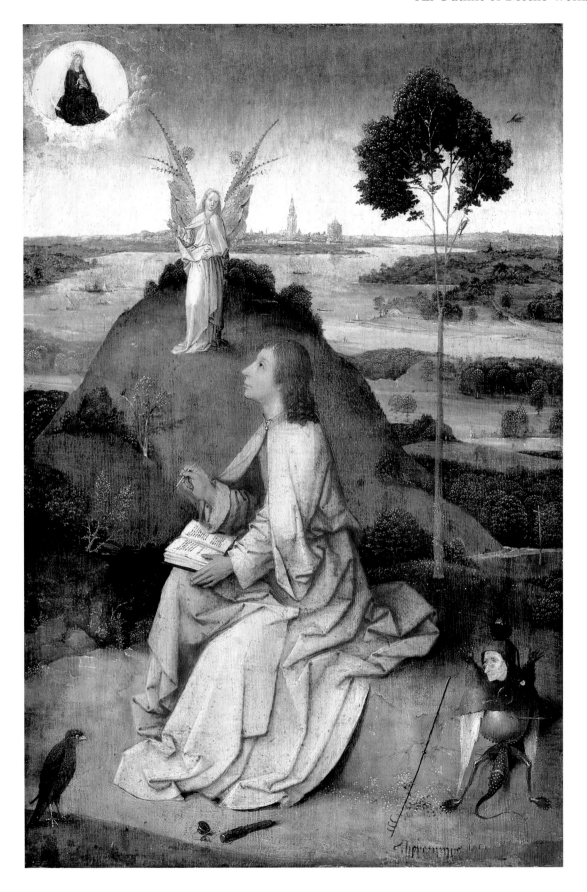

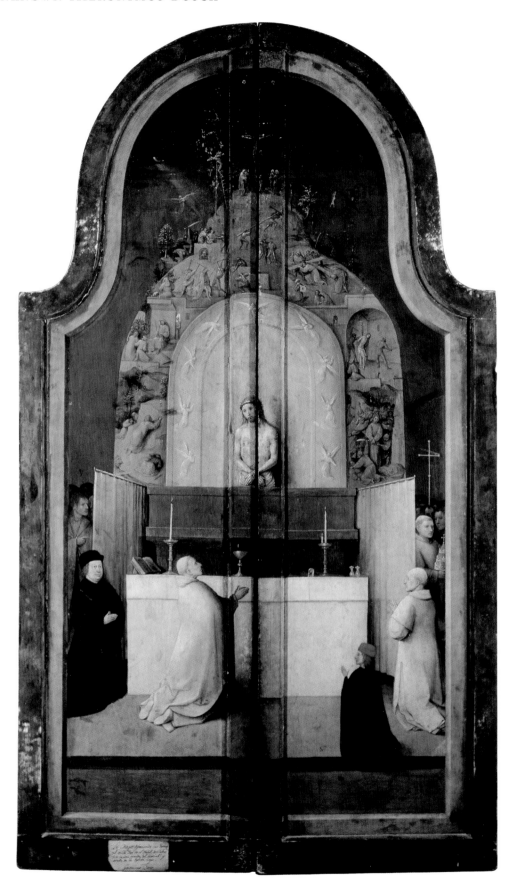

The Epiphany Triptych
Madrid

The Mass of St. Gregory is executed in grisaille on the closed panels of this triptych. Christ, the man of sorrows, appears to the saint, who is celebrating the mass. Gregory I—pope, doctor of the Church—and saint, kneels before the altar slightly to one side to allow the observer to be included in the presence of Christ. Nine angelic beings form his heavenly aura, behind which the steps of the passion ascend to Calvary. The seven stations appear as Christ's earthly aura, which the deeds of mankind have created for him.

This crucifixion scene on Calvary, cloaked in deepest nocturnal darkness, is peculiarly affecting. On the right of the crucified Christ is the repentant sinner to whom the Lord says: "Verily I say unto thee, Today shalt thou be with me in paradise." "There we have an indication," Rudolf Steiner says, "of the heavenly power of Christ, which draws the human individual into the realm of spirit. Of course, earthly judgment will say: the thief on the right will have to make up for his sins just as much as the one on the left, as far as karma is concerned. But heavenly judgment is different."

How, then, does Bosch depict this process? The repentant sinner is surrounded by a spiral of heavenly beings who guide his immortal part upwards, as the Lord promised him. But the cross of the unbelieving thief is no longer to be found at the side of the Lord. All that remains is a broken stump next to the tree on which Judas hanged himself. The upper part of the cross with the unrepentant sinner is carried away into the skies by demons, and he hangs upside down on his own broken cross accompanied by a swarm of birds from hell: what a difference in karma between the two sinners, although both sinned on earth.

* * *

It is a shocking experience that we have to divide the most holy and indivisible of things, the body of the Lord, in order to gain access to the inside of the triptych by opening the wings of the altarpiece.

This dividing line, the cosmic axis that passes through Christ on the cross and Christ rising from the grave, prepares the observer inwardly for the birth and the worship of the Savior on the inside of the altarpiece and also to recognize the work of the adversary. Here the living Christ rises from the grave for the faithful in the sacrificial mass.

The interior of the painting, the epiphany, reveals a mature work of art with a new experience of color. The worship of the Child is placed boldly in the center of the yellow and green hued landscape that fills the whole painting. No less daring is the transition from the green of the plant world to the pale and delicate colors of the horizon. His depiction of nature makes clear why Hieronymus Bosch is lauded as the originator of modern landscape painting. And yet the holy events in the foreground indicate that, in spite of its naturalism, the master's landscape fundamentally mirrors the spiritual mood that permeates the epiphany. It is more than just nature! To think other than this would be to misunderstand the master.

The figure of Mary and the child, of the three kings, and of the donors of the painting are depicted in a noble and solemn manner. "We experience the Jesus child on Mary's lap as if it were the host. The worship of the Child here turns into a holy mass and the enthroned Virgin becomes the altar," writes Jacques Combe. The child being worshipped has the same expression as the child abandoned in the effluent of mankind on the St. Anthony altarpiece.

King Melchior's votive vessel is decorated with a golden falcon similar to the one in the upright group in the painting *Hortus Deliciarum.* The two pelicans

with the cherries in their beaks that decorate the helmet on the ground
are also present here, as is the red fruit on the head of the Moorish boy who
is following Melchior. The seam of this king's garment is embroidered
with Egyptian ba or soul birds. Joseph, the father of the child, sits apart
at a fire drying the swaddling clothes. He is seated next to a doorway
crowned with the upside-down toad (see the gateway to the palace of hell,
hemmed with toads, in *The Last Judgment* in Vienna).

King Herod, in a false splendor, and his scribes are hiding in a ruined
hut that forms the background to the rich and noble world of the magi, the
child, and the Virgin. Herod is wearing a crown of thorns similar to the
one worn by the black magician priest on the St. Anthony altarpiece. His
magnificence has a sinister effect because it reveals a nakedness clothed only
in appropriated things. His crown of thorns is probably a reference to Christ,
but there is no humility in the way he holds his head. The white band of
the priest is visible, and the thorns have not wounded him. The green twig
on his head is a shoot that has been usurped; it has not grown within him.

Herod appears as a marked man, for the color of his skin is patchy like
a leper's. He exudes a sinister atmosphere that has nothing in common
with the events in the foreground. The purified worship of the child forms
a strong contrast to the world of Herod—the king who wants to be
woshipped himself and who wants to appropriate the pure forces of child-
hood because they are what is lacking in his own power. He is the
representative of the Antichrist, clinging to the wood of the cross of the ruined
hut. He stares at the child with strange greed: the shadow of the Adversary
is always present where Christ is born.

The intermediaries between the stark contrast of the worlds of the child
and of the usurper, which clash spatially, are the shepherds who are painted
in muted colors. They have climbed onto the dilapidated structure to be
present from above at the adoration. They are contrasted with Herod's evil
following in the shadows of the hut.

Here, too, the somber, occult covertness of Herod's world, familiar from
so many works of the master, reigns. Here this obscure world has a
particularly vivid effect because the scene is placed in the immediate context
of colorful nature.

The landscape is hemmed in at the horizon by a city, the New Jerusalem.
A clear sky without demons forms a dome above the city. The five-pointed
star in the vaults of heaven—the star of the magi and of love, the star that
heralds a new earth—sheds its light on the events.

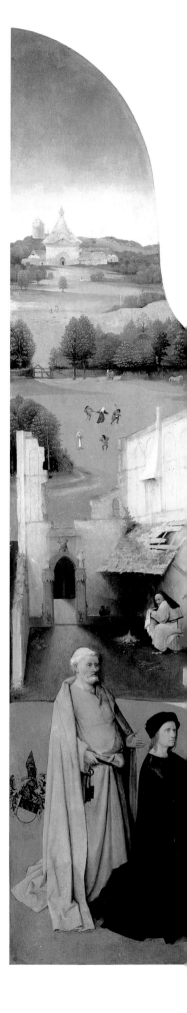

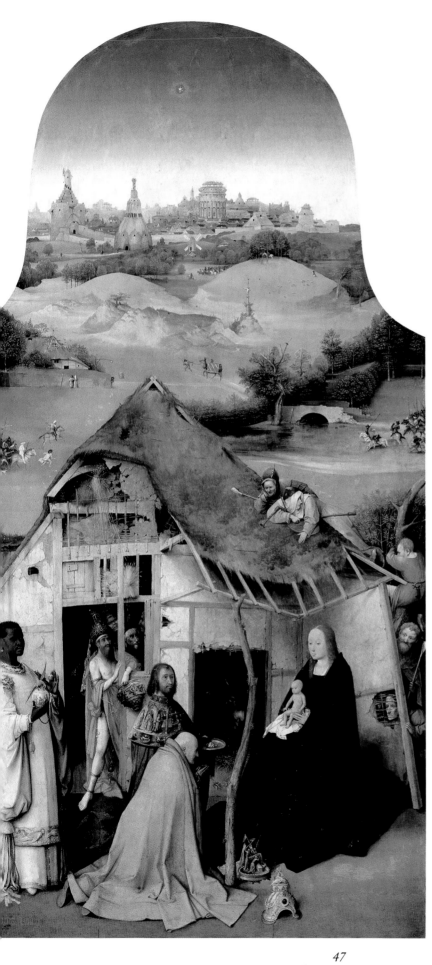

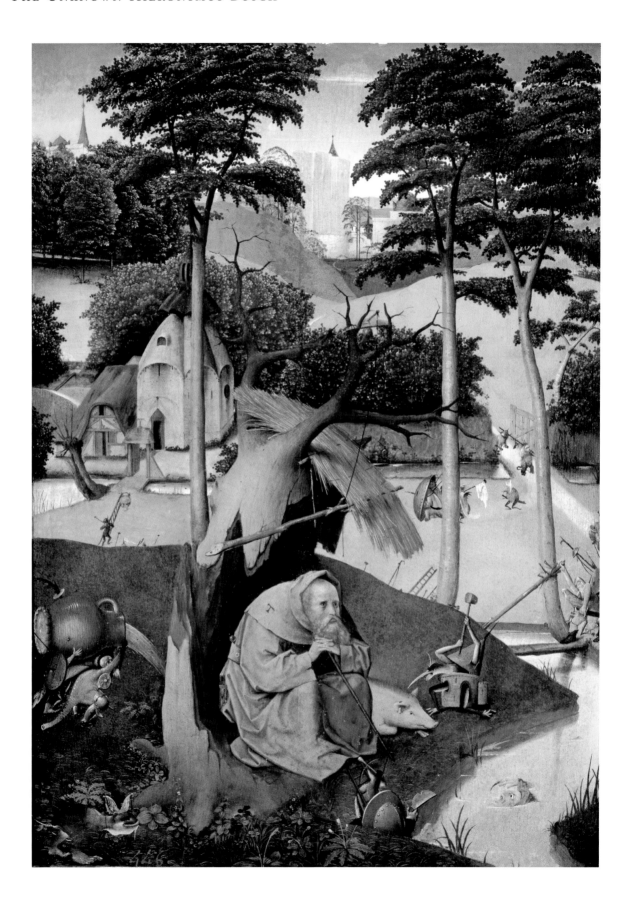

The Temptation of St. Anthony
Madrid

Following the Madrid *Epiphany*, in which Christ and the Antichrist stand in direct opposition urging us to recognize these cosmic polarities, let us now consider the painting of the so-called *Temptation of St. Anthony*. The saint's shelter is hollowed out and rotting, but he is firm within himself and the demons are nothing more than empty apparitions to him. Both paintings are closely connected in their use of color, something that allows us to assume that they must have been painted at approximately the same time. The magical tension and covertness of the previous painting is resolved here.

St. Anthony is enveloped by the peaceful landscape. The earlier wrath of the demons that are still present has softened; they appear more like goblins who no longer disturb the general feeling of peace. A deformed elemental being is attempting to empty a large jar, but this does not concern the saint. His content is new, and the once lowly and dirty pig has become a well-liked companion in his solitude.

Nature is familiar, a homely landscape of the soul, and all the former demons have dissolved into the commonplace. The plant world is depicted with loving care down to the finest details. It could well be described as Hieronymus Bosch's *Piece of Turf.* * The sparseness of his dwelling, the hollow tree trunk, has lost all importance for him. His disregard for outer possessions drives away the slither demons. St. Anthony's meditative stance recalls the saying by the Dutch mystic Ruysbroeck: "Staring and devoted, and joy at the unity of objects and beings." The saint's gaze gives an insight into the depth to which he experiences the unity of objects and beings. It

is wrong to speak of temptation here; it is a threshold experience: the transfixing devil comes to the surface of the soul, appearing from the most profound depths of the soul as a monster, as a human nightmare. Here we have fear at its most concentrated. Thus there is maximum tension between the meditating saint and the rising, fearful phantom—his lower ego—which faces him at the threshold of his initiation. But the saint has become imperturbable.

No other subject was painted as many times by Bosch as the temptation of St. Anthony, and no other subject was imitated so frequently by others. Altogether there are fifteen works on this subject that are considered to be originals, with varying degrees of certainty. Bosch allows us to see his spiritual state and attitude of soul in the figure of St. Anthony. The subject will be better understood if one takes the naked female figure that is often present to be the soul that watches, filled with inner expectation, the transformation of the saint.

* *Cf. the well-known painting by Albrecht Dürer,* The Great Piece of Turf.

The Last Judgment
Cairo*

What kind of strange fate could have brought this work of art by a Dutch master to Egypt? There is a peculiar feeling in discovering this *Last Judgment* in a country where thousands of years ago—for the first time in human history—the idea of a judgment of the dead appeared: the heart of the deceased was weighed against the feather of Ma'at, goddess of justice, in the presence of the god Osiris, the judge of the dead, and his forty-two assistants. The god Anubis then entered the result in the Book of Life.

A study of the painting in Cairo reveals that it is concerned with events after death.

Christ is shown in the central panel of the triptych in traditional fashion as Lord over the earth with palm frond and sword, surrounded by four angels and a group of saints deep in prayer. Below, the scene is dominated by the so-called Treeman. His alert and serious face is the only truly human countenance achieved by the painter, of whom it is a self-representation. It is the face of an initiate, of a true son of the approaching age of the consciousness soul, who has a knowledge of the destiny of mankind and knows that a religion that has become dogmatic no longer has the power to penetrate the thinking, feeling, and willing of the human being. His gaze is alert and conscious, neither confused nor frightened by the dramatic scenes taking place around him.

The observer may well find these surrounding scenes confusing. The painter has penetrated deeply with his consciousness into the kamaloca world, into the world of purgatory where souls are cleansed and purified before ascending to higher spiritual realms. He recognizes and comprehends the destinies of human beings.

At this point, we must briefly describe the path of purification that the heightened consciousness of the painter is able to perceive; a consciousness that remains self-aware even in a crumbling body and that is strong enough—supported by nothing, yet penetrating everything—to experience in full wakefulness the events that occur in the world of purgatory.

** Please note that, since this painting is now lost, we have photographed its only known color reproduction from a copy of a 1966 edition of the German magazine* Kristall.

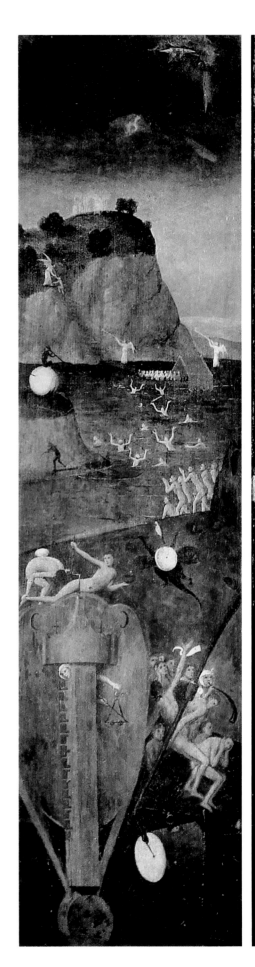

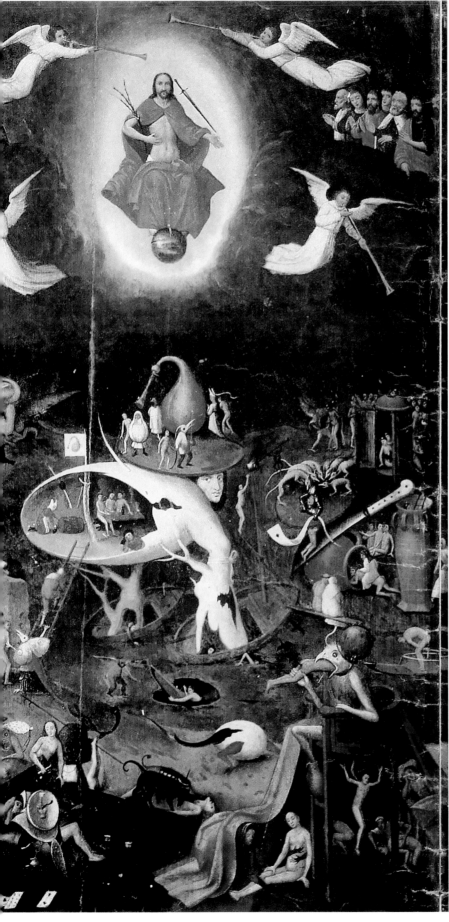

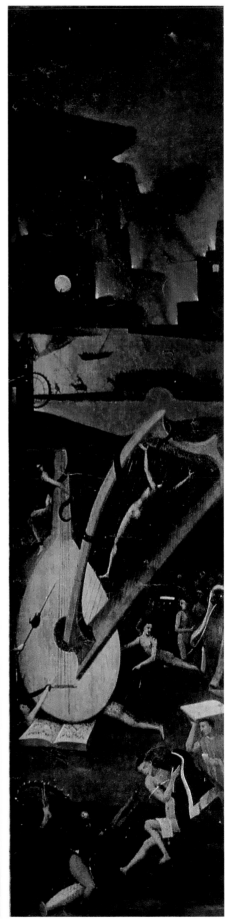

The physical senses have been shed. Eyes and ears, the senses of taste and smell have become useless here. The painter shows how the Treeman has discarded them.

To his right, however, the soul's life is shown to the extent that it is anchored in the etheric body. The part played by heredity, education, and character traits in the development of a person's destiny is understood and recognized in its effects.

Below left, his consciousness penetrates even more deeply into the realm to which the astral or real soul body belongs. Is the human being able to give direction to his life, is he able to resist the astral temptations? Or will he become a gambler, gambling away his spiritual inheritance and, blind to the real task of mankind, become the victim of demonic forces?

Below right, the souls that have passed through the kamaloca world and have awoken stand in the presence of the demon of the threshold, a being that also appears in Egyptian mythology. The souls that have arrived before this threshold-being experience a final purification here. Everything that has not been transformed into purified substance has to be left behind. Only nonearthly substances and forces that are capable of further development pass through the demon of the threshold to spiritual rebirth.

The "I" of the human being in the four stages of the kamaloca world:	The
1 Shedding of the senses = organs of the physical body	birth
	of
	the
2 Shedding of habits = organs of the etheric body	"I"
	in
3 Shedding of the emotions = organs of the astral body	the
4 Shedding of the earthly ego at the threshold leads to…	spiritual
	world

The painter depicts both individual destiny and human destiny in the central panel. No soul is spared the passage through the individual stations of this preordained path. The soul experiences individually what mankind as a whole has to pass through after death—or, anticipating this path of cleansing and purification, by initiation. These are experiences that are normally accessible only to a consciousness that has left the physical body after death. In this painting it is the artist whose "I" has developed the strength to behold in full awareness the four stages of the path of purification.

The two side panels, on the other hand, depict individual fate as human fate. When the original divine cosmic music falls silent and dies in the instruments of the body—harp, lute, and hurdy-gurdy—they share the fate of the earth that has become uninhabitable and suffers destruction in the cosmic flames. Those who experience spiritual rebirth cross the heavenly stream. But even here the individual still faces the danger of falling prey to false soul guides. The survivors who have gathered under the rose-red canopy—a community of free human beings walking on the waters in humility—cross the threshold confidently and without fear; they are elected. The angels make a new music audible. These souls are guided by their angels, higher and higher, to ever loftier spiritual realms.

* * *

The painting of *The Last Judgment* in Cairo depicts an event that focuses on the ego-conscious human being, the Treeman—one of the most important leitmotifs in Hieronymus Bosch's works.

In the painting, Bosch's imagination of man is screened from above against any new spiritual inspiration by the weight of the millstone resting on his head. As long as he is unable to break through this protective shield, he is incapable of hearing anything other than the same old bagpipe tune. His

foundations, his steadfast position in the world, are also rather shaky; his limbs have withered and become sclerotic, and his body has become a broken shell, at best a place for the indulgence of gluttony. His dead limbs are supported by unstable boats floating on icy waters: they are vehicles that he can no longer direct.* This ruin of a body can no longer offer support to the human being, can no longer house his real being. But his countenance, his wakeful, self-possessed gaze show that he is not led astray by this outer help-lessness, not even by the millstone of mechanical thinking that weighs him down and that has died the death of monotony, cliché, and conformity.

In this painting the head of the Treeman is covered with a black folded cloth hiding his hair, which strongly protrudes in the *Hortus Deliciarum* painting in Madrid. His face shows a completely new expression of great seriousness and wakefulness. It is no longer the face of a human being rooted in the Netherlands of the late Middle Ages, broad and sedate. It is a severe countenance, simultaneously wakeful and penetrating, which, at the threshold of the modern age, sees through the paucity of medieval forms of life. This face observes a new age dawning, whose approach it already experiences. The observer begins to feel that the surrounding events in the painting are more than just drolleries or criticism of the conditions of his time.

This countenance, with its deeply serious gaze, reminds us of a Christian initiate who is neither paralyzed by Ahrimanic actions nor lulled to sleep by Luciferic hopes of self-redemption. Knowledge of a higher degree such as this, wakefulness of this nature, will find access to the world of Christ, who is enthroned above the earth and human events.

As we have already observed, the Treeman in this

* *Consciousness is acquired at the cost of the life forces. This theme is also present in Goethe's* Fairy Tale *and in the Greek myth of the Medusa.*

painting is surrounded by scenes similar to those that appear on the right-hand panel of the *Garden of Celestial Delights* in Madrid. To his left there is a severed ear, severed from the rest of the human being. It no longer serves as a tool through which the language of the spirit is made comprehensible. Those who have omitted to develop an organ for a new kind of hearing will not be able to understand this language. All that remains in the absence of a link with a higher consciousness is the razor-sharp edge of abstract thought passing its judgments, and the two bits of the hearing organ are held together only by the arrow of unsavory habits. Therefore the ear becomes the victim of demonic promptings that strike fear into human beings in the form of specters and rumors and deprive him of his self.

The bare skull of a horse is placed just below, with empty sockets in place of eyes. New wisdom becomes inaccessible even to those with knowledge gained through contemplation once the human element has died within a human being, even if the key to it is dangling right before its nose. The tool for unlocking becomes an instrument of torture. Cornelius Agrippa expresses this situation when he says: "You Pharisees have taken possession of the key of wisdom so that no one here can unlock it; and you also refuse to do it."

A white dove beset by black ravens is perching where the organ for scenting out things, the basis of healthy human reason, used to be. The muted sound of a bell is all that can be heard where once the word resounded in the human being and became audible through the tongue. A demon has become the bell ringer and the human being, nothing more than the bell clapper, has to obey his tug of the rope. He produces neither the tone nor the stroke.

Strange things penetrate a human being and take possession of his dwelling when his sense organs start to separate before he has experienced initiation. The

death's head moth points the way upward into the empty room of gluttony where even the landlord is no longer at home.

To the right of the Treeman, a knight is trapped in the lamp of his own illusion. He ought to be the guiding light for others, but he is not! Having fallen prey to demonic beings, he is tied to his own family tree, which brings him death instead of the forces of life. Like the human being in the bell scene, who should have proclaimed the proper word, the knight who fails to prove himself suffers a similar fate.

In front of the lamp without light, basilisk devils are attacking a knight who is defenseless against the hellish pack, despite his armor. After all, the symbol on his banner is a louse! The standard has long since fallen from his hand. Although his mailed fist still grasps the chalice of eternal life with the host, the struggle for his human nature is balanced on a knife-edge. The image of God in him has been desecrated. The two clay jars also belong to the scene with the fallen knight, whose soul as receptacle for his eternal "I" has become cramped and bare. A demon forces the naked soul back into the empty jar and force-feeds it, since its own past wealth has long disappeared.

Below, a human being glides on the ice-hardened water of ossified thinking. He is so concerned with his own progress that he fails to notice completely the shipwreck of another human being in a craft constructed in the same way as his own. A dull demon watches indifferently as he drowns and does not waste even an arrow on someone whose thinking has long been pinned down by his own actions.

Below left, we meet the cheat. The gaming table has been knocked over by the impetuous gamblers. The game is over and there is nothing further to tally up because fighting has already broken out among the evil company. The gambler is being strangled and stabbed by the gambling demon. His hand, which used to deal sharp cards, is pinned to the table

by a dagger. The cards have been thrown away and lie scattered on the floor. They no longer matter. The content of his jug has drained away into the sand as well. A person has three throws in his life. Three times he can choose. But the devil of the senses starts to mock the gambler who cheats with the given values. A different kind of consciousness from the gamblers is needed in order to fulfill the tasks given by destiny to human beings.

His god-given soul, the female being with the burning candle and the jug, observes with deep regret the life that has been gambled away. But once someone is in the stranglehold of the oath-demon, he is beyond the intercession of the good soul; she has to give him up. In the Madrid painting the soul carries a die on her head: the pointers are wrong; the four occurs twice. But here the dice lie scattered on the ground.

If life is not lived and accepted in accordance with the opportunities offered by destiny, the human being has to invent false values and become a cheat; he falsifies his destiny. He becomes a victim of the hare, a being in which the ancients always experienced something divine. It is known that the voice of the hare is heard only in the throes of death and that they always sleep with their eyes open. The hare was also a symbol for sacrificial willingness and devotion; it takes the place of its brother when the latter is being hunted by dogs. According to legend, Buddha gave himself as food to starving mankind in the image of the hare. In art, the hare is always present where change and purification take place in the human being and higher states of consciousness are achieved. Thus it becomes clear that Bosch uses the hare as an expression of the moral act of will, as a symbol of the highest condition of the soul. If this much-hunted animal now itself becomes hunter and the human being becomes its prey, then this represents an inversion of the natural and divine order, from which the human being has

fallen. Here the hare blows the hunting horn, and its dogs savage the human prey.

The image of the hare as the hunter points to the process of reversal that occurs in the life after death: once the physical body, which gives support to the soul, has been discarded, the "I" faces its own inner soul world outside itself. If the soul, with its drives and passions, has not been purified and cleansed during its life on earth, it becomes the victim of demons who find their nourishment in the undigested, untransformed parts of the human soul-body.

The bird-demon, guardian of the threshold, sits in the bottom right-hand corner of the painting. He is starving and emaciated since the human bodies he devours greedily do not really provide him with nourishment. His long legs are stuck in clay jars in which the deeds and omissions of the human being's past life are preserved as the essence of his next life on earth. The soul looks at itself in the mirror on the backside of its own demonic being, clasped by a beast from hell that seems to support it. One curiosity in this scene with Vanitas before the backside mirror is that in the Madrid painting a black dog with a red tongue nestles up to the naked Vanitas and looks attentively at the mirror. In the Cairo painting the reflection of the girl and the dog is clearly visible in the mirror, but the dog at her side is missing. Presumably the dog will reappear when the painting is restored.

The demon of the threshold devours that part of the soul that is undigested and unpurified. What is not transformed is vomited out, and even undigested pieces of gold are excreted. Their former mint value is still identifiable; the talents, too, appear unchanged. The process recalls Goethe's *Fairy Tale,* in which the will-o'-the-wisps lick up the unpurified gold but reject it again because it is indigestible for them. Here, in the painting, the unpurified soul qualities leave the human being as blackbirds as he is devoured by the demon of the threshold. But the essence of the

human being is excreted. It leaves the demon through something like a placenta, transformed and changed: expulsion becomes a new birth! This newborn being slips out of the kamaloca world, the place of purification, through a cervixlike opening. It enters the lower spirit world, the lower devachan.

Christ, with palm frond and sword, floats above these happenings in the kamaloca world in a bright mandorla, his feet resting on the world with the upright cross. Palm frond and sword, attributes of mercy and justice, are here arranged not diametrically but in parallel with him.*

Christ is enthroned, surrounded by angels, who sound their trumpets towards the four points of the compass. Saints are deep in prayer between each pair of angels on either side. They are spirit human beings who have transformed their sheaths and who have been received into the sphere of Christ. The group of women on the left follows the events happening in the lower spheres with deep feeling and in prayer, while a group of men on the right follows them with compassion and attention. For the question is still open: will mankind find the way to its spiritual goal or will it fall prey to the demonic world?

Compared to the style of the rest of the painting, the heavenly scene depicting Christ with the angels and the spirit human beings appears to be painted in a purely traditional church style. The assumption is justified that it might have been painted over. But deeper contemplation of the individual faces shows the lack of any religious sentimentality. Both the angels and the spirit human beings have expressions that reveal their own individual character. Christ's gaze encompasses the world and transcends time; it is the gaze of the Lord over the earth.

* *In* The Last Judgment *paintings in Bruges, Ghent, and Cairo, these attributes of Christ are arranged in parallel; in Vienna and on the tabletop of* The Seven Deadly Sins*, they are arranged diametrically.*

That, in broad outline, is the composition on the central panel of the triptych in Cairo. The remaining elements on the purgatory panel of the *Hortus Deliciarum* in Madrid—the closely assembled group of musical instruments between the Treeman and the demon of the threshold and their setting—is here spread over the two side panels. The hurdy-gurdy with the wind instruments and the drum is now on the left panel, the harp with the lute on the right panel.

The upper half of the right-hand panel depicts burning human dwellings, the stream of purgatory, and the throng crossing the bridge toward the illuminated mill. It is the stream of the men in armor who, led by a demon, are crossing from one bank to the other in an orderly fashion. Their hardness and armor are ground down and crushed between millstones.

If we are to do justice to the peculiarities of the Cairo painting, we must not ignore the small deviations and additions. Thus the men in armor in the Madrid painting, led by a demon riding on a cowlike animal, are being lured across by a devil that is hardly visible. In contrast, this being can be seen clearly in the Cairo painting. It is larger and similar to a hare, looking back at the mass of humans behind it and beckoning them to follow. As we mentioned earlier, the hare is an ancient symbol that is familiar to occult circles and was frequently used by Bosch. We find him using both mythical hares as well as hare demons. But the animal depicted here as a hare has a peculiar shape and stance. Standing upright, it is reminiscent of the Egyptian animal gods, leaving an impression of a divine being revealing itself in animal form.

The hare used to be a symbol for the work of the Buddha, as was mentioned earlier in a different context. The Rosicrucians in particular had knowledge of the continued existence and influence of the Buddha who remained within the spiritual realm of the earth. "Thus the Buddha continues to live anonymously in Western literature and only

makes an occasional appearance in the guise of the hare." In this sense Rudolf Steiner refers to the Gautama Buddha as the being who, working from the spiritual world, "is the force behind the existence that has progressed to the intellectual stage." The fact that the hare is here depicted as the leader of the men in armor turns him into the representative of such Buddha influence.

The second stream of humans in the Madrid painting is plunging naked and panic-stricken into the waves. These naked and desperate human beings do not appear in the Cairo painting and seem to have been painted over. This threatening division of mankind into the naked and the armored is also mentioned by Rudolf Steiner in connection with the Buddha's mission after death: "The danger existed that in the future a development would take place that would leave only technicians and scientists on the one hand and monks, mystics, and anchorites on the other. Such a threatening division of mankind would be the death of true humanity, a development that would make it impossible to receive the Christ."

Doubts can reasonably be raised as to how a higher being, guiding mankind, can be hidden in the upright, forward-striding being of the hare when, after all, the group is clearly being led by a demon from hell. In this context it is worth referring to the Persian image of the camel of mankind in which the camel is led by the halter by a grim-looking Ahrimanic demon that, however, has to obey the divine instructions given by an angelic being riding on the camel under a canopy.

A harp, floating in space beside a lute resting on a music book, is depicted in the lower half of the right-hand panel. According to Wertheim-Aymès, the harp is the instrument symbolic of the human soul. If it is not sufficiently anchored in human life, it drifts around full of enthusiasm but without a proper base. Lacking a proper link with life, an instrument

like this can never produce the correct tone. As a consequence, the human being is crucified on it. The lute, on the other hand, which rests firmly on the ground, represents the etheric or life-body that is too much inclined towards the physical body. It now receives its resonance from the physical body rather than itself providing the sounding board for the harp sounds of the soul. Thus the human being is fettered to the lute and the harp and is bitten and poisoned by the snake.* The music has died, and one demon grasps the human limbs while another rouses sexual passion in his victim: it is the fiery toad, speared on the lance of our lower ego nature. It is the same lance that wounded Amfortas, the grail king redeemed by Parcival.

A group of humans is singing devoutly in a demonic choir in the background to this scene. They are singing skillfully from old music, including some written on a human backside. They sing without suspecting the origin of their music, with whom they are singing, or who is accompanying them. The formerly god-given harmonies fade at the dawn of the age of the consciousness soul. Human beings are no longer in control of their bodily instruments. But when their music falls silent their own nature is extinguished as well, and the clamor of hell makes itself heard. Right at the bottom, the human being is beset by the knighthood demon and the demon of fornicating nuns, and the latter demon is wheedling his name and signature out of him. In the Madrid painting the human being, caught between both demons, still has his sight, but here he has become blind.

The hurdy-gurdy, instrument of the physical body, takes up a considerable part of the left-hand panel.

* The snake bites the genitalia of the human being crucified on the instrument of the soul-body. In contrast, the human being crucified on the lute, the instrument of the lifebody, is bitten on the head by an amphibian creature. This corresponds to the nature of the astral body and the emotions in relation to the former and to the nature of the etheric body and thinking in the latter.

In the Madrid painting it is part of the group of other bodily instruments directly beneath the Treeman. In both paintings the demonic wind instruments are situated to the right of the hurdy-gurdy, as is the human being locked in a drum, locked in his own will. A perverted monkey-being is playing a drumroll. The hurdy-gurdy, firmly supported on the ground, is being played mechanically by an acrobat who lies on it. He seems concerned above all not to spill anything from the dish he is holding in his left hand. He reminds us of the biblical saying: "No man can serve two masters." Strapped into his bodily routine, he is afraid of losing even just one drop of his life content. It is no easy matter to be given over completely to the mechanical functions of the body while attempting to preserve the soul content.

Next to him, bent over, another acrobat is making an effort to achieve exceptional results through special physical training. He is attempting to flip an egg that is balanced on his back onto his head without using his hands. However, he is using a support to maintain his balance and is also holding onto the heel of his companion. The success of his trick seems more than doubtful. For the attempt is being made by a physical effort of will to relocate forces that have their seat in the spine to the consciousness realm of the head. Bosch was by no means a stranger to such phenomena of occult acrobatics, nor to the fact that the consciousness can be expanded through exercises.

A woman, trapped in the body of the hurdy-gurdy, is playing the triangle. In the Madrid painting she is squinting upwards, showing great interest in the actions of the two acrobats. But here the old woman is blind and filled with resignation. She has given up all hope of anything from above. The triangle is usually used to prevent the congregation from falling asleep. Here, the monotony of the triangle, played by the soul tied to the instrument

of the physical body, has the opposite effect.

The background to the hurdy-gurdy is formed by human beings who are intimidated by the noise of the demonic drum and the wind instruments from hell. The hellish noise is causing them acute agony. Their standard is the banner with the moon, the symbol of the infidel.

Above, in the upper part of this panel, a scene has been added that is not in the Madrid painting. Here, too, a stream must be crossed that, however, leads to other regions. The souls that have passed through purgatory are swimming across this stream. But even here a demonic seducer, enthroned on a rotten egg, produces stifling, seductive tones. His accomplice, the false Psychopompus, the false soul guide with the antlers, catches many of the individual souls in his nets.

Opposite these naked and swimming souls, almost at the other bank, a group of human beings is overshadowed by a canopy. Their angels are waiting to guide them to the heights of the mountain. Bright spiritual beings, angelic beings, are waiting there to carry them to still higher realms where the great heavenly fish, the symbol of Christ, is waiting to receive the souls carried and guided by the angels:

> The human being's Father-World
> approaches destruction.
> The Son judges human beings by
> their deeds on earth.
> Human communities arise in
> the Holy Spirit,
>
> Making new things audible to
> the spirit world.

Silently and unnoticed, a bark with red sails glides away from the ruined earth on the right-hand panel of the triptych.* Unhindered and undisturbed

by the Ahrimanic and Luciferic fate of the human souls that remain behind, the bark glides away from the realm of the destructive world conflagration.

Silently and unnoticed by the clamorous world, the human community crossing the river of heaven in prayer is overshadowed by the red of the canopy, the color of the Holy Spirit, the purified red of the blood. The Last Judgment is not a single event, incomprehensible to human beings and infinitely distant on the brink of eternity. Hieronymus Bosch presents it as a process of continuous purification that increasingly brings individual destiny and human destiny into harmony through the work of Christ. The path on which Bosch guides the observer of the painting is in accordance with, and in the spirit of, esoteric Christianity.

In conclusion, let us give a summary of the two streams of humanity that are crossing the river of hell and the river of heaven:

The Armored Ones	The Naked Ones
those who act and those who are led	fleeing in desperation

The Self-contented Ones	Those Fulfilled in Themselves
full of themselves; swimming, they lose their ego in the trap of false music and become victims of the false soul guide.	who walk on the waters in humility, creating new music in the angels through their deeds on earth.

The same red appears in the color of the canopy on the left-hand panel.

The Structure of The Last Judgment

In contrast to the *Hortus Deliciarum* in Madrid, there is no indroit and no creation of the world and of the human being in this triptych. The painting depicts the present, which stretches into the cosmic future.

Christ appears as the Triumphant, the Lord over human destiny. This is how the painter might have experienced and anticipated Him. In our time, Rudolf Steiner points out that with the start of the twentieth century the great event for mankind will be the experience of Christ as being eternally united with our development on earth and the advance knowledge of the consequences and effects of our deeds on earth.

It may be that, connected with these events, Hieronymus Bosch, too, has only begun to be comprehensible to us in our century and equally that *The Last Judgment* has been rediscovered in Cairo.

Summary of the Composition of the Painting

	Left	Center	Right
Above	ICHTHUS	CHRIST	STELLA
	mountain summit		planetary sphere
	Canopy	World Sphere	Bark
Middle	The naked ones	Treeman	The armored ones
	The instruments	The human being drowning in the icy waters	The instruments
Below	The Human Being numbed by the demonic noise	The Human Being savaged by the dogs	The Human Being blind among the monsters
	Fish above ascending mankind	Christ judging human destiny	Star stellar wisdom above burning earth remains

Dimensions

	side panels	*central panel*	*painting overall*	
Hortus Deliciarum	97 X 220	195 X 220	389 X 220	cm
Last Judgment	26 X 95.5	59 X 95.5	111 X 95.5	cm

The reverse side of the side panels from *The Last Judgment* were prepared but remained unpainted.

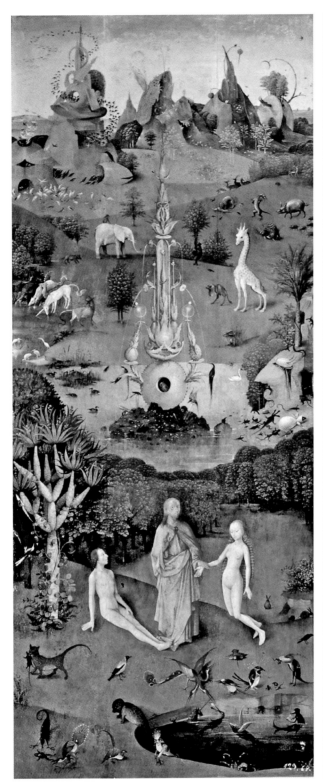
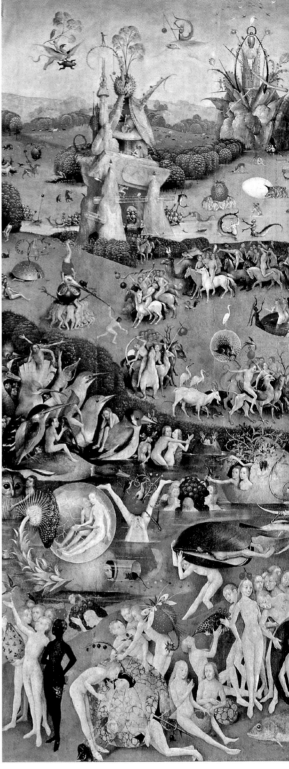

THE LATE WORKS

The Garden of Celestial Delights
 Madrid

With its 220 x 390 cm size, this painting, also called *Hortus Deliciarum*, is without doubt the largest work by Bosch and also the most rich in

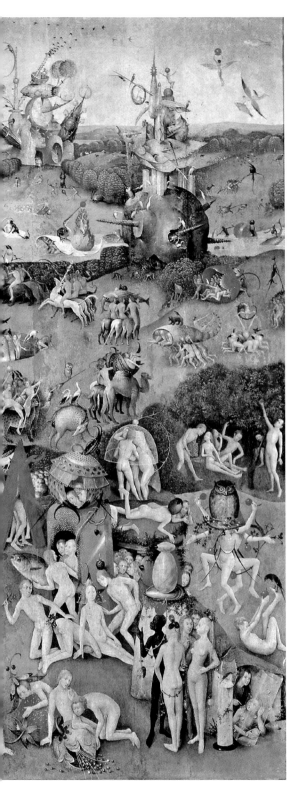
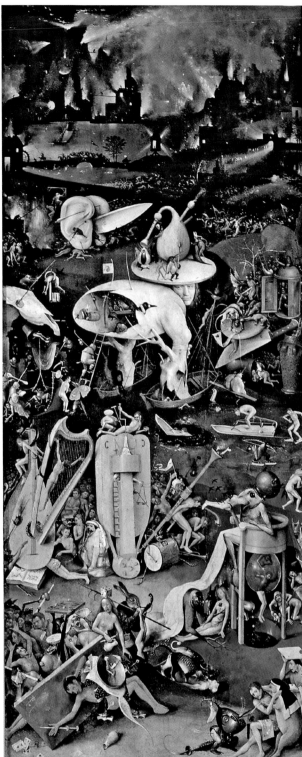

content. It is the most clear expression of the differences between Bosch and the painters who were his contemporaries. He depicts his vision of events in the spiritual world with rare clarity and insight and manages to avoid the trap of the outdated traditions of the Church and traditions of a decadent-occult nature. His self-depiction as someone looking in on the spiritual world reveals him to be an initiate.

Bosch certainly takes us into a new world in this painting, a world quite different from *The Marriage*

at Cana or the deception of *The Conjurer,* different even from the world of the oppressive chaos and disordered visions of *The Last Judgment* in Vienna. There is perhaps no better illustration of the difference between the person who observes and the person who has knowledge in the spirit than the two paintings in which Bosch reveals his direct experience. His earlier observation has grown in scope in *The Garden of Celestial Delights.* It has avoided outdated and no longer comprehensible occult symbols. Bosch places the creation in the Saturn stage of the earth and reveals regions stretching far beyond the moon region into the spaces of the ichthus worlds.

There are no children in these realms, only adult human beings; no earthly love, only love of the kind appropriate to the upright in spirit. Love becomes the driving element. It has often been asked whether or not Bosch was caught up in the conception of the time of the predestination of human beings, according to which only the elect few will achieve salvation.

Such a view does not stand up to an examination of this central work by Bosch. Certainly, he would not have depicted such mighty and specific images in such detail if he had not been filled with the idea that all mankind is capable of salvation. Indeed, he shows us in the various scenes of the creation how Christ is connected with the blood of Eve and the deeds of Adam from the beginning. Of course the upright and the active stride ahead of mankind, far ahead, but nowhere does Bosch depict eternal damnation here.*

Bosch shows in this painting that no demon of the threshold can separate human beings from the fabric of their "I" if they have brought it down to earth. No person is lost *sub specia aeternitatis*—as

regards eternal salvation—for He is all-compassionate, not merely all-powerful and omniscient. That is the message of Bosch's work. The painting bears witness to the divine cosmic plan, to the formation and resolution of destiny and incarnation and excarnation in the process of cosmic harmony. Human destiny is linked with cosmic destiny, with the destiny of the divine world. The eternally evil is represented as a stage we pass through and an element of purification, not as something predestined and absolute. Since he became man, Christ is linked with the earthly deeds of mankind through the stream of human destiny, deeds that become the cosmic future. He, the Christ, appears as the genius of earth and ascends with the transformed *terra lucida* to new fields of endeavor.

* * *

The Last Judgment in Cairo deals with a subject that is of fundamental importance in the work of Hieronymus Bosch and that is depicted repeatedly in a variety of forms. It is striking that motifs and details similar to this painting appear on the right-hand panel of *The Garden of Celestial Delights (Hortus Deliciarum)* in the Prado in Madrid. But the repetition is only superficial. For the same elements have been assembled into a completely new composition in the Cairo painting in accordance with a quite different subject.

We will therefore continue with a detailed description of *The Garden of Celestial Delights* in order to help us understand the message contained in the Cairo painting and the position it occupies in relation to the other works. The analysis is based largely on the work of C. A. Wertheim-Aymès. The changes in composition, called for by the different subject of *The Last Judgment* in Cairo, will thereby become more comprehensible, giving an understanding of the language of the latter painting.

* *In fact there is only one painting,* The Last Judgment *in Vienna, that depicts the region of hell.*

* * *

In a wide sweep the painting of *The Garden of Celestial Delights* encompasses the complete drama of mankind. The closed panels give a preview of its scope and of Bosch's breadth of treatment: we see the gray-green planet Earth suspended in the dark cosmic spaces, recalling the *prima material,* the protoplasm and primeval ether. The earth is like a cosmic embryo, a primordial cell from which new life arises. The awakening globe of the world is shown in Ptolemaic fashion as a disk and a surface with the spherical firmament forming a dome above it. God the Father, creator and source of all being, can be seen far in the background in the crystal sphere with the open book of the world revealed.

Opening the triptych, we can see the creation of the world on one side panel and the end of the world on the other, both preceding the realms of further spiritual development depicted on the central panel.

On the left, the still paradisiacal creation appears in strong colors. In the background we can see previous planetary states of the Earth, whose inhabitants are represented entering and departing as soul-birds. Below that, in the realm of the spring of life, is the animal kingdom. The owl, nesting in the Saturn-like ball of the spring, points to the creation taking place below it. The lake of life in front of this scene leads into the actual earth realm.

Adam and Eve are being led to one another by Christ, not God the Father. The actual creation seems to have taken place already. The temptation by the snake is lacking, as is the scene with the expulsion from paradise. The snake is coiling itself around a date palm at the level of Saturn by her pulse, making holy her blood, and is touching the feet of Adam, testifying to his connection with the future path on earth of the father of mankind.

The three-headed phoenix, the crow, and the snipe correspond to this group of Christ, Adam, and Eve, and complete the scene at the bottom.

The events continue on the right-hand panel. Human beings are leaving the burning and no longer habitable Earth. They flee over the river of hell into the region of purgatory. The upper third of this area is dominated by the Treeman, whom we have already met in the central panel of *The Last Judgment* in Cairo. Also familiar in this context is the threshold being at the bottom right, the great devourer. This guardian of the threshold, sitting on the three-legged throne, is devouring human beings. But they are excreted again and disappear into a cervixlike chasm. The half-visible embryonic shell of human beings who are being passed out indicates that this process leads to a rebirth. The reborn human beings reach the lower sphere of the spirit world through this chasm.

Four realms can be identified on the central panel, of which the lowest one takes up the largest part. It is the moon sphere where the fruits of human earth existence ripen. Dante also mentions this realm in his *Divine Comedy.*

We can identify three ways of entering this realm, arranged diagonally* towards the right of the painting: a bloodred, treelike triangular opening, an orange-colored portal with a superstructure, and the pillar of the "I." These three entrances, which give access to this celestial realm, are formed in accordance with the human sounds *A, O,* and *I* and appear as alpha, omega, and iota. They appear as the three seals of man's development: as his creature state in the *A,* finding himself as earth ego in the *O,* and as the creative human being in the *I.*

At the end of the diagonal in the bottom right-hand

* *The diagonal line is of incisive character. It introduces the contrast of temporal historical events into the timelessness of these cosmic spaces.*

corner of the panel, we can see an earth inhabitant who is not a member of this sphere. It is a youth who is observing events by laying aside his temporary earth mask, his earth persona, for the time of the vision. A deceased sister-soul, similar to Eve, helps the visionary to remove the dividing wall of earth consciousness, an act that is symbolized by the two crystal pillars with the glass goblet filled with the water of life. The two soul-birds also give an indication of the state of consciousness of the visionary and his sister-soul.

Bosch research has established that this watching earth figure is a representation of the artist, who lets the source of his wisdom be known here: his own spiritual vision.

The three streams of mankind emerge from the three entrances. At the top is the stream of newly flooding-in souls who squeeze past the red coral tree. They are the souls who were still very much immersed in the stream of blood relationships and heredity during their earth life. Weak and hungry, they appear like birds of passage after a long journey. They are completely dependent on the food given to them by the jaybird since they have not brought anything from Earth yet.

Later they are refreshed and nourished by the creative forces from Adam and Eve: a large blackberry, which, in contrast to the grape, is the image of Saturn development.

Further to the left we come across a male figure that has its head in the water and is spreading its legs in the air. He covers his genitals with his hands, a gesture that attracts the attention of the observer.* Our attention is also drawn upwards to the child's figure squashed into a sphere; it cannot free itself

* *The sexual forces in human beings are natural as long as they are subordinate to the generative forces of the sexes (the duck) and individual consciousness has not yet misused them for its own sensuality (the ego-consciousness is submerged).*

from its shell and sinks. It has not mastered its hard and rigid physical body. The face of this child reminds us of the child in the nutshell boat in the St. Anthony altarpiece, which is desperately defending itself against the deathly learning of the Middle Ages.

This first stream of mankind ends in a peculiar hybrid shape. Its lower part consists of a hard polished fruit or metal pod from which a blossoming branch sprouts. The blossom itself turns into an embryonic sac inhabited by a human couple. This couple in its male-female nature is chastely sufficient unto itself in its enclosed sphere. The strawberry that is also enclosed, the fruit of faith, is their spiritual nourishment.

A human being is caught in the pod, trapped by his earthly thinking and although he observes the world alertly and sharply through a glass tube he manages to see only a section of this world. He loses the overall picture so that the rat creeps into his field of vision. This kind of sharpness in consciousness does, of course, produce new abilities, including some bright pearls—but on the whole they lack sparkle and are more like rat droppings.

The owl, the bird of Athena, sitting to the left of this hybrid, seems well aware of the dilemma posed by the threatened split in consciousness. The double shape is in essence another image of the state of consciousness symbolized by the Treeman that faces human beings at the dawn of the modern age. The developed intellect with its materialistic orientation is linked really only by tradition to the handed down substance of belief and the original unity has been lost. A human being seeks help in vain; the owl remains silent and inactive. Help no longer seems possible for such human malformation. Such one-sided intellectuality must inevitably lead to the destruction of the human being in spite of the innocence he has preserved in his belief and his pure sexual life. Thus we see him disappear into

the waters. The equivalent image is the young person above, who is trapped in his overly hard and rigid physical body and also disappears into the waters.

Taken together, it is a vivid image of the modern mentality: the adherence to the biblical myth of creation on the one hand, the idea of the origin of the earth and man by chance, from the void, on the other.

A second stream of mankind is flowing from an orange-colored portal below the red opening. The portal gives the appearance of having been built by human hand. A strawberry, the fruit of faith, forms a kind of superstructure. This is the stream of mankind that has become united with the Christ impulse on earth. The fish is brought across. The fruits of the deeds performed on earth and the faculties that were acquired become visible with each individual. The large, magnificent double cherry, the fruit of combined cosmic and earthly thinking, is near the fish, the symbol of Christianity.

Flowers, which should be seen as virtues, sprout in unexpected places where only excretion took place on earth. (We are reminded of Indian fakirs and initiates who are said to have reached such a degree of spirituality that even their excrement was scented with musk and ambergris.) Here these sprouts and blossoms are the fruit of transformation and development of the soul that has not, however, risen to individual consciousness.

The things that cause human beings to progress on their path of destiny and that move them are shown in an impressive manner in the slow process of ripening in the medlar trees. Fruits and faculties brought from earth are ripened here.

The motif of the mussel-bearer is a mysterious one. The couple secretly becoming one in the mussel is the human being transcending the separate male and female principles. The pearls are evidence of this process in the human "I" that occurs within mankind

with the support of the bearer of Man.

Bosch's knowledge and wisdom is shown in the way that he has this part of mankind led by the mature and silent servant of Man, who carries the large and heavy fruit of the human soul. The leader and bearer of the fruit of mankind carries his great burden in all humility. He carries it toward the new fruit that is to be found in the hands of the upright.

The third group of mankind is the group of the upright who have gathered around the pillar of the "I." This pillar is like the stem of a mushroom that has a mussel on it instead of a cap. A rose-colored egg stands on end on the mussel, and a grain of corn is balanced on the egg. Using the symbols of mushroom, mussel, and egg, this scene shows us in the most simple way how the sexual forces in the human being serve to develop the new seed—the "I"—and how they must not become an end in themselves. The heads of the upright are adorned with fruit and flowers, and strings of pearls garland their bodies. These upright human beings with their own name and destiny, the active ones among mankind, form two further groups of three on the far left. They send their soul-birds into the skies with inner confidence and await the tidings they bring on their return. The falcon of Horus, once bearer of inspiration to the pharaohs, comes to mind. The birds in the upper stream of mankind, which still have a hierarchical relationship with the latter, here turn into celestial messengers in the service of mankind. They bring tidings of all realms of existence and of all human achievements.

A new and large fruit is held by this group of the upright.* It is light and free of the heaviness of earth.

* Wertheim-Aymès describes this group as King Solomon bearing the falcon of Horus, the master builder Hiram with the new fruit who is looking at Balkis, queen of Sheba, who carries an apple on her head and in her hand.

A female figure crowned with a red double cherry stands in the middle space between the left and the right groups of the upright. This is without doubt a being of central importance in human history. The fish lies at her feet. To her right a human being sits in an open fruit capsule, a reminder both of placenta and grave.* He is being fed by a wild duck, which is giving him a cherry.

Two inverted figures are leaning, one in a blossom, the other in a larvalike covering, against the capsule or grave. The wild duck giving the cherry as nourishment is perching on the legs of one figure while the other is holding with its legs a fruit that has already lignified but manages to overcome the death processes once more to bring forth a delicate mulberry. The figure on the left carries two peacock feathers, and the one on the right has a dark blue iris growing from it.

To the left of the upright female figure with the double cherry, we can see another fruit capsule, which is cracked and has a black currant branch growing through it. It serves as shelter for a human couple. Mysteriously puzzling events are revealed in this scene. A deep conversation between humans is taking place. One person speaks from the fruit and body shell, and another is lovingly bending over him.

In contrast to these two, the other figure present in the capsule is looking into a closed crystal tube that does not give much of a view. Compared with the more passive observation of the person watching the rat, whose observation tube has smooth sides, this eyepiece has so-called concentration points on its surface. Meditative study of these two figures within the same shell provokes thoughts of life ending and life beginning anew: the scene reminds

us of a Christian initiation, of the disciple initiated by Christ himself.

As we described earlier, the uppermost stream of mankind comes to a halt. The image of man turns into a hybrid form and dies through the duality of intellect and instinct. Such hybrid forms appear in human development like dangerous rocks. The bearer of the mussel turns away from this rock of destiny in order to pursue his proper path. The upper stream of mankind moves in the watery element whereas the middle stream and the stream of the upright are on firm ground.

The mussel carrier with his burden follows behind the self-absorbed bearer of the fruit of mankind. Both are separated from the terrain of the upright by a fold in the ground, but the two streams have the same goal: the lake of creation. The meeting of these two movements of humanity bearing their fruits with them is a great achievement. Having reached the celestial lake, they stand in the presence of Christ with Adam and Eve and the tree of knowledge and life.

What do these two streams of humanity symbolize? The upright ones show by their bearing that they are the ones who stride ahead of mankind in their knowledge of the tasks and aims of humanity. It is the stream of priests and kings, the stream of which King Solomon and his master builder Hiram are members. The others, however, require a long period to mature (the image of the medlar trees) over many earth lives. The "I," the real being of Man, matures within them unseen, supported by the genius of mankind, supported by love they can unfold. These two streams, the stream of love and the stream of wisdom, find their fulfillment at their confluence in Christ.

If we now move on to the middle region of the painting, we reach the zone of the sun lake encircled by animals. If the region of the moon below

* *This figure holds a double cherry in its hand as well.*

corresponds to the ripening fruits gathered on earth and to individual destiny, cosmic events begin at this level. Many different kinds of animal encircle the lake in which virgins bathe in a youthful fountain of cosmic life. Their golden hair recalls the legend of the golden fleece. The birds resting on their heads are evidence of newly acquired states of consciousness. The encircling animals with their strange positions are, by contrast, ridden by a variety of male figures.

Beyond the sun region of the zodiac, which lies at the same level as the paradisiacal creation of the animals, we ascend to the planetary incarnations of the planet Earth, which simultaneously reflect the human stages of past and future incarnations of the earth. Every human spirit passes through this region between one incarnation and the next. Here the souls prepare their future earth destiny and a new earth karma is formed.*

The space at the top of the painting remains open, open to infinity, open for never-ending, cosmic creative acts. It is the sphere of Ichthys, the true sphere of Christ.** New destinies of mankind and earth are formed here, new stages of existence of our planet are prepared. Here the earth past and cosmic future meet. And yet at the same level on the painting, where here the new illuminated earth ascends to fresh spheres of development, to new earth beginnings as a light-permeated sphere, as a new earth embryo supported by its genius, the right-hand panel of the triptych depicts the end of the world, conflagration and destruction.

Here, then, we have in broad outline the content

of *The Garden of Celestial Delights.* It is appropriate at this point to remark that the discovery of the continuity in the content of the painting is due to the Bosch scholar C. A. Wertheim-Aymès. It was he who drew attention to the path that leads from the indroit, the closed panels, to the inside drama of creation and the departure from earth to the kamaloca world, followed by the transition to the higher spheres of the spiritual regions on the central panel. If we experience and view this work of art in such a light, it will reveal the meaning of the events that Hieronymus Bosch wants to depict.

* *See the top right-hand corner: the genius of mankind floats down with fish and crow and the genius of the earth strives upwards with the sphere of the illuminated earth; above them in the etheric sphere, sovereign and in infinite peace, is the great fish.*

** *Ichthys is an early Christian anagram: Jesus Christus Theou Yio Soter—Jesus Christ, Son of God and Redeemer.*

The Last Judgment
Bruges

The elements of which this painting is composed
are already largely familiar to us. Nevertheless,
the usual unity and inner cohesion that form an
essential part of Bosch's other works are missing.
It is considered to be one of the later works
because of the painting technique.

On the central panel, Christ is enthroned on the
rainbow within the sphere of the sun, the earth
serving as a footstool. Christ's aura stands out only
weakly against the sun's brightness. Here, too, Christ
is surrounded by angels and saints but the effect
is not very convincing or moving. Below, on the
banks of the cosmic ocean, the burning earth is
depicted once again and the jaws of a whale with
sail and armored helmsman serve as a craft on the
ocean: the opposite to Jonah and the Whale.

A peculiar procession is wending its way toward
the abandoned tower on the right-hand panel. The
rider with chalice, pot of pitch and lance, familiar
to us from *The Haywain,* now carries a cockerel on
his helmet. The cow has been harnessed to a cart
that is loaded with a pair of clerical lovers in a pot.
The whole scene appears to be a caricature of the
process of incarnation depicted in *The Haywain:* the
cow is turning away from the tower and does not
want to take its rider there.

Two-thirds of the central panel is taken up with
events in the kamaloca world. This may indicate
a painting by Bosch, but its composition does
not suggest an original. The focus of the kamaloca
scene is the lantern in which a cardinal becomes
the victim of ghostly ladies. Above it, the bagpipe is
sitting on the firm base of the millstone, on which
naked figures are performing a dance. Harp and
lute are suspended to the left and the right, with a
crucified figure on the former and an owl in the

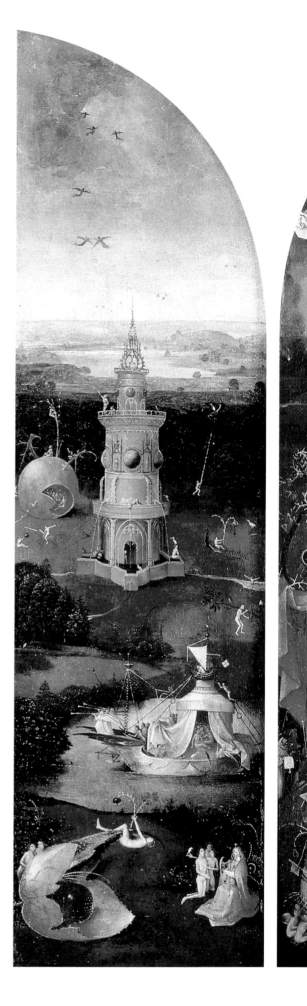

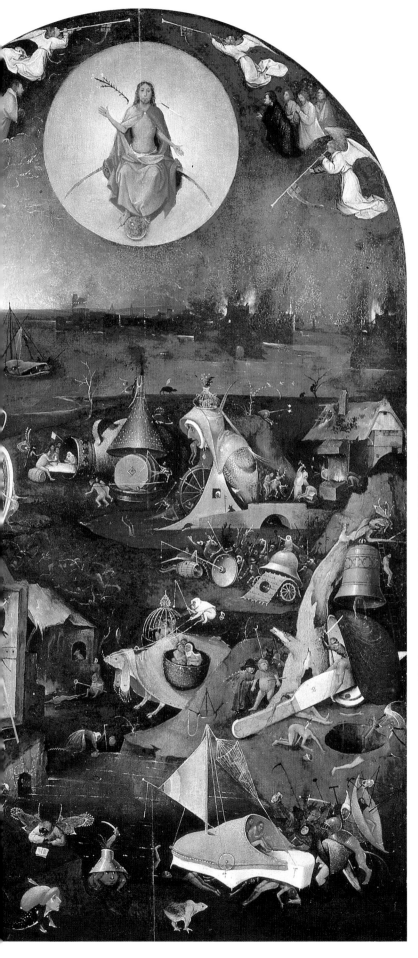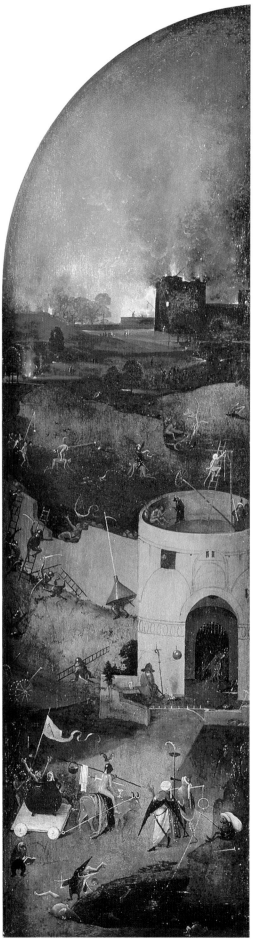

soundbox of the latter. Again we encounter dilatory persons being shod as well as many other beings with whom we are already familiar. The chasm here is dried out and filled in and leads nowhere. A naked soul is being persuaded by an inquisitor to allow itself to be tortured voluntarily for its salvation.

The spring of life in the center of the left-hand panel is earth-colored* and embellished with dragons and waterspouts. A human being on the tower keeps watch but does not notice the dark soul-birds flying on high. Next to the spring a red fruit that has been eaten into is home for a group of people. Some of the people are climbing onto thorny creepers that pierce the fruit. In front of this, a rider on a unicorn directs a naked figure dragging an iron ball along toward the fountain of life. A rider on a peacock presents a new motif. He is holding a panicle that has a fruit of the heart hanging on it that turns into a testiclelike formation.

A winged boat with a rose-colored canopy and trumpeting angel on its bow is landing in the bay. An angel is pointing a small cross toward the naked figures sitting under the canopy, who are making no move to leave the boat.

The fountain of youth seems almost empty of people. At the bottom a mere couple is hiding by the large, shimmering, and poisonous deadly nightshade. Someone is trying to climb up the underside of the thorn of the fruit capsule to catch a berry that has not grown there. The gross angel adorned with a cross to make him recognizable as such, with his strange peacocklike wings, is also part of the deadly nightshade group. Devoutly he plays his lyre to the group of the faithful but they do |not seem particularly moved. Significantly, the angel is wearing a brooch decorated with the star and the crescent, the sign of the infidel.

What religion are we really dealing with here? Neither the worthy angel, the poisonous berry, the earth-colored fountain, nor the dark soul-birds high in the skies can create the illusion of a celestial region.

We are on the lookout for the initiate, the Treeman, or another key figure who, even if unobtrusively, might make the scene comprehensible. It is certainly not the demon hermit with dark hat and hidden bird's claws in front of the ghostly tower; the bent cross at his side gives him away. This painting seems to be in demonic opposition to Bosch's other triptychs. In this capacity it is listed here and discussed in detail.

* In other cases the spring of life shines in etheric rose-colors (Hortus Deliciarum).

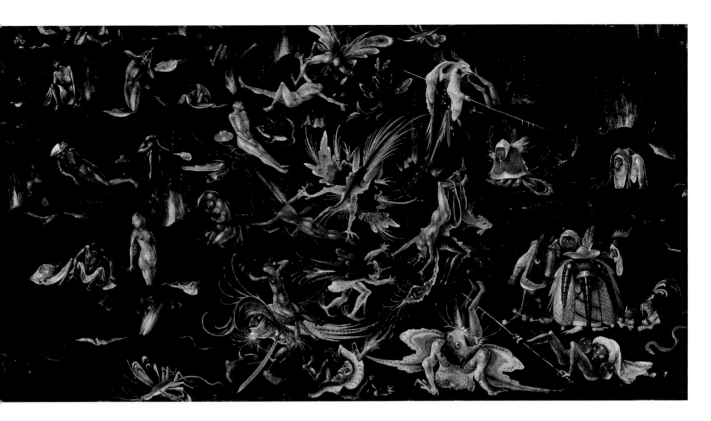

Fragment of a Last Judgment
Vienna

After the devilish apparitions that we have come across in Bosch so far, this fragment must rank as the perfection of his demonology. It is a pity that so little remains of the painting, for the tonality of the colors is new and promising. It indicates an enhanced technique and an expansion of consciousness. This relatively small fragment shows Bosch's power in full, something that is decidedly missing in the previous work. This world has been experienced, not copied. Many new figures that have not made a previous appearance can be seen here. We are thus presented with a colorful tapestry of hell, the delicate colors of which stand out strongly against the dark background. The colors have an attractive effect in spite of the subject, which is anything but cheerful, and they produce an unusual and peculiar mood in this hellish landscape.

The soul's awakening on this continent is a shock. We see how the highest dignitaries of spiritual and temporal might wake up to their new existence. They seem to be rising out of the ground in a complete darkness that is illuminated only sparsely by dull flames. They feel the firmness yet all things earthly are missing. Their new environment is unknown to most of them, and they have no idea what awaits them. The old habits die hard; they are concerned for their crowns, the tiara must be properly adjusted on the head, and the cardinal's hat, too, must not be allowed to become lost. Some look upward in doubt but there are others who are already pondering their past. The one thing that they all have in common is their isolation, their individual isolation, until the beings of hell, who are quite convivial among themselves, grasp hold of them. There are no physical tortures here, only tortures of the soul: pangs of conscience, loneliness, despair.

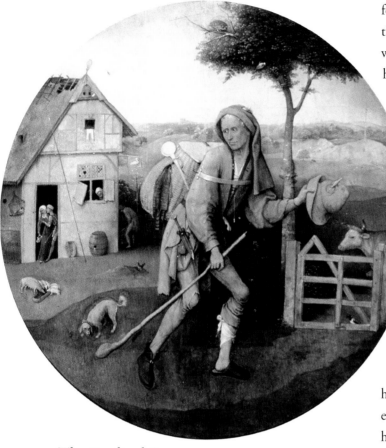

The Prodigal Son
Rotterdam

The first version of the Prodigal Son motif is painted on the outside of the *Haywain* triptych. There the depiction is still hard and stiff and has more of a descriptive character. Here, in this painting, the same subject has ripened into a complete experience as a painting. We are moved by the figure of the Prodigal Son because his countenance lets us see a human being who has lost his faith in the world, who has suffered pain and disillusionment, and who is now ready to take leave of the bustling haywain of the world in order to seek the world of the Father. We are moved by the universal nature of this destiny because we feel how much it is a part of every person's destiny.

The bandage on the left leg appears as a dressing for the wounds of destiny. It is not the bandage of the higher consciousness of the Treeman. The wanderer looks back and sees how his abandoned house has fallen prey to vice. It is like a premonition of his own death and a look back at his past life on earth. Wertheim-Aymès compares him to the Treeman, who in life already had a vision of events after death and who experienced on earth what is normally experienced only after death. In this sense the dressing of the Prodigal Son corresponds to the holy bandage of the Treeman. The Prodigal Son still has the heavy burden of his destiny to bear, which he carries with him in his basket.*
The burden gives him a tragic expression: he has to take too much of an untransformed nature across with him.

The lance of personality leans crookedly against his house and the upside-down jug on the gable end indicates that service is no longer available here. At the gate his tree of life is a healthy green, but its trunk shows the crisis that he had to pass through in mid-life. An angry owl sits in its branches and does not want to let him go, despite the fact that he indicates himself that his thread of life has run out. There was much conflict in his life, as his soul-bird shows; the black and white magpie is depicted twice: in a cage at the house and in freedom at the gate, waiting at the threshold. The gate at the threshold tree separates the wanderer from the eternally green, living etheric world. Present again is the cow that carried him down into the tower of the body at his incarnation (see the right-hand panel of the *Haywain* triptych). The cow is the animal of the Egyptian goddess Hathor, of divine nature.

* *The carrying-basket also appears in the painting* The Last Judgment *in Vienna in which the spirit of Bosch's youth receives insight into the spiritual world through a demon.*

The Adoration of the Holy Child
Cologne

A cool dryness pervades the language of form and color of this adoration, which is likely to be among Bosch's last. The simplicity of the depiction makes the inwardness of the painting particularly moving. The presence of ox and ass at the manger appears to be of special import to the painter. Mary, her soul completely immersed in the child, is seen to be very close to the being that is related to the cow. The posture of the donkey, the animal that has to bear all the burdens of earth and does so willingly, is reflected in Joseph's countenance. His face is given portraitlike prominence, and he is ensouled by the pensiveness of long earth experience. A shepherd with a covered head, hardly daring to approach

the miracle of the birth, joins Mary and Joseph. The Virgin's white mantle stands out noticeably against Joseph's rose-colored garment. The child shows unusual alertness. Its aura is formed by the few stalks of corn on which it lies:

—the child who will give us bread—

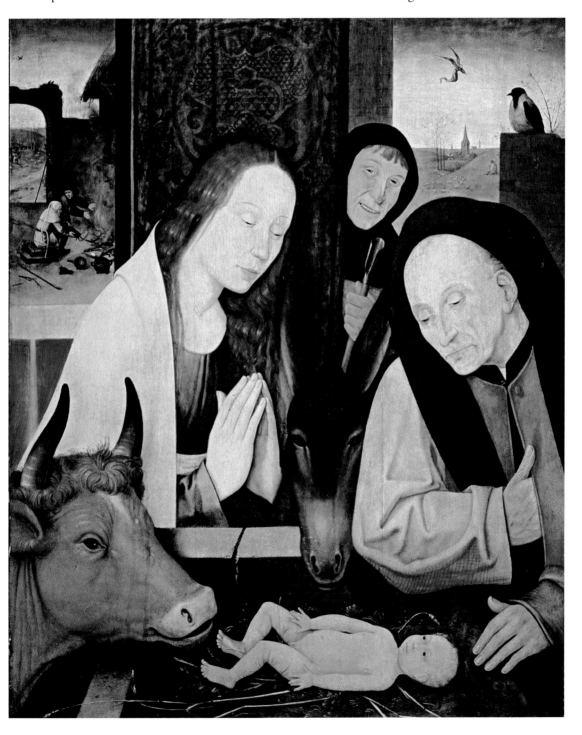

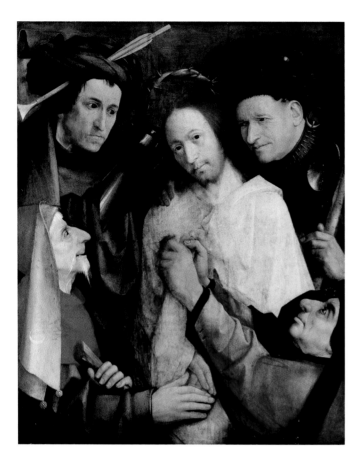

Christ Crowned with Thorns
London

Those who know Bosch only as the painter of demons should study the painting *Christ Crowned with Thorns*. There is nothing didactic in Christ's countenance; only life and substance stream from his gaze. It is one of those paintings of Christ that is untouched by any concept of God tied to specific confessions. It must be classed among those paintings of which Rudolf Steiner says: "A history of the world through the transformation of depictions of Christ should be written. Everything that really took place is expressed therein…."

Four men who cause him pain and suffering surround the suffering Christ. The forces of feeling, the intellect, the soul, and consciousness are at work in them, forces that must appear inhuman so long as they are not permeated by the power of

the divine "I." Thus a man, still caught up in blood-bound feelings, tears the clothes off Christ's body with his rough, fleshy hands to convince himself and the world that there is nothing divine in the body of the Messiah and that he, too, is mortal.

To Jesus's left, Caiphas represents reason personified, purely intellectual, physical thinking that leads to pride and premature aging in its inflexibility and rigidity. Crescent and star are woven into his red headdress, the sign of former mystery knowledge that is no longer present except vaguely and indistinctly. Nevertheless, there is a cross below them, even if it is hard to see.

These two Jewish representatives have their counterparts in Pilate's two Roman soldiers. They take part in the crowning with thorns not of their own volition but in the service of temporal power. The one on the right, wearing the oak leaf of chivalry, looks at Christ with deep feeling and compassion. But his conscience is inhibited by the spiked collar of his sense of duty.

The man on the left with the clear gaze and noble, well-formed features succumbs equally to earthly consciousness. The arrow of habit in his turban prevents him from rising to higher insight. He is aware of his weakness and his ironclad fist places the crown of thorns on the Lord's head.

The divine "I" stands at the center of these four aspects of consciousness and unites them in himself:

> feeling fettered to the body,
> intellect tied to the sense world,
> compassion arising from the forces of the soul,
> and growing self-awareness of the Self.

These four soul-forces are transformed through Him into profundity, clarity, love, and goodness.

Diagonally facing one another are feeling and consciousness, intellect and soul. The divine "I" forms the crossing point as their quintessential nature.

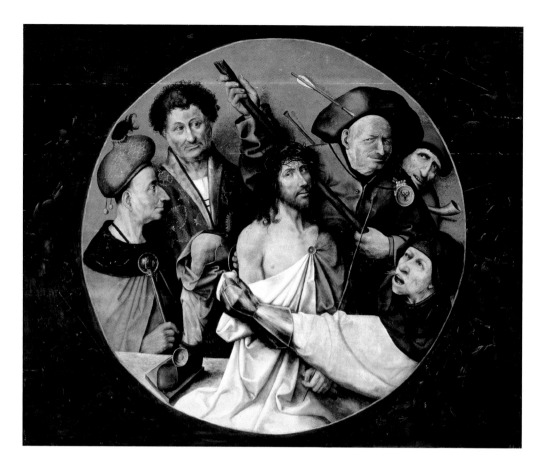

Christ Crowned with Thorns
Escorial, Madrid

Quite a different mood prevails in this painting of *Christ Crowned with Thorns.* The use of the colors is surprising. So is the gold background of the tondo. The square outer frame depicts the battle between the angels and the devils in grisaille.

Is Bosch hinting that the final consequence of events that began with the battle in heaven is the crowning with thorns and the crucifixion so that mankind can be saved? The figures surrounding the suffering Christ are divided into groups on the right and the left. On the right are the soldiers whose archetypes are the evil fellows in the tondo of *The Flood.* Thus we see the uncontrolled will (pig-snout demon) with its foot on the table, the perverted feeling with the iron fist (monkey), and the sclerotic thinking with the horn (spoonbill-demon). These three want to grasp the divine "I" and steal it from mankind. Icy coldness and burning greed are united in the figure of Caiphas against the wisdom of Christ, for which his powerful

will is no match. The cut of his hair, full of suppressed passion, shows the extent to which his thinking is inflamed with emotion. He carries the staff with the horned Moses in a crystal sphere as a sign that the spiritual authority of his time is invested in him. Facing Caiphas is the representative of temporal power, bearing the twin-headed eagle, who carries out his decisions.

Next to Caiphas stands a person who is immersed in the events with a serious, observant expression. He has grasped the words of the Lord: "Father, forgive them, for they know not what they do." This figure, with his uncovered head and curly hair, stands out from the gold background as a self-contained personality. The face has the strongest portraitlike character of all the faces in the painting. It is rightly assumed that this is Bosch himself, who here experiences the stage in Christian initiation of the crowning with thorns.

In the light of the golden background, the bareness of Christ appears even more human here, the suffering that is inflicted on him by a mankind turned demonic even greater.

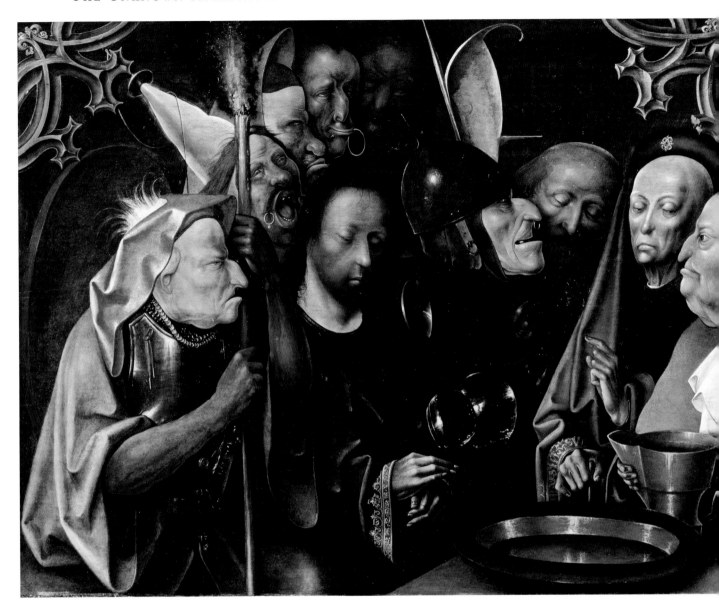

Christ before Pilate
Princeton

The sections of bright red of the head on the left and of Pilate contrast in a peculiar manner with the deep black background. The same is true of the shining metal instruments, the iron breastplates, the silver helmet, and the golden basin.

There are three groups of three whose deepest nature is unleashed. Christ is in their middle. He makes a strange gesture with his hands that corresponds curiously with Pilate's, as if it were

Christ and not Pilate who washes his hands. Pilate's attitude is serene; he is surrounded by his advisers, and his steward whose only concern is to preserve the status of their master. His background has deprived him of any feeling of responsibility to take positive action in favor of Christ: he makes his judgment—and washes his hands "in innocence."

The three accusers and their accomplices appear like masks. Pilate's statement, "I can find no fault in him," is not enough to exonerate him from the guilt of his knowledge.

Christary Bearing the Cross
Ghent

If in the previous painting we admired all the splendor of the colors and the interplay between light and darkness, then the present painting requires a different mode of observation.

Here we are dragged into the midst of the tumult of the thoroughly aroused throng. Where previously a neutral attitude toward events was still possible, we cannot remain neutral in the face of this commotion. The outer splendor of the colors appears subdued. Heads and hands become the main means of expression in the agitation, the actual bodies become invisible in the jostling. A climax of dramatic expression is reached in this last painting by Hieronymus Bosch. Everything human is relinquished; the human form becomes the possession of demons. Leonardo da Vinci's sketches come to mind, in which he studied the degree to which the human form can be distorted.

The individual characters are beyond description. It is above all the nose, the organ of character and true judgment, that has degenerated into terrible tumors and growths. Its real form in the human countenance can be seen in the figure of Christ and St. Veronica with the shroud.

Christ, the real focus in the surging mass, seems forgotten in the swell of excitement. With complete inwardness he concentrates silently on emptying to its dregs the cup of suffering proffered by mankind. His physical body is almost transparent, and the observer might well ask whether it will survive to the bitter end.

The diagonal line of this painting, starting in the top left-hand corner and indicated by the cross, ends in the bottom right-hand corner with the unrepentant sinner who clings to his hate in the face of the hate of his executioners.

The other diagonal starts at the top with the repentant sinner, who meets such a surge of fanaticism from his confessor that he gives the impression of being submerged by the decision to turn to the Lord. This line, which has Christ at the intersection with the other diagonal, ends at the bottom with St. Veronica. She bears the image of the Lord on her shroud. It becomes part of her and she preserves it for posterity as Vera Ikona.

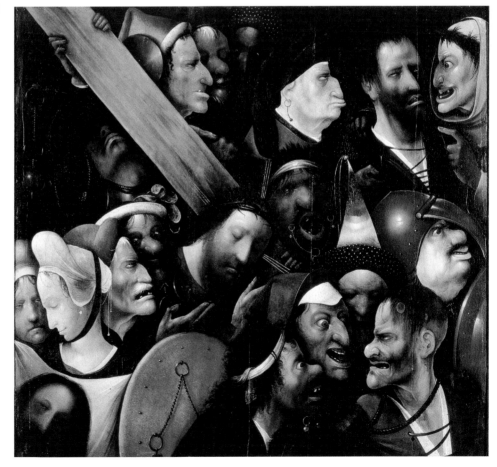

THE WORK
OF THE MASTER

HIERONYMUS BOSCH'S CONCEPTION OF THE WORLD

The origin and authenticity of The Last Judgment in Cairo

The question as to whether the triptych in Cairo is an original work or a copy has been deliberately avoided so far. First, the reader was to be familiarized with Hieronymus Bosch's works and introduced to the content of this *Last Judgment.*

The discovery of an unknown painting by Hieronymus Bosch rarely occurs these days. It is particularly surprising when this is reported from the land of the Pharaohs. The skepticism displayed by the experts in this respect is not hard to understand, as many imitations of Bosch's paintings already exist in the world.

Yet if we are not dealing with an original here, something that can only be proved conclusively by laboratory tests, the question remains of which unknown original this is a copy.* The current state of the painting, with its seemingly hasty execution, does not allow us to assume a work by the master or of his studio. Be that as it may, the painting should be examined to discover whether the inferior brush technique might not indicate that it has been painted over and whether the brush stroke of the master may not emerge from beneath.

The clarity and naturalness of the painting's composition exclude the conclusion that this might be a work by one of Bosch's pupils or imitators. Rather—and this is shown by the way that the sub-ject is treated—it seems to be a continuation of his previous work in that it is closely connected with *The Seven Deadly Sins and the Four Last Things,*

* The Last Judgment *painted for Philip the Beautiful in* 1504 *(3.0 x 3.6 meters) has been lost.*

The Last Judgment in Vienna, and, above all, *The Garden of Celestial Delights* in Madrid. As mentioned earlier, almost all the details on the panel depicting hell are taken from the latter.

The objection that we are dealing with an international fake in which elements from the other works have been arbitrarily copied in order to avoid discovery cannot be sustained, particularly as the painting contains important motifs that do not appear in the other works. Furthermore, the overall composition is anything but arbitrary. On the contrary, it is executed with the kind of inner coherence we would expect to find in Bosch, in which all the elements are justified and necessary. Of greater importance is the fact that the elements from other paintings, with the addition of completely new motifs, are restructured to deal with the subject in a way not attempted before. This creates something new, something in its own right, that indicates a further step forward in the wisdom of the master. Only a very superficial view would maintain that this is a forgery or a work by a pupil.

The increasingly lucid consciousness in the countenance of the Treeman—the true key figure, viewed in connection with the resurrection in the flesh—and the realistically depicted entry of the spirit-souls into the sphere of the flesh on the left-hand panel are in themselves enough evidence that this painting cannot be imitation. Nor is the objection that Bosch never repeated himself, never used the same elements twice (cf. the repeats in *The Last Judgment* in Bruges) very accurate.

Many scenes in this painting, such as the rearrangement of the instruments, the change in the face of the Treeman, the division of mankind into the streams of heaven and of hell, the leading hare-being, as well as the ascent and entry into the reign of the Ichthys, bear witness to Bosch's esoteric wisdom. The condition of the painting forces us to disregard in the first instance painting technique and aesthetics in our examination of the painting and to concentrate primarily on the content. Bosch's hand as we know it is clearly not apparent here, but his spirit is unmistakable.

Only recently has it become possible to throw some light on the history of the painting. It can be traced back as far as 1870, when it was in the possession of the respected Lucerne family of Kaspar Pfyffer, town clerk of Altishofen. In 1895, the painting was inherited by the Degan family of Lucerne. In 1902, the Degans gave it to their son, Dr. Louis Degan, then in Cairo, as a wedding present. In 1936, it was bequeathed in Cairo to the local museum of modern art.

Problems of chronology

The observer of the painting soon notices a certain lack of uniformity in the style. The depiction of the celestial scene on the central panel might appear somewhat antiquated at first glance. That places it in strong contrast to the realism in the rest of the painting. The saints and angels surrounding Christ are depicted in an almost traditional style so that the contrast between the upper and the lower sections of the painting gives rise to the suspicion that it has been painted over. But if we immerse ourselves in the timeless figure of the cosmic ruler in all his grandeur, surrounded by the celestial aura, such ties of tradition must be out of the question, as is the suspicion that an unauthorized hand was involved.

If we compare this painting with the *Hortus Deliciarum* in Madrid, which depicts cosmic and planetary states, we will find, to our surprise, that the creation in the latter is painted in an almost traditional way. Might it be the case in both that it was necessary to use different forms of representation? Might it be the case that it is the contrast

between the form of the old beliefs and the new language of the spirit that is to be expressed? After all, new knowledge requires new forms of expression.

Be that as it may, the fact that the elements of the Madrid painting were incorporated in the Cairo one and made into a new composition through the addition of fresh elements shows that this work was created after the *Hortus Deliciarum*.

The chronology and its consequences

If we were to make the assumption that *The Last Judgment* in Cairo was painted before the *Hortus Deliciarum*, we would be faced with the following contradiction: the musical instruments, which are not grouped around the Treeman in Cairo but are spread out on the side panels, are then regrouped around the Treeman on the Madrid hell panel chronologically later than the Cairo painting. As a consequence there would no longer be any inner connection between the view that the instruments have separated from the Treeman, the ego proper, and the fact that they are a symbol for the fate of the egoless human beings at the millennium. This chronology would therefore represent a regressive development that would stand in inner contradiction to the awakened countenance of the Treeman in the Cairo painting.

The relationship between the two paintings can be characterized in the following way: the Madrid painting depicts the drama of mankind from a cosmic-planetary standpoint, as the fate of the earth and the cosmos in equal measure. The Cairo painting, with its depiction of the Last Judgment, makes human beings the focus of events. They experience the Luciferic and Ahrimanic destiny of mankind in apocalyptic fashion. At the same time they see human beings who have acquired a spirit-body leave their earthly forms behind and follow the path to

the Ichthys: earth-ego is transformed into spirit-ego.

The *Hortus Deliciarum* in Madrid undoubtedly represents the quintessential nature of Hieronymus Bosch's encounter with the wisdom of the grand master Jacob Almaengin under whose influence he stood both directly and indirectly. The esoteric processes that form the basis of this spiritual vision can be seen jointly in the youth who looks into the devachan sphere and the Treeman depicted on the right-hand panel—his reflection. *These two visionaries must be seen as one, as two aspects of the spiritual achievements of one human being, achievements that are revealed in different elements of his being.*

In contrast, the Treeman in the Cairo painting awakens to his vision without the help of a companion soul and without casting off his earthly persona. He unites what is still expressed as a division in the two figures of the *Hortus Deliciarum*.

The Last Judgment in Vienna also depicts a meditating person who stands in the foreground of the overpowering kamalocan events. With him is the equally insignificant spirit of his youth who, with demonic assistance, has glimpses of these spheres.

Three stages of consciousness can be recognized in Bosch's development if we look at the three works in Vienna, Madrid, and Cairo together. The first was reached with the aid of the spirit youth. The second, the initiation achieved with the help of the grand master, opened up the angelic being in him. The third stage is revealed in the Treeman whose "I" has awoken and who experiences himself and human destiny as a disciple of Christ. On the basis of this analysis, the Cairo painting must necessarily be dated later than the *Hortus Deliciarum*.

Yet it might be questioned how the Cairo painting, in its simplicity, can be seen as a culmination, indeed, as the crowning achievement of Bosch's life in contrast to the riches of *The Garden of Celestial Delights*.

As mentioned earlier, the abundance that can be experienced in the *Hortus Deliciarum* does not arise from Bosch's own spiritual vision; the richness that the painting reveals still remains a gift of spiritual guides through the grand master Jacob Almaengin. In contrast, the depiction in the Cairo painting corresponds to Bosch's own strengthened consciousness and is thus an enhancement of the threshold experience of a Christian initiate who wears his band of wisdom with some justification.

In conclusion, the question needs to be answered as to how the Treeman in the Cairo painting, with the millstone and bagpipes on his head, can be described as an initiate, since it is well known that Bosch always depicts on the head of the individual the thoughts and feelings that can be found within him.

This is a valid objection. The answer is that the Treeman, with his penetrating and alert gaze, has already overcome inwardly the things that his outward existence still forces him to contend with. This human being is in the process of shedding his mineral body, of leaving the grave of his body; the Last Judgment has begun for him. Everything of an external nature has become part of the past and no longer counts.

Hieronymus Bosch's method of depiction

The way in which all the elements are thrown together seemingly arbitrarily is characteristic of Bosch's work. But detailed study shows how each object is placed organically and by no means arbitrarily within the composition. Everything is linked by an inner logic that is familiar to us only from dreams. The smallest of scenes has its focus and its corresponding surroundings. Nothing appears contrived and his demonic beings look just as real as his depictions of the ordinary world. By

this means he can make transitions from the drama of hell to the most peaceful landscape without us becoming aware where one ends and the other begins. He uses nature as a backcloth for the soul, as an expression of the action. But this never appears forced, and nature willingly serves as an expressive means within its designated framework.

Bosch has been described as the foremost landscape painter of his time, although he is basically neither a landscape painter nor a romantic artist. Nature mirrors its content for him and provides the right atmosphere for his paintings. But it serves gladly because it is enhanced and not degraded.

Bosch can be described as a moralist just as little as he can be classed as a naturalist. It was widely believed that he created his abominations to deter people from evil. But he neither invents nor uses symbols nor moralizes in the conventional sense. His essential problem is: How can I create the correct form for my experience? He is struggling for unity of form, color, and content in order to give unfalsified expression to his vision. He is faced with the great problem—as is every artist and researcher of the spirit—of putting supersensible subjects and experiences into forms that belong to the physical world so that his fellow human beings can experience them in the right way. The seriousness and the truth of these supersensible experiences must be evident in such forms if their content is to be taken seriously—seriously in the way of dream experiences, of a hidden reality.

Dreams—as we know—are symbolic, filled with the sap of life, neither dull nor dry, and unrestrained in their construction. Their material is memories found in the subconscious. They use these memories in accordance with their own logic. This mise en scène provides the basis for what the dream wishes to impart. The same dream technique can be found in Bosch. He combines fantasy with reality in a way

that is only experienced in dreams. Thus he paints things in his aberrations that are essentially part of another world but that need to, and must, find expression. What the psychoanalytically trained observer will see as symbolic-allegorical elements, capable of psychostructural interpretation, are subject to the control of the principles of dreaming in Bosch. His paintings relate a spiritual realism that is enhanced by the dramatic nature of his colors.

His early style still harks back to illustration as the legacy of miniature painting. But very soon his painted accounts become filled with drama. He has a peculiar relationship with painted space. Basically, Bosch is not interested in the logic of spatial perspective. Anatomy and special perspective, the main problems of the Renaissance, do not concern him. He creates depth in his paintings by stacking one plane on another. In other words, spatial depth becomes layer upon layer of surface. Three-dimensionality is not the focus, as it is with his contemporaries. Structure and monumentalism are foreign to him.

Above all, Bosch creates his spaces through light, through the successive illumination of various planes of the painting. The middle panel of *The Last Judgment* in Vienna serves as an example. At the bottom, everything is submerged in bright daylight. This is followed by half-light that turns into darkness only lit up by fires. In the upper part, this has become celestial brightness. The colors, too, have a three-dimensional effect. The colors create spatial depth and guide the observer away from the foreground. Thus it is not enough to speak only of parallel planes; we also have to take account of parallel zones of color in which the planes are submerged. One can see why C. de Tolnay speaks of Bosch's negative attitude to space and reality.

The horizontal lines and aerial perspectives act on the eye like a mirage without the dimension

of depth. The colors are more in the nature of soul qualities than physical reality. The transparent shadows have a similar effect. These are not physical spaces but dimensions of the soul. We can understand therefore why Bosch is considered to be an anti-Renaissance artist who casts doubt on space as the one and only dimension.

The strong impact of the painting is achieved by the effect of the colors in their own right. Bosch has been described as a color symbolist, but he is more correctly described as a color realist, addressing the observer with the immediate effect of the colors. Observe the wisdom that Bosch can transmit through the nuances of color—the red in the garments of the various figures, for example. It becomes apparent that we are not dealing with mere color symbolism but with a direct experience of color: the colors do more than symbolize; they are part of our experience! The colors also express inner relationships by using similar tones to depict spatially separate but internally linked events. Examples of this are the rose color in the Christ figure and the fountain of life in the paradise scene of the *Hortus Deliciarum* and the carnation red of the canopy and the sails on the two side panels of *The Last Judgment* in Cairo.

It is easy to understand that Bosch, as a painter of threshold experiences between the spiritual and the physical world, cannot restrict himself to the use of purely optical colors but has to use colors that reflect such transitional states in a convincing and real manner. In this context we speak of alla prima painting, which attempts to deprive figures of their solidity, to turn them into phantoms, and to make them melt into a landscape that is equally insubstantial *(Hortus Deliciarum)*. There is also the soft style that tries to place greater emphasis on the meaning rather than the figurative elements. At the same time we must also mention Bosch's flamboyant

style, which is less heavy and monumental and uses color to affect the observer *(Haywain)*.

Drawing from nature, of which Dürer is the foremost exponent, is essentially foreign to Bosch the esotericist. He does not use outer models in his paintings as the Renaissance painters do. He certainly made studies of movement but not purely anatomical ones. A purely secular art in this sense, as can be found in Dürer, is unknown to him. Spiritual and secular subjects are not mutually exclusive, and realism is never an end in itself. Bosch uses only the latter to achieve the best possible mode of representing the subject matter of his paintings. Genre painting arises through and after Bosch, but he never practices it himself.

Jacques Combe, the Bosch scholar, describes Bosch as simultaneously innovator and late arrival, situated between the Gothic and the Renaissance periods: "He is of relevance to us because he represents an age that is passing through a period of spiritual insecurity, like ours, and that is characterized by common norms being breached."

Combe continues: "The symbol in Bosch is not an allusion but exists as a language in its own right, arising directly from the source where thought is formed." The nature of this source is shown in Bosch's imaginations.

Art historians think that medieval art was primarily communal art with common standards, similar to the guilds that existed at that time. Bosch begins to break out of these standards even where he uses the models of his predecessors. In particular, he uses the subjects of miniature art. We are quite right to ask whether his world of demons is not fundamentally based on the bizarre, Romanesque imagination. The ghost world of the Romanesque period—in contrast to the world of the Gothic period—possesses the same reality as our own everyday world. This world becomes more moral in its aspects during the Gothic

period, and, later, caricature and social criticism become established by way of the personification of the vices and the virtues.

But the origin of Bosch's inhuman machines, his synthetic demons, and biomechanical ghosts, remains a riddle. Such creatures did not exist in painting before Bosch. Wilhelm Fränger speaks of his symbols as "revelations of secrets that contain elements of the coming apocalypse." They appear on the Vienna *Last Judgment* for the first time, as well as on the *St. Anthony* altarpiece. Perhaps the ghostly figures and creations remind us of elemental beings perverted by man that have come about because of the spiritual emptiness of our world of ideas. Fränger's words might be understood in this sense.

This brings us to the concept of magical realism, a concept that was known to exist in ancient Egypt. The so-called Ka statues had to replicate exactly the former earth form of the deceased if they were to mediate between the soul, the Ba bird of the deceased, and his former physical body, the mummy. Only in this way could they act as magical media. Bosch chooses his symbols with the same, almost pedantic, exactitude. His diverse animal and plant symbols can be precisely classified zoologically and botanically. We are also reminded of the medieval teaching of the signatures with its law that like cures like. Such precision was necessary if the essence and the healing power of the objects were to be acquired. As was stated, "The thing itself contains the idea," that is, the potency and effectiveness of the idea. Bosch makes us recall this *Scientia signata,* for everything is related to everything else and nothing is arbitrary. But a special schooling had to be undergone to enter this world fully, to gain knowledge of its laws. Thus his paintings, too, require such preparation; they were not painted for the unprepared.

Bosch had to present much of his message to the world in the form of apparent drolleries; after all,

the Inquisition was at its height. In that period only the wise man who played the fool could endure, for fools were given free reign even then.

Hieronymus Bosch's sources, the contemporary painters, and his influence

Bosch is rooted in the provincial art of his native region, but even in his earliest work there is no direct connection with the great painting schools of Europe. At the start of his career the masters of Bruges, Ghent, Louvain, Haarlem, and Delft painted in accordance with the principles of the Master of Flémalle and Jan van Eyck. Besides the obvious influence of the miniaturists, the influence of the painters Dieric Bouts, Justus of Ghent, Hugo van der Goes, Hans Memling, Rogier van ger Weyden, and Robert Campin are all thought to have been discovered (Baldass). Yet Bosch went his own way despite this. Bosch's work aroused great interest among the noble and ecclesiastical art collectors of the sixteenth and seventeenth centuries. Painters all over Europe also became interested. They include names such as Lucas van Leyden, Quentin Massys, Jan de Cock, Patinir, Jan Mandyn, Peter Huys, Elsheimer, Bruegel the Elder, Hieronymus Cock, Tenier, and Brouwer. Even El Greco appears to have been inspired by Bosch. Lucas Cranach copied him. His influence can be found in Altdorfer, Giorgione, Rubens, and Rembrandt.

Bosch was much discussed by the Spanish and Italian writers of his century but during the eighteenth century he sank into obscurity. Historians rediscovered him in the nineteenth century, and in the twentieth he was a revelation to the surrealists and Freudians. Some claim that his greatest achievement was to prepare the way for those geniuses of Flemish painting, Bruegel and Peter Paul Rubens, but this judgment is made only from the confines of art history. There is considerably more to Bosch than that.

Hieronymus Bosch as the father of surrealism (Or: The misinterpretation of a world view)

It has become very fashionable to make Hieronymus Bosch famous by describing him as the father of surrealism. It is, of course, worthwhile on the whole to cast one's eye back to the venerable progenitor. Yet there is also much falsification of pedigree in the intellectual field. From a purely superficial perspective the compass of his creation might well qualify him for such an honor, for surrealism also attempts to move away from a superficial naturalism, from a world in which human creative forces are degraded to the level of merely copying the external world— a field in which modern reproductive techniques have long reigned supreme.

Yet an investigation of the content of Bosch's works and of the worlds he reveals demonstrates the following: a comparison between the experimentation of the surrealist school and the world that forms the foundation of Bosch's painting makes it clear that the choice of this patrimony for such modern excesses is not a happy one—even if that school could greatly benefit from such a spiritual foundation. From an objective point of view, there is no common ground between the worlds from which Bosch draws his inspiration and the phantasmagoria that seek to come alive in surrealism. His madness comes from being transported to higher worlds of which he brings the content as an unfalsified gift. He gives true dreams, not nightmares! In the final instance, the criterion for relatedness must be based on the sources of the inspiration!

Apart from the slick but empty platitudes of a Salvador Dali and of those who copy him, the

fantasy and dream world that the surrealists create is the product of an uncultivated and chaotic consciousness. Although it may shock the bourgeoisie, this art is not capable of giving form to spiritual experiences. It provides poor nourishment for human beings in spite of its apparently strong effect. A chasm opens up between Bosch and this school that is like the chasm between real imagination and fantasy. Franz Kafka would be eminently suitable as the progenitor of surrealism. He, too, inhabits a similar shadowy world: not of spirits but of ghouls. It is not for nothing that a link has been forged between surrealism and psychoanalysis, which has no access to the objective spirit, as it were, but must be content with revelations of psychological structures instead of developing moral consciousness through self-knowledge. Yet such subjective revelations provide great relief to their subject by being objectified in this way as the inadequacy of human beings.

Imaginations or decadent visions?

Is there any justification for describing the paintings of Hieronymus Bosch as visions of an atavistic nature? Painters whose work shows such apparently atavistic content generally have a quite specific attitude to nature. Such artists are caught up in their visions and driven by their intuition. They cannot stand back from their work and have to paint as those intuitions indicate. When nature takes a more central place in such works, which does not happen that frequently, its representation occurs in a curious way: a freshness is lacking; it is as if nature were degraded and robbed of its innocence.

In contrast, the whole of Hieronymus Bosch's work depicts the true, undistorted essence of nature, which reflects the events in the foreground as a unifying backcloth to the soul. Nature, selfless and naïve, serves as a counter to the mostly dramatic events taking place in the foreground to which it gives depth in a refreshing and satisfying way.

It is certainly most rewarding to look at the role that nature plays in Bosch's work and the way he deals with this subject. In this connection specific mention should be made of *The Temptation of St. Anthony* in the Prado in Madrid, in which St. Anthony overcomes his own transfixing devil and sets free the retreating host of elemental beings in a pacified natural setting: a painting of the saint's inner vision. In the Prado *Epiphany,* nature, which provides the setting for the holy events, also calms the tension between the pious adoration and the jealous and impotently furtive stare of Herod and his court in the background. Here the de-demonizing role of nature—essentially its true function—becomes particularly clear.

These transitions between demonic furtiveness and the calm textures of nature show Hieronymus Bosch's sovereign command of the demonic worlds. Such an attitude, self-assured and at one remove, is by no means self-evident in the visionary artist, and such a visionary is not always a freely creating artist; he does not know the contemplation of, and loving attention to, the phenomena of nature.

There are many examples of visionary artists in the history of painting, particularly in modern times. Marc Chagall's works, for example, are full of atavistic-visionary elements. In his paintings nature takes on an astral dream character, and he uses it to symbolize his dreams. This, of course, by no means contradicts his mission to recall the reality of human dream experiences to consciousness! The painter Franz Stückgold should also be mentioned. He composed wonderful still lifes with flowers, but they no longer possess that real plantlike innocence and have already been penetrated by an astral world that is fundamentally foreign to them.

Without doubt, Salvador Dali has been supremely successful in cultivating enigma in his work. He

subordinates nature and its creatures to his fearsome effects. We may be gripped by real fear when it becomes apparent in Dali's paintings that even nature, peaceful and innocent until now, has become unbalanced, or at least can be made so (see *The Burning Giraffe*).

Returning to Bosch, it is worth looking at the self-portrait that he painted at the age of sixty—the charcoal drawing of Arras—in which his clear gaze encounters the world full of freshness. His sovereign manner, which displays absolute freedom, places him among those luminaries of mankind who have found their inner equilibrium and have not lost their love of nature and humanity.

> The ego rules in the foreground,
>
> the "I" works in the background,
>
> and demons haunt the shadows,
>
> waiting for salvation.

Hieronymus Bosch's conception of the world

The realism of Hieronymus Bosch's paintings, which cannot be dismissed as absurd, forces the observer to declare where he stands with regard to the question: does insight into the spirit exist? is there a way by means of which consciousness can be raised?* For his imaginations speak of the illumination of consciousness, not of the atavistic dullness of mediums. Certainly, it is very difficult to come to terms with the question of the extent to which human cognitive powers can be developed in our time. Our schools and educational institutions have accustomed us to thinking of such questions as outdated and to considering them only from an historical point of view. They have long since lost any reality for us.

* Cf. *The Cure of Folly*

Hieronymus Bosch's sin in the eyes of many is that he resurrects questions that have long been forgotten and dealt with. Basically, we want to ignore the whole problem, for Bosch touches on deeper layers than we find comfortable. He touches on a sphere that we have a certain reluctance to connect with our everyday knowledge. We would encounter a world, the world of the essence of being, which would cause us to face conflicts of which we are afraid.

If Bosch were satisfied to be solely a critic of his own time and society—without his profundity—as Bruegel often was, he would be more acceptable to the world. But there is a general reluctance to take the spiritual world as seriously, in its essence, as Bosch demands. Therefore he is often misunderstood and explanations of a Freudian nature are preferred, with relief and satisfaction at their half-truths. Here, too, it is fear of the spirit that prevents an understanding of the truth.

If we are to understand the world from which Bosch drew his insight, we will have to investigate his knowledge and the sources from which it flowed. With no other artist is it as necessary to investigate the background to the paintings. The difficulty that Bosch scholars have in penetrating this world is shown by the contradictory views and explanations with which they seek to understand his work. This is particularly true of his main work, *The Garden of Celestial Delights* in Madrid, which still poses great riddles.

If Siguenza, a contemporary of the painter El Greco, sees the painting as a didactic sermon against the desires of the flesh, the famous Bosch scholar de Tolnay describes it as an encyclopedia of loving. The celestial pool becomes the pool of lasciviousness and the whole painting the dream of paradisiacal life on earth. Wilhelm Fränger, in contrast, sees the painting as a depiction of the sacred prostitution in the Gnostic sense. The figure of Eve becomes an image of seduction for him and the whole *Garden of Celestial Delights* a

nightmare of mankind and its suppressed desires.

The Treeman is described as a "lecherous idiot" by de Tolnay, and Fränger calls him a "monster." The interpretation of this painting by the Freudians and their followers is better forgotten. Jacques Combe and C. A. Wertheim-Aymès seem to be the only ones who have sensed that it is inappropriate to talk of lust in the context of this triptych. A quotation from Jacques Combe demonstrates the analysis possible when one avoids the obsessive ideas of psychoanalysis: "Those who see in it a refined but immensely lustful Freudian dream of lust are mistaken. Has any painter ever painted paradise in such paradisiacal terms? If Bosch had wanted to depict lust he would have used greater harshness and more biting satire, as in *The Haywain* for example. His naked figures contain no passion, no depravity. They are not conscious of their nakedness. Sensual pleasure requires such awareness! Thus the atmosphere in the painting is not one of unchastity—peace and innocence reign!"

It is therefore quite wrong to interpret the events depicted on the hell panel as being the consequence of lustful failings (see the central panel), intended as a moral deterrent. A judgment of the painting based on moral precepts is out of place here. Rather, the drama of mankind is depicted in the painting as part of cosmic events. A quotation from the Bible gives us an inkling of the mightiness of this imagination of human development: "They are the instruments destined to be the body of the Lord."

In contrast to other contemporary esotericists, Bosch did not use any of the handed-down esoteric traditions. He consciously avoided their use and always clothed his experiences in his own forms and images. No artist before or since Bosch has been able to represent the spiritual world with direct depictions of this kind with such artistic creative power.

Only in the paintings in the large and small cupolas of the original Goetheanum, depicting

Rudolf Steiner's insight into the spiritual world, has there been the artistic representation of such knowledge once again.

Whether we like it or not, as human beings in the twenty-first century we should investigate Rudolf Steiner's science of the spirit. It leads to individual knowledge and perception of spiritual facts through strengthening and raising our consciousness. This path, which leads to the development of forces latent in human beings, was started in Bosch's time by the Rosicrucians, who were well known to him, and was developed further to meet the requirements of our own time by anthroposophy.

In his book about Bosch, published by the Skira publishing house in 1957, Delevoy attempts to compare Bosch's world with the only method of supersensible experience apparently known to him: mescaline, the *aventure mesquin* of Micheaux and Huxley.

By means of this drug, the author believes that he gained access to similar worlds and submersion in the zones that gave Bosch his visions. In other words, initiation by methods that cloud the consciousness. Yet using such methods of comparison seems somewhat dubious if we compare the light of consciousness that streams from Bosch's work with the chaotic soul content that results from visions induced by mescaline or LSD, indeed, with the proximity to mental breakdown that its victims suffer. Of course Bosch also experiences somber regions with elemental demons but his experiences do not end there—that is the point!

Bosch sets no simple task when indirectly he calls on the observer of his paintings to penetrate his world conception. Have we not become unaccustomed to constructing our own conception of the world as a result of scientific empiricism? Immersion in modern relativism has deprived us of the courage to work out our own view of the world, let alone live with it. After all, one might almost consider it a presumption to construct something in one's thinking

and adhere to it when it might become obsolete with each new scientific discovery.

Perhaps it is the unifying elements in Bosch's metaphysic that we—at the mercy of existential relativity, imprisoned in the duality of spirit and matter, submerged in the contradiction of belief and experience—find so attractive.

There is a view that Bosch's metaphysic has to be seen as dualistic in the Catholic and Protestant meaning of the term. If the contrast of good and evil is taken in the Zarathustrian sense, such dualism can be seen to exist, but not if these two principles are conceived as unbridgeable opposites of spirit and matter. It is precisely Bosch who points to the path of development of the soul, the transition between time and eternity, as a process that is experienced by everyone, every night and in death. Temporal consciousness should not accept its own limitations as absolute even though such processes are not experienced in ordinary, empirical, everyday consciousness. It is startling to realize that Bosch dares to paint processes of consciousness that reflect the experience of other worlds, that he makes the apparently absolute limits of today's consciousness relative, and that he dares to embark on the adventure of the spirit in a sovereign manner.

Superficial observers like to talk of his pessimism as a central part of his world view. This interpretation becomes untenable if one follows Bosch's guidance and resists entanglement in his world of demons. He demands a great amount of determination to learn of those who want to understand him. He challenges us to develop the faculties of imagination and inspiration with and through him. This path begins with contemplation in, absorption of, his work. Bosch does not present us with finished products; he demands development! The broad outline of his conception of the world is there from the beginning. It becomes more profound in the course of his life

but there are no fundamental changes.

It can be seen how Bosch encloses his own experiences in the imagery of the Christian tradition and can unite the two harmoniously. Thus his path leads from historical Christianity to a world of time-transcending Christianity. Some have sought to describe Bosch's spiritual monism, his unity of physical and spiritual worlds, as a "theo-biological world conception."

It is easy to understand that Bosch did not allow himself to be swayed by the idea of the predestination of human destiny that gripped people's minds at that time. He had an ingrained knowledge of the meaning of earthly existence and the earthly deeds of human beings and knew that human beings can transform the fruits of this existence, their individual achievement, into substance of their own making.

"The proper fruits of earthly existence" is a fundamental theme and leitmotif that recurs in all of his works. Those beings who want to rob human beings of the fruits of their earthly existence are also present everywhere in his paintings. He paints the eternal transformation of destiny to ever higher stages, as well as the release of the innate divine spark striving for resurrection in each of us. His art frees human beings from the bane of the dogma of predestination that burdens them and that would result in their despairing of their earthly existence in the long term. In Bosch's time, those who dared to doubt this dogma had to expect to be burned as heretics by the Church (cf. the Cambray documents mentioned in Fränger's *Das tausendjährige Reich).*

Bosch's work speaks of the progression of destiny. He does not teach; he paints imaginations and shows how the fruits of earthly existence, the possession of each one of us, can be stolen from no one. They become our possession, an intimate part of our eternal selves.

There was another question of deep concern to the people of that period. The problem was not so much the promise of eternal salvation; rather, they

had a deeply embedded need to know the answer to the questions posed by *The Imitation of Christ.* Too much had been preached to them about this subject and still the dogma of predestination blocked their hopes. With the exception of a number of saints who had possibly reached that supreme aim, nothing in the life of individual people gave any indication as to how they might follow such a path and approach the longed for goal, let alone ever reach it. The allotted time between birth and death was too short. Not even Dante in his *Divine Comedy* supplied an answer to this dilemma.

This and many other questions lived profoundly in the souls of a mankind that was preparing to cross the threshold into the modern era. They were more strongly in people's minds than is generally assumed. Later on, this fundamental inquiry into the spiritual existence of the individual, developing soul was restricted by new discoveries in physical knowledge. The increasingly secure life of the new bourgeoisie drowned out the insecurity of the spiritual life. The growing number of dogmas of the faith—absolute in nature—rendered people unused to thinking of their own spiritual existence and "disputing with God," as the saying went. Hope paled for awakening reason that human beings could look to the divine world for justice and justification. The widening gulf that human consciousness encountered between visible, temporal justice and invisible, divine justice became too much.

Bosch took many of his subjects from the life of the pious hermits and ascetics. Mostly, they represent stages in the soul's development. For Bosch, the path of the ascetic is contained not so much in the withdrawal from the world but in the imitation of Christ. The vanities of life should be recognized for what they are; yet there was a Rosicrucian saying: "Live and work piously in the world." The love with which he depicts nature and the creation shows that Bosch was not concerned with escaping from the world.

It is thought that the mystic Ruysbroek (1293–1381) had an influence on Bosch's spiritual maturity, perhaps through his pupil Geert Groote, who founded the Brotherhood of Communal Life and also taught in 's Hertogenbosch, the Netherlands. The painting of *The Temptation of St. Anthony* (Prado) appears to illustrate Ruysbroek's words: "The contemplative reason of a person deep in meditation is a living mirror that FATHER and SON imbue with the spirit of truth so that the reason of such a person be illuminated and know all truth that it is possible to know through the mode of thinking, the forms, the images, and the resemblances."

We know that Bosch depicted himself in the figures of the saints, or rather, expressed himself through them in a way he was unable to do in words. Therefore the words above may be taken as expressing his own attitude as well. We can assume that a further influence on Bosch was Erasmus of Rotterdam (1467–1536), for he, too, lived in 's Hertogenbosch for three years. The praise of folly in the sense of Parcival—innocent folly, not sinful foolishness—is a saying that originates with Erasmus. Erasmus the humanist supported neither Catholic dogmatism nor Luther.

Let a quotation from the apocryphal gospels conclude this section on Hieronymus Bosch's world conception. Salome's question:

> When does death end and when will the
> kingdom of Christ begin?
>
> When everyone overcomes the garment of
> shame and when the two become one and
> the outer becomes identical with the inner
> and the female becomes identical with the
> male so that there will be neither female
> nor male.
>
> I am the sacrament of love, come to defeat
> woman's deeds.

THE FIVEFOLD IMAGE OF THE HUMAN BEING

In the Hortus Deliciarum *and* The Last Judgment *in Cairo*

The different grouping of the musical instruments in *The Last Judgment* in Cairo and the *Hortus Deliciarum* gave rise to the assumption that the Cairo painting anticipates the Madrid one. But as we mentioned earlier, it is more likely that the difference in the grouping of the instruments is due to the difference in the subject matter of the paintings.

Rudolf Steiner, referring to the human "I," tends to speak not so much of the threefold nature but rather of the fivefold nature of the human being. The mineral body as the lowest and the "I" as the highest elements supplement the threefoldness of the physical body, etheric body or body of formative forces, and astral or soul body, whereby reference is always made to the close connection between the mineral body and the activity of the "I." In particular, the lectures on the mystery of Golgotha speak of the Christ-ego ruling the physical realm right down to the mineral body as a unique event in the development of mankind. As it says in the Gospel of St. John: "A bone of him shall not be broken." The lectures also mention that there are beings who have a physical but not a mineral body. Accordingly we have to distinguish between the laws of the physical body (the form-giving body) and the matter, the mineral substance that pervades the physical body and that is renewed every seven years. Rudolf Steiner also speaks of the mineral body crumbling, of it losing its function since the mystery of Golgotha.

A study of the arrangement of the musical instruments on the right-hand panel of the triptych in Madrid reveals that the three instruments of the body are clearly together: the physical body in the image of the hurdy-gurdy, the etheric and the astral bodies in the images of the lute and harp. If we examine who controls these three instruments, we see the Treeman above, with his crumbling body. Although the latter's organic origins are still visible, it has turned into an amorphous and lifeless shell without any content of its own. Yet this shape has something important to express: the human countenance and the band of initiation. This is reason enough to include this grotesque shape of an indeterminate nature with the musical instruments. But we notice the peculiar phenomenon of the elements of the body separated from the actual human being, separated from the highest and the lowest—the head with its alert consciousness and the crumbling physical body—which are now in the closest proximity. At first glance, linking outwardly disparate elements in this way may seem to be arbitrary and without justification, but it is only from this perspective that the events depicted in the painting become comprehensible.

A central part of *The Last Judgment* is the dead rising from the grave, leaving the mineral earth world. Only this gives meaning to the event, for the souls that rested in their graves, their own bodies, up to that point leave their bodies forever on that day. They rise from the dead and face judgment. In this sense the Treeman has become a symbol for rising from the grave.

The face of the Treeman has changed from one who beholds in the Madrid picture to one who knows with fully awakened consciousness in the Cairo one. It has become the countenance of an initiate. The holy band indicates the process of initiation. In ancient Egypt the priestesses of Isis wore the knotted band as the knot of Isis on their breast and head as a mark of their position. Here it has migrated to the lowest region of the human extremities, to below the knee, where the process of initiation takes hold

of the human will, that is to say, the entire human being down to the bone structure.*

The image of the Treeman shows how the mineral body—both human grave and prison—crumbles without endangering the "I," without extinguishing it. In another imagination—different, of course, but similar—Goethe speaks of this process in the "Fairy Tale of the Green Snake and the Beautiful Lily": "The three kingly forces arise in the fifth, the youth, and the fourth king, the impure one, crumbles."

The three instruments of the body that are still positioned close to the Treeman in the *Hortus Deliciarum* are completely separated from him in the Cairo *Last Judgment:* mankind has progressed from instinct to intellect. If these elements of the body are not filled with and transformed by the "I," they fall prey to the Luciferic and Ahrimanic forces to the left and right of Christ at the Last Judgment. Then, once everything human in them has died, they become the servants and tools of these powers. This is shown in the instruments on both side panels of the altarpiece, where mankind is poisoned by the old forces of the serpent on the right hand and, on the left, the instrument of the physical body, in its progressive automatization, becomes the image of false Ahrimanic immortality.

The *Hortus Deliciarum* depicts the story of the creation and the Christ impulse at work in the course of human history. At the same time we are shown life on earth coming to an end and the transformation of individual destiny being suffered in purgatory as well as the formation of a new destiny in the region of the zodiac.

The Last Judgment, in contrast, depicts the old beliefs with the Lord over heaven and earth, the saints and the angels. But Bosch shows the way out of the grave, the way to the fulfillment and salvation

* *Cf. also the Order of the Garter founded in England in 1350.*

of the "I," in his own pictorial language, in the image of the redeemed Treeman who can only be fully understood in his fivefold nature.

It is only in this context that the real meaning of *The Last Judgment* in Cairo can be assessed properly and we can see in it Bosch's extended power of composition and heightened wisdom.

The fivefold nature of the St. Anthony altarpiece

Hieronymus Bosch often painted St. Anthony. He uses the saint to express important experiences that he himself had. This is also true of this painting.

On the opened triptych the eye of the observer is initially drawn to the three depictions of the saint and his surroundings. More detailed study shows that the subjects on the side panels point to the event on the central panel.

The review of the past on the left-hand panel shows St. Anthony's detachment from material possessions, the death of initiation, and the simultaneous flight of the spirit with the assistance of the conquered demonic world. It is the path of the mystic who, through his schooling, rises above the world and its challenges.

The right-hand panel of the altarpiece depicts a quite different situation. There the saint reflects deeply, hermitlike, on his past life as a cleric and where it would have led him had he pursued it. The devil of forgetfulness wants to lift him out of his impotence and distract him from the suffering of the world. He feels himself lifted to the highest levels of the hierarchy by the fish of the Church. It is a false flight without the light of knowledge and without any transformation. This is also shown by the inner celebration of the cult, which is supported not by the power of the self but by illegitimate soul forces. So he is left with the walking frame of

his habits to keep him upright in old age.

On the two side panels the saint is shown from the front but only on the central panel does he become the focus of the painting. His meditative gaze is turned fully on the observer. After his initiation as a mystic and rise through the Church hierarchy, he now appears as a pilgrim. St. Anthony as ego-personality, as pilgrim, is situated in the middle between the suffering fish and Christ resurrected. He is the key figure in the fivefold division of events in the painting, which is revealed in the five different groupings.

The fivefold division as temporal threshold

Outside the choir screen, the balustrade that divides the place of worship from the congregation, St. Anthony kneels with the figure of his soul who recalls Mary Magdalene in *The Marriage at Cana.*

His free gaze and relaxed posture reveal that he has freed himself from the old covenant. He has crossed the threshold to the new consciousness and has made it his own. The gesture of his hand shows the content of his soul. It is the same as the gesture of the risen Christ in the background who, as spirit-form, celebrates the new act of worship in a physically real way and visible and present only to those who have experienced their consciousness in this way. This gesture sets St. Anthony on the pilgrim's path to follow the risen Christ. The pilgrim's staff beside him indicates that he is already on his way.

The saint and his soul figure are confronted by two figures who are leaning on the pillar of the old covenant. They are a medieval theologian and an abbess who are still standing within the enclosed area of worship. Their faces have strongly portraitlike characteristics. It is all the more surprising to see that they are misshapen. The scholar with the shrunken body cannot take hold of the drink from the golden cup offered by St. Anthony. The nun is in a similar

situation. She, too, cannot receive the food being offered in a blue bowl. Their atrophied limbs prevent this despite the obvious sharpness of his thinking and the strict faith of her feelings. If the scholar is the representative of the medieval striving for knowledge, then his companion, with her hard, strict expression, is an image of the religious life hardened into dogma. This singularity of perspective and these failings allow them to gain salvation and strength neither from the draught of the new wisdom nor from the bowl of humble piety.

Both groups stand on the threshold of two different types of consciousness. The time of the mind and intellectual soul has come to an end, and the time of the consciousness soul has begun. Living in the past, in abstractions of thought and the dogmas of faith, makes the forces of the heart atrophy. Such stagnation perverts thinking, feeling, and willing. This is indicated here in the image of the three dubious characters. Five figures like this hardly serve the salvation of mankind: thinking is tied to the dead letter, which turns the inner human being into a shell. The will screens itself by means of the inverted funnel of wisdom because it does not want to be disturbed by new things. Feeling carries on its helmeted head a nest with an egg that is unlikely to hatch.

If we inquire after the fifth member of the original group, which is divided by the temporal threshold, we have to turn our gaze to the back of the painting. There the fifth appears at the altar, the Risen one who completes every group and gives it meaning. He gazes at St. Anthony with the utmost seriousness and great simplicity. Christ looks on the one who does not look at Him; He has become the inner strength of St. Anthony.

We must still mention the ray of light that breaks into the darkness surrounding the altar. It is light from the world of stars, the world of the Father. Through the power of the Risen one it is transformed as the power of the "I" into the power

of the Holy Ghost in St. Anthony.

> Those who tread the path of the "I,"
>
> who strive to follow Him,
>
> will see Him,
>
> present,
>
> always and for eternity.

Here, too, as in the painting of *The Marriage at Cana*, we can follow the "I" unfolding in the individual parts of the soul:

The Sentient Soul	Filled with the "I"	St. Anthony's Soul Figure
The Consciousness Soul	The Transformed Mind and Intellectual Soul	Awakened in St. Anthony
The Divine "I"	The Trinity of the Human Spirit	The Image of the Risen Christ
The Mind Soul	Not Transformed by the "I"	The Abbess
The Intellectual Soul	Not Filled with the "I"	The Theologian
Egoless Thinking, Feeling, and Willing		The Three Dubious Characters

The fivefold division as lack of ego—the anti-"I"
A peculiar act of worship is taking place to the left of the St. Anthony group. Magical tension and enigma are interwoven in the event. The fellow in green*, an image of the etheric body, with pig

* "The green one" was the description once given to the god Osiris.

snout and an owl on his head, lute under his arm, and the magician's dog on a lead, demands the consecrated wine. He is followed by the senile and crumbling physical body with the hurdy-gurdy, who clings on to the green fellow since he no longer has any support of his own.

The priest holding the wine is filled with magical tension and fear and is by no means certain of his magical powers. The only person with any certainty is the green fellow, whose desires have become overpowering. The highest element of fivefold human nature, the "I," is ridiculed here: a homunculus figure with uplifted host is carried on a silver platter by a woman of the lowest astral nature; she is the servant of the antigrail.

The two priests are depicted as the mind and intellectual soul that have not been purified by the "I"; they are the victims of obscurely magical mystery cults. The priests are under the spell of a sinister spoonbill being that dominates outside the magic circle. There are no human traits in this being of anti-ego magic.*

There are three centers of worship in the painting. The first is the altar of the risen Christ whose power turns to ego-substance in human beings. The second center is the table of magical worship that results in inhuman possession. And the third center is the table of the hermit on the right-hand panel, an image of lack of substance.

The fivefold division in the affairs of Bosch's time: the empty ego falls prey to demons

This group provides an image of demonic influences at work in general human affairs at the threshold of the new age. Together with the heraldic animal, a

* It is an image of the influence of Gondishapur and its spiritual being, who is not named.

being dominated by a demon, its head hooded by a branch, causes havoc. Wertheim-Aymès describes the two of them as the Inquisition united with the egotism of the lords temporal. A third being, an animal demon, follows behind wearing a broken clay pot on its head. The fourth member of this sinister grouping has an animal body—the dullness of the masses who, emotions roused, turn savage and willingly allow themselves to be used by the temporal and spiritual authorities.

The Church, the institution that once provided a secure, patriarchal environment in which human beings could live in harmony, degenerates here into the Inquisition. Together with the land-hungry nobility it subjugates the awakening populace at the threshold of the new age, which is signaled by the Reformation.

Here, the image of the human being, the Treeman, is usurped by the Inquisition for its own purposes. The snake in the withered branches appears to replace the former band of wisdom. If we inquire after the whereabouts of the master of this fivefold group, the "I," we will find a huntsman's hat with a proud cock's plume in the branches. This gives some clue to the identity of this invisible huntsman. Who is being hunted here? The human being? The devil's pack, the Dominicans—hounds of the Lord—are the servants of the Inquisition and have already been set on his trail to destroy the free human spirit.

So this community of five is ruled by the spirit of tyranny, death, and the beast in place of the spirit that ensouls St. Anthony: the spirit of humanity is in danger.

The fivefold division in relation to the creation and the elements of human nature

The former richness of the creation is depicted in the image of the red kaki fruit, "the fruit of the divine seed" (Wertheim-Aymès). Overripe, it has burst and

its life forces are spent. Decay and decomposition are at work, and nothing more of any substance flows to human beings from that quarter. The forces of death setting in also set the demons to work. The former harmony, the unity of body, soul, and spirit, has been irretrievably lost. A sclerotic horse-skull being is plucking a sad song on the lyre, the instrument of the soul. It wears a green veil in place of its band of wisdom. It appears armored and in harness and the golden stockings, reminders of past riches, are still visible under the spurs.

The following passage can be found in the twelfth lecture of Rudolf Steiner's book *The Gospel of St. John*:

> If human development continued without Christ, the etheric body could no longer transmit any wisdom to the physical body. For the latter would be abandoned by the etheric body, which would no longer be able to protect it from decay. Thus human beings would lose all the fruits of their life on earth; they would have to leave the physical body behind and without that they would never achieve their mission on earth. The empty etheric skull, which they once brought full, would be lost.

The poor horse's skull almost gives the impression of tears welling up with pain of its own emptiness.*

Above all, it is perhaps the plump feet of the mount, the head of which squints strangely from a goose's body, that reminds us of the Treeman and his boat limbs. They make us aware that, here too, the stage of the Treeman should have been achieved. Since the "I" has not developed freely within the social framework, the forces of heaviness—skeletal forces—prevail. If the instrument of the soul is not handled

* The same subject matter can be found on the southeast corner of Chartres Cathedral.

correctly, the astral witch shamelessly and threateningly swings the saber over the poor horse's skull. The forces of the illusionist and the fairground astrologer hold sway in place of the proper forces of the "I."

The fivefold division and the counterimage to the wisdom of the future: the false epiphany

At the foot of the tower of the old covenant, we can see the group of the false epiphany. The former sidereal virgin in the withered tree of life has died, as has the fruit of her womb, which has lost its essence. She is surrounded by the three representatives of contemporary human activity who no longer worship her. Once they were true kingly forces but now they resemble stuffed puppets. They are unholy and the subject of their worship is unholy:

> the untruth — armored reason
>
> the incorrect — the empty thistle
>
> the inhuman — economic power

The former wisdom of the stars, Sophia, has metamorphosed into earthly reason; learning has become irrelevant, economic forces have become all-powerful, and the rigidified state is incapable of action. In the background the ancient figure of Joseph stands out from this group of three just as helpless as the true child of mankind who must perish alone in the effluent of life and without human love.

* * *

The five groups on the *St. Anthony* altarpiece demonstrate in five different ways how human beings at the threshold of the modern age are threatened in many different ways in their future development and free humanity. All this is experienced by St. Anthony who, inwardly awake through the power of the Risen one, is on the path of Rosicrucian initiation. He has overcome the mystical path of withdrawal from the world and the clerical path of temporal power.

Other aspects of the fivefold division

Quite a different sort of fivefold division is experienced in the painting *The Crowning with Thorns* (London). An enormous peace and calmness flow from this painting in spite of the complete consciousness of pain. Four figures are grouped around Christ: the high priest with his mocking, jealous intellect; his greedy and dull henchman; and the soul and intellectual forces of the two Roman soldiers respectively. The latter two have become aware that they are doing a deed in which they have not made any decisions of their own. These four have a fifth in their midst from whom divine love flows in his suffering.

The *St. Christopher* painting also belongs in this group. The Treeman is alive in him. Permeated by the "I," he has become one with the Christ-child. He has left his abode in the old tree, the tree trunk with the broken jug, and the dubious dovecote, and is crossing the ice-free river. In full command of his powers and the constituent elements of his body, he no longer serves the most powerful on earth but the child whom he carries across the river.

Finally, we should note the fivefold division that appears in the new Treeman imagination of the resurrected Faust in the cupola painting of the Goetheanum. There the former instruments of Faust's body have been transformed into coverings, into new garments. The four garments envelop him in spiritual eternity as an image of our culture.

* * *

The Seven Deadly Sins and the Four Last Things, one of Bosch's early works, depicts the seven constituent elements of the human being and the

self-conscious, divine "I." That latter, with its innate fivefold nature, points to the original twelvefold nature of the cosmos. Human beings become world citizens in these relationships and find the correct relationship to the last four things.

What would otherwise be imperishably preserved and mummified crumbles to ashes and is resurrected in the Christ-filled etheric body. Shortly before his death, St. Anthony wrote an epistle to his brethren: "Let my body perish. Do not preserve, mummify it. My savior, Christ, will resurrect it in the flesh."

THE LEITMOTIF OF THE TREEMAN IMAGINATION

The tree of knowledge and the earth-brain—the paradisiacal archetype of the Treeman imagination

On the paradise panel of *The Garden of Celestial Delights* the tree of knowledge is depicted as a date palm *(Phoenix dactylifera)* with the serpent of temptation coiled around it. The palm is growing on a rock that appears to be the sharply outlined profile of a head, the features of which are indirectly indicated. The eye and eyebrow are formed by a centipedelike beetle and the thick-lipped mouth is shaped by a snake. The sharp, prominent nose stands out against trees. This fantastical profile, a nature profile, appears to slumber and is part of the landscape.

This rocky countenance is unambiguous and grotesque and reminds us of the earth-brain on the icon of Jacob's ladder,* the earth-brain that human beings are destined to enter with their physical thinking in the age of the consciousness soul.

* *A twelfth century icon in the Sinai monastery at the foot of Mount Sinai*

But there is more that points to the phenomenon of the earth-brain than the form and shape of the rock. The whole context, the situation of the object, points in this direction. Thus the Luciferic tree of knowledge grows on the Ahrimanic and sclerotic earth-brain. Through the fall, the sun tree of cosmic wisdom is turned into earthly intellect usurped by Lucifer. We can see Luciferic and Ahrimanic influences working together in the destiny of earth, the one rooted in the other.

The fountain of life rising from the waters of paradise in the center of the painting indicates the pre-earthly state of the world: the fountain of youth and life standing on the newly created primeval matter; the owl, wakefully reflecting ahead of its time, is staring along the path of the creation that has begun. A rare bird of paradise has settled on the fountain, and a solitary swan is gliding on the celestial waters towards the rocky countenance and the palm. "It is the image of the pure, unsullied soul that is mirrored in the waters of the spirit ocean" (Wertheim-Aymès). A hare, the image of the ego at work in the physical body (Wertheim-Aymès), is hiding on firm land above the peacock and the swan.

On the head-shaped rock a blossoming rose bush grows next to the trunk of the palm with the snake coiled around it. Both the palm and the rose bush are growing at a spot on the rock where the pineal gland and the pituitary gland are situated in the corresponding positions in the human head, both of them essential organs for the formation of consciousness. These are important circumstances depicted in the most straightforward way: a new growth, the rose-covered bush, greens and blossoms beside the tree of serpentine wisdom.

The tree of life, with Adam resting in its shadow, stands toward the bottom of the panel on a diagonal line from the tree of knowledge, with the fountain

of life and the owl in the middle. It is his own genealogical tree that is depicted as a dracaena palm with creepers twined around it.*

Paradise, at the beginning of creation, still combines what appears divided in the Treeman as death in the mineral body and resurrection in the "I" on the one hand while the other instruments of the body are possessed on the other. The power of the tree of life outshines the tree of knowledge as the archetype and model of future development.

The scene portrayed here of the unification of Adam and Eve through Christ as the future of human destiny—before the actual fall—corresponds to the rootedness of the cosmic tree of wisdom in the rock of the earth-brain as depicted in the painting.

A look at the painting shows the biological and esoteric exactitude with which the artist hides—and reveals—the wisdom of mankind in his work.

The motif of the Treeman in Bosch's work— The tree as bearer of the "I"

The image of the Treeman appears in a great number of variations in Hieronymus Bosch's works. As we have already indicated in the section on the *Hortus Deliciarum,* the motif is used by the artist to indicate certain states of consciousness. In the *Hortus Delicia-rum* he appears in his basic form as a monster with a human countenance in the midst of the world of purgatory: an indication of the awakening ego-consciousness. Human beings awaken at the cost of the death of their life forces. At one time cosmic music surrounded them when they still retained control over the different instruments of their bodies

and determined their actions on the basic of this harmony. At that time the music of the spheres had not grown silent in them. Now the music has died and the human life forces are on the wane.

The Treeman is often linked with the concept of the soul-dwelling (cf. *The Prodigal Son, The Haywain),* as, for example, in the self-portrait as a young man (Baarn, Holland) in which the wise man with the band around his head is sunk in meditation in the shadow of his own tree of life in the branches of which his soul-house nestles. This subject also appears in a depiction of St. Christopher by Bosch's contemporary, Joachim Patinier.

In the painting of St. Christopher, Bosch depicts the former dwelling of the saint, a hollow tree, in which a fire is burning low.

The tree as hermit's cell has become unimportant in *The Temptation of St. Anthony* (Prado, Madrid) as a protection and dwelling for the saint for he no longer needs the old shelter. His "I" has become strong, and his shelter can disintegrate.

The ruined hut in the *Epiphany* in the Prado in Madrid, from which Herod is stepping and in front of which the adoration of the Child is taking place, also indicates the connection between the soul dwelling and the Treeman as a symbol. The house of Herod, dark power and servant of the antichrist, becomes a ruin.

Another variation appears on the *St. Anthony* altarpiece in Lisbon. Here we have a rough-cut figure, overgrown by his own house, who can no longer stand upright under the weight of his own possessions. His limbs have already taken root and have become useless for any kind of progress. The arrow of everyday habits has become fixed in his head. In this kind of existence his soul appears deeply buried under the weight of his body and is hardly visible. The same painting depicts a further three scenes that are connected with the

* *Particularly beautiful specimens of this longest living of all trees can be found on Tenerife at the edge of the former continent of Atlantis. They are thought to be more than 4,000 years old. In spite of their great age these trees possess strong vegetative forces and do not reach the stage of true bark formation.*

tree. The figure of Mary, the false Sophia, appears in the false epiphany with a fishtail. She is like a withered tree.

The other soul figure on the right-hand panel of the altarpiece also hides in a hollow tree. Wertheim-Aymès describes it as man's body after the fall, the body of the old Adam, overcome by St. Anthony.

A third version can be seen in the armored, violent being on the middle panel, disguised as a withered tree of life.

On the *Tondalus Vision* (Prado, Madrid), the Treeman appears as a mask with a band around his forehead next to an owl with a burning torch on its head. This painting is not an authentic Bosch but has been painted completely in his style.

There are many other Treeman variations in those of Bosch's paintings that are extant: a ghost with mill wheel and an owl is an image of earthly thinking and habits that turn the real human being into a ghost, that is, deprive him of his real existence. Another figure depicts a fool sticking his tongue out, with one leg in a jug and the second in a boat. No one can understand how he can make progress with such disparate footwear and standpoints. Another picture depicts an invalid, both mocker and critic, hobbling along with a bell and a feathered barrel for a body. He seems to seek people as Diogenes did before him—or is he merely mocking? Another figure (Wiesbaden) with the face of a gnome and a jug for a belly stands on stiff legs. A sketch from Dresden has a frightening effect. In it a human being has to bear the extra burden of a shield and canopy, apart from all his other accessories, and is almost crushed by them.

The most detailed sketch of the Treeman can be found in the Albertina Graphics Collection in Vienna. We see him with the millstone on his head, and this makes his face pinched and insecure. With unkempt hair, he is placed in a peaceful landscape. He is soli-tary within the harmony and riches of nature, the only disharmonious being failing to fit into his peace. The withered branches that grow from his stomach, bearing the flag with the crescent moon and the owl, stand in contrast to the young tree, gracefully striving upwards, that stands full of new life on the bank.

As well as the *Owls on a Decaying Tree,* the drawing *The Forest Hears and the Field Sees* is particularly impressive. The dense forest in the background, with its attentive ears, and the field in front with the seven eyes surround the withered tree, which has a large owl sitting in its hollow. Vibrant birds of paradise play in the dry branches.

This unusual depiction with the hollow tree is an image of the human being who, through his physical thinking, has turned his own body into a ruin and is unable to perceive the message conveyed by the birds of higher imagination because the owl in him, the lifeless thinking, makes the trunk wither. The fox, representing worldly intelligence and cunning, lies in wait at its roots. The proud conceited cock falls prey to him in spite of all its alertness.

It is almost as if nature, the world of the senses, is observing, listening out for human beings. It is waiting for them because nature is innocent; the senses lead human beings into sin. Is nature waiting for the purification of the seven constituent elements of the human body? Is it waiting for the day of man's resurrection? For is nature not His body too, the body of the Lord, and is His suffering not the suffering of nature? This is what St. Paul means when he says that nature is waiting in pain to be delivered by man.

* * *

If we look now at the Treeman in the Cairo *Last Judgment* in the context of all these variants, we see something quite unexpected that is not present in

the previous depictions. Outwardly the Cairo Treeman may still be the same as the Madrid one. But the earlier countenance of resignation and melancholy has become filled with the "I" and has taken on an expression of consciousness in Cairo.

Where the Madrid painting reminds us of *The Prodigal Son,* lost in the world around him, *The Last Judgment* in Cairo depicts a human being whose "I" has awoken, who has found himself and who no longer possesses the character of a Rumpelstiltskin in his "incomprehensible anonymity" (Fränger). He reminds us of Christ who descended into hell before his resurrection, of the true representative of mankind.

As Christ stands surrounded by the seven ways in which human beings can sin in the contemplative work *The Seven Deadly Sins and the Four Lost Things,* the "awakened human being" stands as initiate among the seven constituents of his body, which he forms with the help of the divine "I." He experiences the heightened drama of becoming an ego, a full human being. The garments, now useless, fall off of him. They are the coverings that contained the seven ways of sinning. But the Treeman has found his way through them alertly and consciously. He has not fallen prey to the seven sins. He has become more and more free. Thus he can safely abandon his physical body, his grave, because he has built his risen body, the future tree of life.

The Treeman in mythology

The apparently strange imagination of the Treeman, that is, the link in the form of a tree between the essential human "I" and its constituent elements, probably appears less strange if we point out that in Norse mythology the tree was always perceived as an image of the human being. Human beings sprang from the two trees Ask and Embla. Who has not heard of the Yggdrasil, the ash tree overshadowing the world; it is the human being on a cosmic scale, its mighty roots planted in the earth, its forest of leaves grandiosely binding light and air into earth substance?

Such an archetypal experience of the tree leads to the image of the genealogical tree and the succession of generations. It also leads to mankind's family tree in the Bible with Adam as its progenitor: "and he was of God"; "The branch grew from the grave of the old Adam, and from its sprig Christ sprang forth." Legend has it that, when the earlier strength of the tree of mankind threatened to wither, its timber died in the wood of the cross.

Once it was Wotan "who hung on the wind-swept tree for seven days and seven nights." Then it was Christ who brought the withered wood back to life. His blood and his wounds brought about the miracle of the new blossoming. His five wounds inserted new roses into the tree of mankind. Thus the world ash, the sun tree, turned into the Christ tree and Adam's grave became the manger for the Savior.

In German, *blood* and *balsam* can be used as terms only for the sap of trees, not of plants. Language, too, mirrors the relationship between human beings and trees that we see in mythology. The philologist K. Althoff refers to the connection between the Gothic words *glaujan* articulated by Wulfila (from which the German word *glauben* = "belief" is derived) and *laub* (German *laub* = "leaves, foliage"), which at that time already described the leaves of trees. This shows that the people of that time already possessed the strength to maintain their belief in the power of the newly rising sun, the new beleaving that intimates new life and growth to humanity, throughout the barrenness of winter, through cold and need, stripped of the summer's riches. This inner strength in human beings, the power of belief, was

equated with the undying power of nature: the hope for the new glaujan.

The following linguistic parallels exist:

In Old English	*to believe* was written as "to beleave."
In old Danish	*Løv* (foliage) and *Love* (belief) are identical.
In Dutch	*Loof* (foliage) and *Geloof* (belief) are also identical.

In ancient Egypt the sycamore was regarded as the tree of life on the leaves of which the names of the pharaohs were written by the goddess Seshat, the wife of the god Thot. The major festival of the year was the Hebsed festival with the erection of the Djed pillar, the leafless tree, which, through the power of Osiris, lifted human beings upright from the horizontal position of the animals.

The image of the Treeman as represented in fairy tales is described particularly impressively in the Rumpelstiltskin fairy tale. Even the structure of the word—*Rumpel* and *Stiltskin*—indicates the joint Luciferic and Ahrimanic forces of unconscious influence and rigid destruction at work in the human being. These forces, which become visible in the Treeman, infiltrate every part of the human being. As Rumpelstitskin says:

> O how good that none can claim
> Knowledge of my proper name!

The task is to guess the name of this composite being. It is the sphinx's question about man. The fairy tale relates how this monster wants to rob the miller's daughter of her unborn child, the king's son and new scion of mankind. Rumpelstiltskin, who has power over the soul for as long as she does not know his true name, takes great care to remain anonymous. But when the queen discovers his name and declares it, the comic little man explodes with anger and disappointment at being discovered.

The Treeman in Pieter Bruegel the Elder (1520–1569)

Pieter Bruegel is often described as following in the footsteps of Hieronymus Bosch and yet there is only a distant connection. Bruegel's clear critique of his time and its social conditions already points to the approaching seventeenth century, the early part of which his work encompasses. There is no doubt that Bruegel is more than a mere moralist. But the more is hidden behind games and rural scenes. He portrays people's foolishness rather than their sinfulness. But his landscapes, particularly the seasons, already depict the new relationship between man and nature. His pictures express the independent experience of nature's rhythms while in Bosch nature reflects the soul and forms the background to its content. For Bruegel nature no longer plays a subservient role. Human beings are enveloped in it, in its character, its riches.

Efforts have been made to represent Bosch as a moralist but this has never been entirely convincing. Bruegel, by contrast, has clearly been classed as such and as a critic of his time by art historians. On closer inspection, his pictures of the wisdom contained in Dutch proverbs are more of a criticism of people's dullness, rather like Till Eulenspiegel, than of the social conditions of his time. But the change in consciousness that has taken place in Bruegel is exemplified in the different way that each of them depicts landscapes. Although Bosch is often described as the first landscape painter, his natural backgrounds are only reflections, summaries of the events in the foreground. They do not exist

independently but only draw together and emphasize the subject matter of the picture.

Bruegel, on the other hand, is in his element in the seasonal moods of nature. Each human activity that he depicts accords with the season. Bruegel makes his people part of nature. His moving portrayal of the blind provides a contrast to this, demonstrating his understanding of their feelings. But in works like the *Proverbs*, the people are like puppets, representing living images without any experience of their own.

Yet one of Bruegel's most well-known works takes up Bosch's central theme, the Treeman, again. The way in which he transforms and develops it in accordance with his own time shows that he possessed a profound understanding of Bosch.

Land of Cockaigne is generally considered to be Bruegel's most amusing painting as an image of Dutch joie de vivre. But there is another way of looking at it. The description *fool's paradise* is perhaps apt to describe Bruegel's real concern: "A fool's paradise is the object of your desires. That is all you can think of! What do you want there? It is only for fools!"

The focus of this painting is a withered tree with withered branches that has on it, like the Treeman's millstone, a table full of food ready for eating: ready-made subject matter.

Three human bodies in red, brownish black, and rose colors are stretched out on the green grass below. They have fallen asleep after the exertions of a pleasurable meal.

The knight, representative of the nobility, is the soldier personified. He has cast away his weapons in sleep and appears to be tormented by nightmares: his conscience is worrying him. His red leggings and cape show that he is dominated by his emotions.

The second dreamer has sunk into deep sleep. He is a peasant, representative of the farming class,

resting on his flail. His sleep is so dulled that not even his conscience can disturb him. He is overcome by the weight of his own body.

The third dreamer is a daydreamer. His eyes are open but he is not present. He wallows in his dreams and, as a traveling scholar, ignores his book and manuscript lying on the ground. He uses the manuscript as a headrest. He feels completely at home in his skin, his rose-colored clothing and his gold-linked black fur gown—a lazybones!

Almost in the background, below a roof covered with sweetmeats, a female figure who is armored but fettered waits longingly for roast doves to fly into her mouth. The obvious impotence of this soul-figure is the consequence of the incapacity of the other elements that constitute the body. They are filled with nothing but physical nourishment and cannot give any real nourishment to the soul. She has no choice other than to wait.

But now the question arises: where is the "I," the counterpart to the countenance of the Treeman, the master of the group of five? It appears in the form of the small boy with the cooking spoon who has eaten his way with great trouble through the mound of buckwheat porridge to tumble into this fool's paradise. But in this world he will fail to grow up and become master because the three instruments of his body are lying flat on the ground, drugged by the surfeit of material subject matter they have consumed. In her present state, the help-less soul cannot help him either.

Bosch still draws his imagery for the instruments of the body (harp, lute, and hurdy-gurdy) from quite a different realm. For Bruegel these instruments have sunk more deeply into the weight of matter. They no longer mourn the music of the spheres, which is now dead and forgotten. They have consigned themselves to a paradise different from the one of celestial delights. The instruments of the human

"I" painted by Bosch have become personified as elements of society in Bruegel. The thinking, willing, and feeling of the body social of mankind lie asleep. The conscience, the soul, is paralyzed; the child has wandered into a false paradise, an illusory paradise from which there is no escape.

Here Bruegel is a moralist in a concrete way but with a higher meaning. He holds a mirror up to his contemporaries—as Bosch did before him—apparently smiling but fundamentally serious!

The new imagination of the Treeman

As we said before, no painter before or after Bosch has painted the conditions prevailing in the spiritual world with such spiritual realism; no one except Rudolf Steiner in his paintings in the cupolas of the first Goestheanum in Dornach, Switzerland, which burned down at the turn of 1922–23.

The painting in the smaller cupola, which was executed by Rudolf Steiner himself, depicted Christ surrounded by the inspirational beings and leading representatives of the various cultural epochs. Christ was depicted as the central figure of all post-Atlantean cultural epochs. In the portrayal of the fifth cultural epoch, the period when the consciousness soul is developed, the figure of Faust appeared above as the representative of the present age. He was carrying a book with the symbols I-C-H (German: "I"), the signature of the human being, eloquently described by the gesture of his hand and by his gaze. Just below, there was a skeleton, the converse aspect of our age, also carrying a book but without any initials.

The human being taking possession of his "I" seems to have brought about a new creative hiatus in human history. The hand of the Creator comes into this world from above, from outside. On the left, Faust's eternal "I" descended, while a being wrapped

in Luciferic veils looked down in blessing on this human being. If we study this depiction of the link between the figures of Faust and the skeleton, which is an expression of our time, if we study the divine helping hand, the thought suddenly comes to mind: is this not reminiscent of another imagination from the early sixteenth century? Is it not reminiscent of Bosch's Treeman imagination?

The gaze of the Cairo Treeman already contains the Faustian initials, the initials of the "I." The cosmic ruler is enthroned above him. Faust, surrounded by the four constituent parts of his being, has the initials of Christ inscribd in his book of life. The skeleton is related to the crumbling mineral body of the Treeman. It is standing upright in the grave, carrying its book and hemmed in by the gravestones of birth and death. Above, we see the human being resurrected in the spirit in his complete human form. He has transformed his earthly form into spirit, and his mummy can crumble to dust. His skeleton has dissolved, and Faust awakens to a new existence in the spirit, appearing in his new fivefold nature. He has transformed the former instruments of his body into spiritual egohood, filled with the new music of the spheres.

THE SELF-PORTRAITS OF HIERONYMUS BOSCH

The attempt to compare and gain an overview of Bosch's various self-portraits is fraught with obstacles. In particular, problems arise if we try to view the self-portraits in a chronological context. Enormous discrepancies arise between his age in the so-called self-portraits and the real age of the painter at the time when the portrait is assumed to have been painted. Certainly, it can be very productive to use such a comparison to try and gain an insight into

the nature of Bosch's development in this way. But the discrepancies in age discourage most attempts in this direction. It is not surprising, therefore, that this kind of portrait analysis has been abandoned by specialists in the field.

In addition, there is some controversy as to which depictions may be considered as self-portraits. The following are under discussion:

		Presumed age in portrait	of painter
1	Boy in carrying basket (*Last Judgment,* Vienna)	15	50
2	The person looking in (*Hortus Deliciarum*)	20	50
3	The alter ego (*Hortus Deliciarum*)	20	50
4	The spectator (*The Conjurer*)	30	30
5	The middle king (*Epiphany,* Philadelphia)	35	35
6	Participant (*Christ Crowned with Thorns,* Escorial)	40	60
7	Treeman (*Hortus Deliciarum*)	45	50
8	Self-portrait (Amhurst College, USA)	45	45
9	Treeman (*Last Judgment*)	50	60
10	Self-portrait (Charcoal drawing, Arras)	60	60

The dates in any such chronological overview are, of course, presumed dates. The dates of lost works have remained similarly unknown. As a result, the list can only be considered as a working hypothesis. This is particularly true of paintings 1, 2, and 3,

in which there is a difference of up to thirty years. The twenty year discrepancy in painting no. 6 might be explained by the possibility that it has been placed in the wrong chronological order, but we can conclude by saying that the great chronological differences do not provide a basis for further research.

There is, however, a way of achieving a satisfactory overview other than the purely chronological. The following method reveals a certain continuity while allowing us to disregard the chronological discrepancies; namely, to investigate the various self-portraits not on the basis of their date of origin and Bosch's resultant age but on the basis of the situation of the subject.

Using such a method, we have to distinguish between paintings that are plain self-portraits corresponding with Bosch's age and paintings that essentially represent stages in the development of Bosch's consciousness and maturity. Painting no. 8 from Amherst College, and the charcoal drawing from Arras, no. 10, can be described as simple self-portraits. But paintings 1, 2, 3, 7, and 9 would then have to be described as stages of inner development. The remainder, nos. 4, 5, and 6, can be seen both as chronologically correct self-portraits and, on the basis of the subject-matter, as stages of development.*

Looked at from the perspective of the continuity of the maturing consciousness, *The Last Judgment* in Vienna shows a youth of approximately fifteen years. He sits in a basket being carried unwillingly

* *A figure in* Christ Crowned with Thorns *in Vienna is also thought to be a self-portrait, but it appears to be too impersonal; the same is true of the meditating person in the Vienna* Last Judgment, *who appears more like a caricature of a person in meditation. The innkeeper who turns away from his somber guests (Treeman, Madrid and Cairo) is also considered to be a self-portrait of Bosch, as is the countenance of the person carrying St. Anthony (left-hand panel of the* St. Anthony *altarpiece).*

by a demon and looks around with burning curiosity at this kamaloca region. He is guided by an equally unwilling devil who wants to deny him access to this threshold region. The forces of the spirit of his youth give Bosch his demonic vision. The innate forces he carries with him (cf. also the carrying basket of the *Prodigal Son)* help him to leave his body to achieve this vision of the kamaloca. His entry into this terrible world is not quite legitimate, and one can understand the fearful look of the boyish soul.

Bosch's consciousness is in quite a different position in the painting *The Garden of Celestial Delights.* The person looking in (painting no. 2), the youth with the angelic gaze, here achieves his spiritual vision of the realm above purgatory with the aid of the soul of Eve, a deceased woman connected to him. He points to her clearly as helping him to his new insight. The youthful figure standing close beside him with features that are similar, if coarser, is his earthly self discarded like a mask during his vision. This alter ego plays no part in his vision. What was achieved with the help of demons in the Vienna *Last Judgment,* a vision of horror, becomes here the joyful vision of the highest spheres with the help of his angel and the soul of the deceased linked to him. But this vision could only occur because he shed his earthly consciousness.

However, it is somewhat surprising to discover the countenance of the Treeman on this triptych, a countenance that must also be considered to be a self-portrait of the artist. It contrasts starkly in attitude and expression with the youthfulness and calm on the countenance of the boy and the angel youth. What explanation is there for the appearance of the twenty-year-old and the fifty-year-old on the same triptych if the Treeman really is a self-portrait—and there can be no doubt about this?

It is important to take note of the environment in which the Treeman, this caricature of a man, is

to be found. We have already noted that in Bosch's paintings this "monster" (Fränger) is always an expression of the ego-human being who undergoes his supersensible experiences without shedding his earthly identity. In contrast to the boy's horrific vision in the kamaloca sphere, which was dulled because the demons were unwilling to serve him, the Treeman has enhanced his consciousness. Here the human being does not achieve access to supersensible spheres with the assistance of the deceased soul and does not need to shed his alter ego like a mask. He has developed within himself the powers for this kind of vision. Nevertheless, his own powers are not yet sufficient to allow him to look beyond the world of the moon sphere after death into the spaces that the boy was allowed to observe with the help of his angel. The inability to enter these worlds with his consciousness, the inability to penetrate through the demonic world, lends his countenance its deep resignation and disgust.

The following quotation from Rudolf Steiner occurs in the section on the Rosicrucians: "The scholars were filled with a tragic skepticism and their profoundly serious expressions revealed that they had had the terrible experience of seeing shells that were no longer inhabited by human beings. Nature was no longer a revelation of the gods. That saddened them." Is this not the Treeman's expression?

In comparison with this Treeman countenance, filled with resignation and disgust, the face of the Treeman in the Cairo *Last Judgment* represents an enhancement of the visionary consciousness. His strengthened "I" has given him full insight and knowledge. As an initiate he is now unconstrained in these worlds and has a commanding view of the whole drama of mankind. Kamaloca, or purgatory, becomes a temporary place of purification and transition, not the kingdom of eternal damnation, as it was in the Vienna *Last Judgment.* The Treeman

has ascended to an apocalyptic vision of things to come, and he experiences the time of judgment. He experiences the dead rising from their graves and the resurrection in the flesh as a process that has already begun and that takes place in every human "I" in the imitation of Christ.

The countenance of the master amid the human tragedy provides evidence of the high degree to which his consciousness had developed toward the end of his life. His countenance has taken on a timeless character by overcoming death. He has become imperturbable.

To reach these conclusions from such an analysis of Hieronymus Bosch's self-portraits might appear risky, as there is no documentary evidence for them. But if we consider how little documentary evidence there is for the whole of Bosch's life then this kind of intuitive observation could well provide some fruitful insights into the nature of his personality.

If we immerse ourselves in the individual self-portraits with a precise phenomenological imagination, we can find in each of them the constant expression that always signals the characteristic Bosch. Taking account of the different ages, this connection can be shown in detail. It is relatively easy to see the similarities in paintings 5, 6, and 8 and to a certain extent in nos. 1, 4, and 10. The strongest contrast exists between the faces of the Treeman in Madrid and Cairo (nos. 7 and 9).* But if we take into account the completely different emotions that are dominant on the two faces, resignation and initiation, the relationship can be established there as well.

These ten faces of Bosch reflect a multitude of

emotions. At first it is the fear and shock of the kamaloca vision (1), then the heralding of a vision of joy (2), mere existence (3), seeking to understand the deception (4), intimations of the future (5), the knowledge and experience of suffering (6), melancholy resignation (7), engagement in active work (8), the gaze of the "I" (9), and finally the transfiguration of the wise man in old age (10). A full life indeed!

Is this kind of comparison and contrast of the different stages in Bosch's life really of such significance in understanding his character? Should the Treeman be seen rather as an allegory of the human predicament?

The countenance itself challeges us to take it seriously when we study the motif of the Treeman over a number of years, particularly the countenance in the Cairo discovery, which has so obviously become the focus of events. It provides evidence of the rise in consciousness and achievement of Hieronymus Bosch's personality and work.

> The field has eyes — the forest has ears
>
> I want to see — be silent — hear.

These words from the drawing of the Owl in a Withered Tree might well be written as a caption for Bosch's last self-portrait, the charcoal drawing in Arras. They are a complete expression of his character and his work, work that was his message for mankind, for whom he felt a deep attachment, to hear.

Jacob Almaengin
Grand Master and Source of Inspiration

It is due to Wilhelm Fränger's efforts, who, with the help of the archivist Mossmann from 's Hertogenbosch, succeeded in finding documentary evidence relating to grand master Jacob Almaengin, that attention has

* A slide of the Treeman from an unknown copy of the Hortus Deliciarum was used by Rudolf Steiner in the lectures on art that he delivered in 1916. Peculiarly, the picture depicts a Treeman whose outer features are the Roman ones of the Cairo painting while his expression is the same as the resigned look on the face in the Hortus Deliciarum. It is therefore the missing link between the Madrid and Cairo pictures.

focused on this hitherto quite unknown grand master of the Rosicrucians. The documents reveal that Jacob Almaengin, a Jew who apparently came from Germany, was baptized in 's Hertogenbosch on December 13, 1496. It is a peculiar fact that this baptism took place under the patronage and in the presence of Philip the Beautiful, Duke of Brabant, son of Emperor Maximilian I, father of Charles V, and grandfather of Philip II. For a Jew this was an unusual patronage at that time.

On the basis of a doubtful report (Cuprianus), Fränger writes that Almaengin soon abandoned the Christian faith and returned to Judaism in spite of the princely patronage. All the circumstances indicate that this report came from an untrustworthy source since Judaism at that time would never have allowed an apostate to return to his old faith. It would also have been out of character in such an eminently Christian personality.

C. A. Wertheim-Aymès also concludes that Jacob Almaengin inspired Hieronymus Bosch on an esoteric level, and he accordingly differentiates between the works that were produced before Almaengin's influence and those that were inspired by him.

There is no concrete evidence of a specific time from which such an influence made itself felt on Bosch. It is a fact, after all, that there is already clear esoteric knowledge in his earliest works. The following evidence, quoted by Wertheim-Aymès, makes it likely that a meeting took place between the artist and the souce of his inspiration: the initials I. A. and B., discovered through infrared radiation, were found both on the original as well as the copy (Zurich) of the *St. Anthony* altarpiece.

In Fränger's view, the St. John type figure that frequently appears in Bosch's work is the image of the grand master. This figure can be found in the following pictures:

The Marriage at Cana	the bridegroom
Four Medallions	stations in a human life
Christ on the Cross (Brussels)	the figure of John
John the Evangelist on Patmos	John the Evangelist
Hortus Deliciarum (central panel)	background figure of the upright (Wertheim)
Hortus Deliciarum (central panel)	alterego, the mask (Wertheim)
Hortus Deliciarum (central panel)	the angel-youth (Fränger)

The question to what extent the so-called enigma, the things that are unspoken and eerie, so typical of many of Hieronymus Bosch's works, is due to the nature of the artist or only developed under the influence of the grand master is one that is not easy to answer. The first picture that contains such an indefinable atmosphere is probably *The Conjurer;* then there is also *The Marriage at Cana,* painted a short time later, in which this mysterious tension comes to the fore. In this connection we can still name the two panels of *The Flood* as well as *The Haywian,* in spite of the vitality of its coloring. The *St. Anthony* altarpiece, with its black mass, also belongs to this series, as well as the *Epiphany* painting with Herod, a work of the late period.

Fränger tries to explain how such teaching and initiation into the Rosicrucian spirit might have taken place. Without doubt it was a very intimate process and not merely lessons between teacher and pupil, which then enabled the artist to transform the images he had been given into color. It must have been a process deep within Bosch that allowed him to be filled with this wisdom, experience it, and

bring it to the surface again. The contrast between
the expression of the Treeman and the angel-youth
in the *Hortus Deliciarum* shows that this was a new
kind of consciousness.

That such initiation or influence reduces Bosch's
artistic merit can not be considered as a serious
argument. In addition, it should still be pointed out
that the Rosicrucian writings such as the *Chymical
Wedding* and the *Fama Fraternitatis* mention the
Brother I.A., the spiritual heir to Christian Rosenkreuz,
who took on a clever painter with the initial B.
The former is described an a non-German (see
the translation by M. Weber, Basle). I. A. was
baptized as Philip van Sint Jan. After the baptism
he was received into the Brotherhood of our Lady
in 's Hertogenbosch, a community that had close
connections with the Rosicrucians.

Works by Rudolf Steiner *Number of Lectures in parentheses*

1.	The History of the Middle Ages to the Time of the Great Inventions and Discoveries	Berlin (8) Oct. 1904
2.	The Path of Knowledge [or Insight] and Its Stages	Berlin (1) Oct. 1906
3.	The Theosophy of the Rosicrucians	1907
4.	European Mysteries and Their Initiates	1909
5.	The Orient in the Light of the Occident	Munich (9) Aug. 1909
6.	The Spiritual Guidance of the Individual and of Humankind	Munich (3) 1911
7.	The Christian Rosy Cross and Buddha	Neufchâtel (3) Sept. 1911
8.	From Jesus to Christ	Karlsruhe (10) Oct. 1911
9.	Tales of the Occult: Personalities and Events in the Light of the Arts	Stuttgart (6) Dec. 1911/12
10.	Rosicrucian Christianity	Neufchâtel (13) 1912
11.	Life between Death and Rebirth in Relation to Cosmic Data	Berlin (10) 1912/13
12.	What Meaning Does Occult Development Have for Man's Outer Being and Inner Self?	Den Haag 1913
13.	The Mysteries of the East and Christianity	Berlin (4) 1913
14.	Christ and the Spiritual World: On the Quest For the Holy Grail	Leipzig (6) Dec. 1913/14
15.	Christ in Relation to Lucifer and Ahriman	Linz (1) 1915
16.	Art History as Image of Inner Spiritual Impulses	Dornach (15) 1917
17.	The Spiritual Background of the Intellectual World	Dornach (8) Sept. 1917
18.	Building Stones For a Recognition of the Mysteries of Golgatha	Berlin (8) 1918
19.	Basic Impulses of the World-Historical Development of Mankind	Dornach (8) Oct. 1922
20.	Esoteric Christianity and the Spiritual Guidance of Mankind	(23) Book
21.	Mystery Cults	Dornach (14) Sept. 1923
22.	Mystery Cult Locations of the Middle Ages, Rosicrucianism and The Modern Principle of Consecration	Dornach (6) Jan. 1924
23.	Guiding Principles and Letters to the Members	Dornach 1924

** This is the state of Kurt Falk's bibliography for this book at the time of his death. We have left it as he left it, a useful tool, though incomplete, for research and further study.*

24.	C. A. Wertheim-Aymès	*The Symbolic Speech of the Friends of the Heavenly Garden*	1957
25.		*The Antonius Altar and the Prodigal Son*	1961
26.	Wilhelm Fränger	*The Thousand-Year Reich*	1947
27		*The Wedding at Cana*	1950
28.	Ludwig Balass	*Hieronymus Bosch*	1959
29.	Delaroy, Skira Verlag	*Hieronymus Bosch*	1957
30.	Hans Roth	*The Garden of Delights*	1959
31.	Anthony Bosman	*Hieronymus Bosch*	1962
32.	Gottfried Richter	*Ideas on Art History*	1958
33.	Rudolf Meyer	*The Grail and its Guardians*	1952
34.	F. M. Godfroy	*Hieronymus Bosch*	1949
35.	Jacques Combe	*Hieronymus Bosch*	1957
36.	Charles de Tolnay	*Hieronymus Bosch*	1965
37.	Günther Wachsmuth	*The Kepler Drama*	195-
38.	Carl Linfert	*Hieronymus Bosch,* Phaidon Verlag	1959
39.	Dino Buzzati	*The Complete Works of Bosch*[1]	1966
40.	Editions Hachette	*Hieronymus Bosch*[2]	1967
41.	Dr. A. Vermeylen	*Hieronymus Bosch*	1950
42.	Louis van den Bossche	*Hieronymus Bosch*[3]	1944
43.	Piero Bianconi	*Breughel the Elder* (Flammarion Press)[4]	1968

[1] *Original title in Italian*

[2] *Original title in French*

[3] *Original title in French*

[4] *Original title in French.*

All other titles in German.

INDEX OF WORKS

Kurt Falk co-founded the Tobias School of Art in Forest Row, England, with his wife, Anne Stockton. He was a teacher of art history. Prior to that, he had been a biodynamic farmer in Germany and then in Egypt. While he was in Cario, he discovered the mysterious Bosch painting that forms the center of this book. He continually researched the deeper background of the paintings of Hieronymus Bosch until his death in 1986.

Text for this book has been set in Adobe Garamond
on Macintosh computers
using Quark Xpress software.
Chapter heads and initial capitals are set in Verdana

Adobe Garamond is based on punches
cut by Claude Garamond in the sixteenth century,
It was redrawn in 1989 by Robert Slimbach
for Postscript composition and offset reproduction.

Verdana, designed in 1996 by Mathew Carter,
and hand-hinted by Tom Rickner,
is optimized to be crisply legible when displayed at
very small sizes on computer screens.
It has come to be used by print designers, however,
often at very large sizes, to sound a
contemporary note in
more traditional typographic treatments.